# Body Style

**Subcultural Style series**

ISSN: 1955-0629

Series editor: Steve Redhead, University of Brighton

The *Subcultural Style* series comprises short, accessible books that each focus on a specific subcultural group and their fashion. Each book in the series seeks to define a specific subculture and its quest to exist on the fringes of mainstream culture, which is most visibly expressed within a subculture's chosen fashions and styles. The books are written primarily for students of fashion and dress but will also be of interest to those studying cultural studies, sociology, and popular culture. Each title will draw upon a range of international examples and will be well-illustrated. Titles in the series include: *Punk Style, Queer Style, Fetish Style* and *Body Style*.

# Body Style

## Therèsa M. Winge

London • New York

English edition
First published in 2012 by
**Berg**
Editorial offices:
50 Bedford Square, London WC1B 3DP, UK
175 Fifth Avenue, New York, NY 10010, USA

Berg is an imprint of Bloomsbury Publishing Plc.

**Library of Congress Cataloging-in-Publication Data**
Winge, Theresa M.
Body Style / Theresa M. Winge.
p. cm. — (Subcultural style)
Includes bibliographical references and index.
ISBN 978-1-84788-023-9 (pbk.) — ISBN 978-1-84788-737-5 () — ISBN 978-0-85785-
321-9 ()   1. Human body—Social aspects.   2. Human body—Symbolic aspects.
3. Subculture.   4. Clothing and dress—Social aspects.   5. Fashion—Social aspects.
I. Title.
GN298.W56 2012
306.4—dc23        2012002604

**British Library Cataloguing-in-Publication Data**

A catalogue record for this book is available from the British Library.

ISBN 978 1 84788 001 7 (Cloth)
978 1 84788 023 9 (Paper)
e-ISBN 978 1 84785 321 9 (institution)
978 1 84788 737 5 (individual)

Typeset by Apex CoVantage, LLC, Madison, WI, USA.
Printed in the UK by the MPG Books Group

**www.bergpublishers.com**

# Contents

# List of Images

# Acknowledgements

My deepest gratitude is extended to my mentor, Joanne B. Eicher, for her invaluable advice, support, and encouragement. I am also grateful to Michael Baizerman, Gloria Williams, and Karen LaBat for their guidance in my early research. I wish to express my sincerest appreciation to my research participants, without whom I could not have begun or finished this book.

I am indebted to those qualitative researchers who gave me continuous feedback and support on this research and writing: Marybeth C. Stalp, Gowri Betrabet Gulwadi, Dawn Del Carlo, Monica Sklar, Heather M. Akou, Rebecca Schuiling, Taylor Morton, Katalin Medvedev, Katie Gunter, and Lauren Paulauskas. Specifically, I acknowledge Heather's ability to make me laugh during my research and keep me clear-sighted during my writing, and Marybeth's steadfast commitment to and support of my completing this text.

This book could not have happened without all of the professionals at Berg Publishing. I owe a special thanks to Hannah Shakespeare for the inspiration and initial efforts in the creation of the Subcultural Style series, where this text found a home. Many thanks are also due to Steve C. Redhead, Julia Hall, and Anna Wright for all of their guidance, support, and patience.

I am appreciative for the financial support from the Design, Housing, and Apparel Research Block grant at the University of Minnesota, and the Humanities and Arts Research Program grant at Michigan State University.

I am most grateful to my family—Bill, Taibhs, Gnasher, Freya, Kalsang, Fluffy, S'bu, and even Earl—for all of their patience and well-meaning distractions. Any typos found in this text may be credited to my not-so-swift-footed feline companions.

# Preface

*Body Style* is the first book in the Subcultural Style series. Future books in the series will look at Punk Style, Goth Style, Fetish Style, Queer Style, and Rap and Hip Hop Style.

Therèsa Winge's pioneering book reveals the subcultural body as a site for understanding subcultural identity, resistance, agency, and fashion. Analyzed, theorized, politicized, and sensationalized, the subcultural body functions as a framework on which a sense of self and a subcultural identity is built. *Body Style* is the result of over twelve years of research with urban subcultures from North America, Europe, and Australia, such as Urban Tribals, Modern Primitives, Punks, Cybers, and Industrials.

As a result of intersections between the subcultural body and dress, the subcultural body has been understood, misunderstood, co-opted, and consumed by the masses. Drawing on specific subcultural examples and interviews with subculture members, *Body Style* explores the subcultural body and its style within the global culture.

Each book in the Subcultural Style series seeks to define specific subcultures and their quest to exist on the fringes of mainstream culture, which is most visibly expressed within a subculture's chosen fashion and styles. The books provide a solid opportunity to reach an academic audience in dress and fashion eager to learn more about subcultures and subcultural fashion.

*Professor Steve Redhead*
*(University of Brighton),*
*series editor*

# Introduction to Subcultural Body Style

The body is a house of many windows: there we all sit, showing ourselves and crying on the passers-by to come and love us.

—Robert Louis Stevenson, "Truth of Intercourse," *Viginibus Puerisque and Other Papers, Memories and Portraits*, 1879/2004

The human body exists as an analyzed, theorized, politicized, and sensationalized entity, concurrently functioning as a medium for physical, psychological, emotional, and spiritual transformation. Every human being has *body style*; that is, the body's appearance reflects individual identity, politics, ideology, and lifestyle.

The subcultural body, however, often amplifies and accentuates body style. When displayed, the subcultural body is a visual celebration of the body: its modifications and supplements; its movements and performances; and its explorations and rituals. In this way, the body becomes a representation of a subculture's visual and material culture and ideology. The subcultural body style encompasses more than just the physical body of a subculture member (dress, adornment, exterior, presentation, etc.), extending the ways the subcultural body is presented, displayed, disguised, and celebrated inside and outside the subculture.

What is subcultural body style? What body modifications and/or supplements signify or qualify as subcultural? Is it a body that has physical modifications, such as a facial tattoo, septum piercing, or green hair? Is it a body donned with a corset, baseball cap, or leather jacket? What piercing loci are subcultural? How many and what kind of body modifications are necessary to create a subcultural body?

The subcultural body is highly time-sensitive and complex in its existence. What was once considered a subcultural body style over time becomes the societal norm instead of the exception. For example, flat-ironed long hair for women in the 1960s was considered subcultural, while in the twenty-first century the usage of hair-straightening devices and chemicals is considered fashionable. When does a subcultural body style cease to exist as subcultural? The body that qualifies as a subcultural body is highly dependent on the perception of what a subculture is defined as within a specific cultural and social context, often in contrast to norms and ideals.

## Toward a Working Definition of "Subculture"

After World War II, subcultures surfaced with prominence in urban spaces within Western culture (Thompson 1998). Scholars speculate that these subcultures formed because of shared issues and common needs that set them apart from mainstream culture and society (Cohen 1955). Over time, the term "subculture" gained negative connotations for four primary reasons. First, the very term "subculture" has a prefix of "sub," which suggests something lower or below. Second, subculture members often come from socioeconomic and sociocultural backgrounds that are overgeneralized and misunderstood by mainstream culture. Third, subcultures often reject their parent culture. In turn, the parent culture quickly associates emerging societal issues with the next generation, often faulting subcultural ideologies as the source of unrest. Fourth, and often influenced by the previous three reasons, the media interprets and presents subcultures as alienated, subordinate, and/or alternative, suggesting that subculture members reject mainstream mores, conventions, and dress in order to achieve *contentious* objectives. Consequently, the media influences the interpretations and representations of the term "subculture" within mainstream society. In fact, the media frequently name emerging subcultures with derogatory or inaccurate labels. In turn, subculture members often embrace the name or label as a subcultural moniker.

The media creates a feedback loop centering on the appearance and style of the subcultural body. The loop perpetuates negative connotations and stereotypes about subcultures when projections of subcultural appearance are linked with certain activities. The media is selective to choose deviant activities, such as crime, disobedience, and civil disturbance, that best suit its agenda. Drawing attention to certain elements of the individual that deviate from normative dress, the media has the power to establish the wearer's possible involvement in questionable activities. Kenneth Thompson explores in *Moral Panics* (1998) the role of the media in drawing attention to any group different from the more homogenous mainstream, and further identifying these groups with the hyperbolic and multilayered terms "moral panics" and "deviant," and thus warranting the label of "subculture."

The news and other nonfiction media make the linkages between subcultural activities and specific body styles for their audiences. Accordingly, fiction writers and screenwriters utilize these overgeneralized and stereotyped items of dress for their characters and storylines, which nonverbally communicate subcultural identity (often with negative and suspicious overtones). Subcultural body style, for example, is referenced in television shows (e.g., *Freaks and Geeks, Glee, Skins,* and *The Big Bang Theory*) and films (e.g., *Animal House* [1978]; *The Breakfast Club* [1985]; *Hairspray* [1988]; *House Party* [1990]; and *Across the Universe* [2007]). Consider movie directors John Hughes and John Waters, who established successful careers on exploiting stereotypical subcultural body and dress. These directors were successful not only because of their portrayals of diverse subculture members, but also in

revealing the three-dimensional qualities of their characters that defied expectations of their subcultural appearances.

In John Hughes's movie *The Breakfast Club*, consider the presentation of five teenagers during a Saturday afternoon detention. Each character portrays a subcultural stereotype found in a North American high school in the 1980s: nerd, jock, freak, popular, and outcast. The viewer assumes they know a great deal about each character based on his or her dress, but throughout the movie the diverse and complicated qualities of the characters are further revealed. As a result, an informative letter, written by the character Brian to the detention monitor, is read to the audience at the end of the movie:

Dear Mr. Vernon:

We accept the fact that we had to sacrifice a whole Saturday in detention for whatever it was we did wrong. What we did was wrong. But we think you're crazy to make us write an essay telling you who we think we are. What do you care? You see us as you want to see us. In the simplest terms, the most convenient definitions. But what we found out is that each one of us is a brain, an athlete, a basket case, a princess, and a criminal. Does that answer your question?

Sincerely Yours, The Breakfast Club (Hughes 1985)

Similarly, John Waters's film *Hairspray* (1988) presents a campy tale of urban youth who participate in a weekly televised dance show in racially tense 1960s Baltimore. The movie draws on the audiences' familiarity with 1960s cultural and subcultural members and exaggerates their dress for the sake of humor. The movie also addresses controversial topics, such as segregation, sex, body size, and popularity. Throughout the film, youth subcultures infiltrate and reject the parent culture causing suspicion, fights, and rebellion; Waters exaggerates these conflicts through the chosen body styles and dress of the parents and youth.

Recapping, nonfictional and fictional media often interprets the term "subculture" as pejorative and negative, which cultivates similar views in the general public. This combined with linguistic bias of the prefix "sub" aids the interpretation that a group is "less important than" or "below" mainstream culture. The term "subculture" promotes generalizations and stereotypes about the described groups, which are often seen as the *Other*,[1] leading to misunderstandings, discrimination, and exploitation. Furthermore, a label such as "subculture" is often perceived as a biased way of recognizing a portion of human diversity. This is a hindrance in understanding both the profound similarities and differences in all human beings (Dilger 2003).

## History of the Term "Subculture"

Moreover, the term "subculture" is rarely defined and used correctly in the media and academia (see Yinger 1960). American anthropologist Ralph Linton first used

the term in 1936 in relation to a group as a subset of a culture, and stated in *The Study of Man*:

> While ethnologists have been accustomed to speak of tribes and nationalities as though they were the primary culture-bearing units, the total culture of a society of this type is really an aggregate of sub-cultures. (Linton 1936, 275)

Still, the more contemporary connotations surrounding the term "subculture" stem from the research of Milton M. Gordon, a cultural studies scholar. He discusses in "The Concept of the Sub-Culture and Its Application" that subculture is a subdivision

> of a national culture, composed of factorable social situations such as class status, ethnic background, regional and rural or urban residence, and religious affiliation, but forming in their combination a functioning unity which has an integrated impact on the participating individual. (Gordon 1947/1997, 40–41)

Early subcultural scholars speculated that subcultures formed with deviant, delinquent, and/or disenfranchised individuals, based on their common problems and goals (Becker 1963/1973; Cohen 1955; Hebdige 1979; Irwin 1970). Much of this subcultural research resulted from direct and indirect studies being conducted at the Chicago School and the Birmingham University's Centre for Contemporary Cultural Studies (CCCS). While the CCCS received only mild criticism, both institutions were critiqued for oversimplifications and generalizations disseminated about subcultures from early research (Edgar and Sedgwick 1999; Hodkinson 2002).

In *The Subcultures Reader*, Sarah Thornton identifies the two ways the negative connotations reflect the label of "subculture":

> First, the groups studied as subcultures are often positioned by themselves and/or others as deviant and debased. [. . .] Second, social groups labeled as subcultures have often been perceived as lower down the social ladder due to social differences of class, race, ethnicity, and age. (Thornton 1997, 4)

In *Subculture of Violence,* Marvin Wolfgang and Franco Ferracutti contend that the prefix "sub" refers only to a subcategory of mainstream culture, which should not necessarily indicate that a subculture is deviant or delinquent (Wolfgang and Ferracutti 1967, 95). Wolfgang and Ferracutti also assert that sociologists, anthropologists, cultural studies theorists, and similar academics often use the label "subculture" without a value judgment. They, however, support the assertion that popular media promotes the negative connotations attached to groups labeled as subcultures (Wolfgang and Ferracutti 1967, 97–98).

The term "subculture" contains understood and value-laden meanings that are not always useful to understanding the described group(s). Still, I chose to use "subculture" over other possible terms, such as "counter culture" or "micro culture," because some subcultures are not rebelling or contrary to the dominant, mainstream, or *parent* culture, and some subcultures are not small in numbers. The following scholars informed my research about subcultural groups and assisted in my working definition of the term "subculture," which attempts to describe in a broad sense the groups and individuals within my subcultural dress research. In *Subculture: The Meaning of Style* Dick Hebdige informs my research by defining a subculture as "a subordinate group, which has expressive forms and rituals, which denounce public order" (Hebdige 1979, 2–3). Also useful to this study, Hebdige states that the meaning of subculture is always in dispute because the term applies to so many different groups recognized solely by their appearances (Hebdige 1979, 3). Sarah Thornton asserts that "subcultures [. . .] have come to designate social groups, perceived to deviate from the normative ideals of adult communities" (Thornton 1997, 2).

Furthermore, in *Inside Subculture: The Postmodern Meaning of Style* David Muggleton questions the authenticity regarding subcultural membership and identity, suggesting that authentication may be part of the subculture's visual culture and inherent to the observer's perspective. Muggleton argues subculture members appear more homogenous inside the subcultural group, but, at the same time, are differentiated from the surrounding (dominant or mainstream) culture (Muggleton 2000, 20–22). Perhaps, most influential to my development of a working definition of "subculture" was *Profane Culture* by Paul Willis (1978), which captures and documents the chaotic and unexpected natures of subcultural research and suggests that the researcher must be flexible (see also Muggleton 2000). Therefore, my research attempts to critically examine the continuous flexibility needed to cope with unpredictable situations and behaviors within subcultures and between insiders and outsiders.

I developed a working definition of "subculture" that captures individuals who occupy multiple roles and identities outside of mainstream society, common in Western culture. For my research I define *subculture* as:

> a group smaller in population than mainstream culture as a whole, and who consciously set themselves apart from the mainstream society with any combination of the following: dress; ideology; music; language; technology; geography; and/or activities.[2]

I acknowledge that this definition is broad. My research, however, with subculture members suggests that individuals frequently belong to more than one subculture simultaneously or over their lifetime. Furthermore, as is the case in North America, many of the individuals whom I interviewed were reluctant to be labeled as belonging to one specific group or another, but accepted the "subculture" moniker for their

rejection of mainstream lifestyles, fashions, ideologies, and homogeny. Accordingly, I also draw on the postmodern assertion that individuals have fragmented existences and are resistant to being defined as one thing and not another, suggesting alienation (Appignanesi and Bennington 1989; Lyotard 1984). Thus, my definition allows for a vast array of groups to be considered as subcultures; it also accounts for individual members from one group to freely move into other groups, and even have member-ships existing in multiple groups at the same time. This definition is particularly useful in subcultural dress research where I have found examples of members whose dress exhibits more than one group membership at one time.

## Dress, Body Modification, and the Subcultural Body Style

The phenomenon of the subcultural body may be discussed and better understood within the context of Joanne B. Eicher's concept of *dress*:

> A system of nonverbal communication that enhances human beings' interaction as they move in space and time. As a coded sensory system, dressing the body occurs when human beings modify their bodies visually or through other sensory measures by manipulating color, texture, scent, sounds, and taste or by supplementing their bodies with articles of clothing and accessories, and jewelry. (Eicher 2000, 422)

Body supplements are items of dress that attach to, adhere to, and/or insert into the body, and may be substantial additions for some body modifications, such as jewelry inserted into a piercing hole, or bone or metal wrapped around dreadlocks; body modifications include tattoos and piercings, and modifications can extend the change or transformation of the hair, skin, nails, muscular system, teeth, eyes, and/or breath, all which can be classified as a form of dress (Eicher and Roach-Higgins 1992).[3] In this study, I also rely on Rufus C. Camphausen's explanation of body modification as a "term for a variety of techniques aimed at changing one or more parts of the body from the natural state into a consciously designed state" (Camphausen 1997, 110).

Accordingly, "[d]ress lies at the margins of the body and marks the boundary between self and other, individual and society" (Entwistle 2001, 37), and in these margins there is space to understand the subcultural body and its complexities. This space is ever changing, in that the boundaries of the subcultural body are continuously in flux, as are most things subcultural. The subcultural body style is a complex visual amalgamation of dress elements. Consider the hairstyle examples presented at the beginning of this chapter; hairstyles worn by subculture members often in time return to become fashionable styles. Both inside and outside the subculture the body is assigned labels in order to differentiate, categorize, research, discuss, and even artificially limit subcultural members.

For my research, I sought contemporary and noteworthy examples in Western culture of the subcultural body since World War II that illuminate the varied and

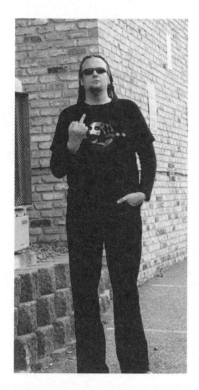

**Image 1** The subcultural body style is a complex visual amalgamation of dress elements, which can sometimes be difficult to decipher, yet at other times the message is very clear. (Photo: Therèsa M. Winge, unpublished research image)

diverse styles associated with recognized, celebrated, and lesser-known subcultures. I primarily draw on examples from North America and Europe, but recognize the global influences and culture in which subcultural body styles are conceived, formed, worn, and known. I also include subcultural celebrities, such as body modification performers The Enigma, The Lizardman, and Fakir Musafar. These celebrities are known for their body modifications and distinctive dress within public performances, and illustrate the new role of the subcultural body, challenging and redefining previous subcultural labels and roles of "folk devils" and "moral panics" portrayed within the media (see Thompson 1998).

I examine the subcultural body for major themes, primarily focusing on the modified body. I reveal the subcultural body as a site for understanding the unique context of subcultural identity, resistance, agency, and style. I explore the appearances, styles, practices, purposes, and meanings associated with the subcultural body for visual clues and cues that reinforce the subculture's ideology and the postmodern experiences. I concentrate on the subcultural body styles within the Urban Tribal movement. This movement includes several distinct subcultures, such as Punks and Modern Primitives, who share body style commonalities but at times conceal their subcultural identities and identifiers in order to disassociate themselves from subcultural labels.

## Introduction(s) into Subcultural Research

In 1992 I attended my first Lollapalooza concert in Wisconsin, where I was introduced to the Urban Tribal movement and several of its subcultural members. I was also introduced to the subcultural body in an entirely new way. While the Urban Tribal movement existed as early as the late 1950s with the Modern Primitive subculture, it was not until the early 1990s that this movement truly gained a place of significance within the subcultural and popular media landscape. In 1991 Perry Farrell, lead singer for Jane's Addiction (a North American alternative music band), organized a collection of musical acts—Lollapalooza—that toured North America. In this concert setting, Farrell brought together diverse musical and performance talents outside the "corporate rock" arena (Thompson 1995). In doing so, Farrell exposed concertgoers to music genres ranging from the industrial songs of Nine Inch Nails to the gangsta rap of Ice-T. Farrell also invited "alternative" vendors who sold hemp clothes, independent music, and handmade jewelry; and showcased "alternative" live entertainment, such as the Jim Rose Circus, which was a loud, humorous, and risqué blend of the extravagant sideshow acts inspired by the Barnum & Bailey Circus[4] and Moulin Rouge.[5]

The Jim Rose Circus performances primarily involved physical acts by individuals who emphasized and displayed styles and feats of the subcultural body for the audience's entertainment. Typical acts included, but were not limited to, the following: the Amazing Mr. Lifto, who covered himself in shaving cream and then lifted heavy weights from his genital piercings; Slug (later known as The Enigma), who swallowed random items—worms, dirt, knives, and swords; and Bebe the Circus Queen, who laid on a bed of nails while heavy weights were placed on her body, or applied a mechanical grinder to her metal chastity belt to shower her body with hot sparks. Most performers of the Jim Rose Circus were heavily tattooed and pierced; their body supplements were often large in size and made of bone or metal.

Later, within my research, I identify these performers as part of the Urban Tribal movement because of their subcultural body modifications and displays. Having a personal history with performers from both vaudeville and sideshows, I appreciated how each performer engaged the audience and modified her or his act according to audience responses.[6] Performers in the Jim Rose Circus not only waited for the gasps and chuckles, reactions to the raw physical humor, before moving on to the next feat, but they also repeated the feats that did not receive the desired responses. Each performance exceeded the expected limits of the body according to (and despite) the screams of both amazement and abhorrence from the spectators.

Then, in 1995, I was reintroduced to the Urban Tribal movement when I began ethnographic research focusing on subcultures that frequented an industrial music nightclub—Ground Zero in Minneapolis, Minnesota. During the study, I also observed members from the Goth, Vampire, Industrial, Punk/Neo-Punk, Cyber, Fetish, and Skater subcultures. From 1998 to 2000 I collected qualitative data from ob-

servation, participant observation, and informal interviews with various subculture members about their subcultural dress and social groups. I compiled this data as a comparative model of the subculture social systems where dress was a significant identifier and mode of nonverbal communication.

From 2000 to 2004 I continued my research with an in-depth phenomenological study of the body modification experiences of members of Urban Tribal movement, specifically individuals who had significant body modifications and subcultural bodily experiences (often identified as Modern Primitives). In 2003 I conducted nineteen qualitative in-depth interviews with photographic documentation of body modifiers and body modification practitioners.[7] (The interview quotations provided in this book reference these participants by their own self-selected pseudonyms.) From 2000 to 2009 I collected data from observations and participant observations at subcultural clubs, coffee houses, and body modification establishments in North America. I also attended several body modification performances, and was present for four body modification appointments with individual study participants. In this study, I use hermeneutic thematic analysis, interviews, photographs, and fieldnotes to interpret common themes (Madison 1988; van Manen 1998).

## The Urban Tribal Movement and Subcultural Body Style

As a result of my research, I understand the *Urban Tribal movement* as a collective of subcultures and individuals who explore and experience elements of belonging to a "tribe" or subculture within an urban environment, extending beyond the mere physical spaces to the social, cultural, and political contexts. The characteristics and connections these subcultures share within the Urban Tribal movement are frequently bodily experiences and body modifications. The Urban Tribal movement demonstrates interconnectivity of urban subcultures, which was first evident during my research studies in Minneapolis. The Urban Tribal movement also led me to broader research of subcultures and their body styles in North America and Europe. My research revealed how individual subculture members from the Urban Tribal movement share their body modification experiences with each other in social settings and through new media, such as email, blogs, and Internet social networks. Technology-driven cultures within a globalized world create fertile spaces for these diverse individuals and groups to experience and celebrate their unique body styles within the Urban Tribal movement as a global subcultural phenomenon.

I am fortunate to be part of this connectivity, and grateful to all of the people who have spoken openly and privately with me about their subcultural body styles. My research primarily focuses on North American Urban Tribal subculture members, who contribute to the origins of the phenomenon of body modifications and its global presence within today's subcultural environments. I include global examples where appropriate, with a constant focus on the visual and material cultures of the

Urban Tribal body style. My subcultural research is responsive to and acknowledges the subcultural *lived body*,[8] in that I include portions of the interviews (indicated with italicized font), images, and observations about the subcultural body within the Urban Tribal movement.

## Introducing Subcultural Body Style

This book contributes to the existing scholarship in Youth Studies, Cultural Studies, Subcultural Studies, and Dress Studies. My research offers new insights for understanding the subculture members and style motivations through the lens of dress (Eicher 2000; Eicher and Roach-Higgins 1992; Taylor 2002). I completed over twelve years of qualitative research that includes a span of distinct and, at times, interconnected urban subcultures. I examine the subcultural body and dress practices (i.e., body modifications and supplements; see Eicher and Roach-Higgins 1992) of urban subcultures and draw on specific subcultural examples and quotations in order to give voice figuratively and literally to the subculture members introduced and discussed. I also supplement these examples with additional subcultural scholarship that contributes to the discussion of the subcultural body, in order to sketch a global illustration with rich and diverse representations of the subcultural body style.

My research focuses on subcultural dress relative to the subcultural body style. This focus provides a crucial understanding of the significance of subcultural dress and related practices for the individual members of the subculture. Specifically, I explore the appearances, style, practices, purposes, and meanings of the subcultural body using qualitative research with an emic perspective, from an insider's point of view.

## Subcultural Body Style and Dress Research

Scant research exists on the subcultural body and its style or dress; most of the available subculture information results from insiders documenting their subcultural experiences. The very idea that subcultures have style or fashion is controversial and even disputed, which may be the reason that the term "antifashion" became closely associated with subcultures and their dress. Postmodernists argue the fragmentation of society produces diverse and vast choices in nearly everything, suggesting a wide array of fashion or style choices available to subculture members (Sweetman 2000). In opposition, dress scholars suggest that abundance of variety and choice should not preclude the existence of subcultural (anti)fashions and styles (Lind and Roach-Higgins 1985). Ted Polhemus and Lynn Proctor (1978) claim that the term "antifashion" refers to any type of dress not strictly part of the Western "fashion system." In this way, the term "antifashion" is problematic; its definition is murky and changes as fashion changes.

Many mainstream fashions are inspired by the dress and styles of subcultures, demonstrating that antifashion is fashionable in the correct context. The North American fashion designer Tommy Hilfiger, for example, drew inspiration from the Hip Hop and Rap subcultures to create his sportswear lines in the late 1980s and early 1990s (Hilfiger 1997). Anna Sui, another North American fashion designer, continues to draw inspiration from the North American 1960s Hippie subculture to create her many highly stylized romantic bohemian fashion lines (Steele and Solero 2000). And British designers Alexander McQueen and John Galliano drew inspiration from the Goth subculture for couture fashion lines (Steele and Park 2008).

Most of the research about subcultures only briefly addresses their appearance and dress, and then only mentions the latter as a means of visual description and identification that launches another discussion (see Hebdige 1979; Leblanc 1999). The limited research on subculture dress usually focuses on controversial or spectacular appearance and styles, such as the Modern Primitives' extensive body modifications (see Featherstone 2000; Kleese 2000; Strauss 1989; Sweetman 2000; Torgovnick 1990). Still, the above research informs my text with discussions about the subcultural body. Historically, dress scholars rarely focus research and discussions on subcultures (see Eicher, Evenson, and Lutz 2008; Kaiser 1990; Steele 1996). But in recent years, subcultural dress has a greater focus within Dress Studies publications, such as Suzanne Szostak-Pierce's chapter "Even Further: The Power of Subcultural Style in Techno Culture" (1999) about the Raver subculture; Paul Hodkinson's book *Goth: Identity, Style, and Subculture* (2002) about the Goth subculture; David Muggleton's book *Inside Subculture: The Postmodern Meaning of Style* (2000) about the British subcultural scene; and select passages in the anthology *The Post-Subcultures Reader* (Muggleton and Weinzierl 2003). I expand the latter body of work and address the gaps in the discipline by focusing on the subcultural body and its styles, dress, and fashions.

## Summary

The body styles within the Urban Tribal movement are fertile for exploration and analysis, which may provide a deeper understanding of the bodily experiences of the subcultural lived body. In this chapter I explored the definitions of subculture, subcultural body style, and dress. Subcultural body style exists as symbolic representations of the subculture's ideology manifested in its material and visual cultures. I also examined the available research in subcultural dress, as well as the scholars and discussions informing my research into the Urban Tribal movement and its subculture members.

The contemporary subcultural body has a diverse and varied history, which is the focus of chapter 2. Significant scholarship about the body is presented pertinent to subcultural body styles; this scholarship is further explored for evidence and contri-

butions to the discussion of the subcultural body. I review a variety of sources about the subcultural body from subcultural music lyrics to scholarly texts, in order to establish a framework for connections to its history, identity, styles, and future. Chapter 2 concludes with an examination of normative and nonnormative labels associated with the subcultural body.

Since World War II, subcultures have flourished in Western culture. Each subculture carves out a niche at the fringes of mainstream culture, distinguishing itself and creating a subcultural postmodern identity with its unique and often controversial appearance and style. I examine, in chapter 3, the identities associated with and created by the subcultural body, and draw on specific examples from the Modern Primitive subculture within the Urban Tribal movement.

I explore specific body styles and fashions, along with related themes of the subcultural body in chapter 4. Some subcultural appearances and styles are highly dependent on the role of the body, while others have more passive roles by simply displaying associated clothes and hairstyles. The body is actively engaged and presented within bold displays of subcultural identity. I conclude chapter 4 with a discussion about Modern Primitives' subcultural body styles.

As the consumerist cycles spiral in ever-tightening patterns, the subcultural appearance is co-opted, bought, and sold at the local shopping mall more rapidly than ever before. The result is the *body renaissance*,[9] which is pushing the subcultural body into new realms with consequences perhaps too extreme for mainstream culture to follow. In chapter 5, I present the possible futures for the subcultural body with examples of the body and new technologies in the light of this body renaissance.

# –2–

# Subcultural Body Style History

A woman with artificially enlarged breasts and a face lift, meeting someone who wears a few piercings in lip or eyebrow, may easily judge herself as normal, but her fellow human as deviant.

<div align="right">

—Rufus Camphausen, *Return of the Tribal:*
*A Celebration of Body Adornment*, 1997

</div>

Subcultures have been an enduring part of the urban cultural landscape for centuries, and while some dissipate within months and remain undocumented, others persist for decades and attract attention from the media and scholars. The post–World War II subcultures captivated wide attention and thus these groups are better documented, creating rich reservoirs of information about the subcultural body. I focus on the histories of the contemporary subcultures within the Urban Tribal subculture movement because of the extensive secondhand information and ability to gather firsthand information from existing groups.

This chapter establishes the history of the subcultural body style, focusing primarily on the dominant subculture—Modern Primitives—within the Urban Tribal movement. I examine the body and dress in order to confirm the basis from which contemporary discussions about the body stem. This discourse also builds a framework from which I introduce and relate the major sociopolitical and sociocultural debates, issues, and discussions surrounding the subcultural body. I also discuss the body as a component of dress; this information remains pertinent to the discussion of the subcultural body in this chapter and the remainder of the book. I present the history of the subcultural body within urban subcultures since World War II, along with the role that the subcultural body plays both inside and outside subcultures, using the Modern Primitive subculture as an extended example. I position the subcultural body within historical context compiled between academic and subcultural sources. Finally, I conclude this chapter with thoughts about the history of labeling subcultures and the subcultural body as something other than "normative." To this end, I explore three types of body modifications common to the Urban Tribal subcultures that are also popular within the mainstream society. This is followed by a brief discussion about the resulting labels assigned to subcultures based on the subcultural body.

## Historic Body Styles

From the time we are born, the human body is modified for physical, spiritual, psychological, social, and cultural transformations. In fact, prehistoric mummies found in recent years suggest that body practices, modifications, associated supplements, and rituals were significant in the earliest of human cultures (Winge 2003). In 1991 a frozen Stone Age male mummy was found in the Ötztal Alps. Nicknamed Ötzi, this mummy shows evidence of possibly the earliest body modifications ever discovered. Researchers hypothesize that the numerous tattoos on Ötzi's body represent medicinal cures, spiritual ceremonies, and social status (Siggers and Rowanchilde 1998; Tanaka 1996). In 1993 on the steppes of eastern Russia, a fifth-century B.C.E. mummy of an Ukok priestess, nicknamed the Siberian Ice Maiden, was found (Polosmak 1994). Researchers estimate that the Ice Maiden was about twenty-five years old when she died, and was dressed in a finely woven wool skirt, wild-silk blouse, an elaborate headpiece, and jewelry (Polosmak 1994). The Ice Maiden also had several tattoos and piercings, which were hypothesized as having medicinal, spiritual, or social significance (Polosmak 1994). Finally, the Xinjiang mummies, so named because they were found in Xinjiang, China, are estimated to be four thousand years old. These mummies vary in gender and age but most of the adult mummies had tattoos, which researchers surmise as having once indicated their gender or social position (Hadingham 1994).

By the late twentieth century, most Western mainstream cultures accepted or at least tolerated minor body modifications, such as pierced earlobes or discreet tattoos, without an assumption of subcultural membership (Gans 2000; McNab 1999; Mercury 2000). Some scholars even argue that body modifications are having a revival and an ever-growing popularity within current global culture (Gilbert 2001; Rubin 1988). This popularity, however, arrived only after similar body modifications were embraced and displayed by subcultures. Consider the facial piercings of the 1970s Punk (Hebdige 1979) and the eventual popularity of nose and lip piercings in the 1990s. Some body modifications, once negatively associated with a subcultural identity, are now accepted by the mainstream, including dreadlocks, shaved scalps, multiple piercings, and tattoos. Other more permanent types of body modifications, however, are still labeled as subcultural and not accepted by the mainstream, such as sleeve tattoos, brands, cuttings, tongue-splitting, and three-dimensional Teflon or surgical-steel implants. Mainstream culture tends to co-opt and adopt the less risqué (and less permanent) elements of subcultural dress. Consequently, subcultures wishing to differentiate themselves from mainstream culture must do so with increasing dedication to their bodily experiences and modifications. Of course, context is always of issue when determining what is subcultural and what is not. Perhaps, one day, a lack of body modifications may be the visual sign of the subcultural body.

Dress scholars inform my explorations about subcultural body style. Their discourse about the mainstream body and its associated dress (i.e., body modifications

and supplements) provides a framework from which I relate and discuss the subcultural body according to its paradoxes, tropes, and practices.

## The Body and Dress

Quentin Bell stated, "[O]ur clothes are too much a part of us for most of us to be entirely indifferent to their condition: it is as though the fabric were indeed a natural extension of the body, or even the soul" (Bell 1976, 19). References to the valuable and intimate relationships between the body and dress exist throughout diverse fields of scholarship. Still, this relationship is elusive in that it is rarely discussed with any depth or breadth. I explore the connections between the subcultural body and dress to address this gap. The following section highlights significant pieces of scholarship about the body and dress that will extend my discussions of the subcultural body.

Some early references to the body and dress found in Thomas Carlyle's (1869) *Sartor Resartus* (*Tailor Retailored*) introduced notions of the body and clothes as socially and culturally constructed symbols. Some Dress scholars consider Carlyle the founder of the field and continue to discuss dress as a significant part of daily life (Keenan 2001). Carlyle posits that clothes embody and communicate culturally understood meanings on the body about the human experience and the varied and fluid social environments and situations (Keenan 2001). Still, the scholars who study the body rarely include discussions about clothing, and even Dress scholars are remiss to include the body in their discussions (Calefato 2004; Taylor 2002). Similarly, Joanne Entwistle and Elizabeth Wilson noted the lack of scholarship about the body and dress within sociology, history, and cultural studies; they postulate that the neglect is due to an "antipathy towards fashion and dress, recognized as frivolous and not worthy of serious, scholarly attention" (Entwistle and Wilson 2001, 1). Entwistle further argues that dress literature often excludes the body from its discussions, presenting another gap in the literature addressing the role of the body (Entwistle 2001).

Still, some dress scholars make significant contributions in the research on the ways the body and dress intersect and their interdependent relationships. Dress scholars Joanne Eicher and Mary Ellen Roach-Higgins (1992), for example, include in their definition and classification of dress that the body is an integral part of dressing and being dressed (Eicher 2000). According to their classification system of dress, body modifications modify the body in permanent, semipermanent, and temporary ways; supplements attach to, adhere to, insert, or are held by the body (Eicher and Roach-Higgins 1992). In this way, the body does not simply function as something on which to drape clothing or to carry accessories; the body is integral to dress and its nonverbal communication. Moreover, Eicher and Roach-Higgins's classification and definition of dress further the research and understanding of dress and the body beyond Western culture.

Literary theorist Roland Barthes considered the structure and "language" of fashion by exploring fashion magazines. Barthes (1967/1990) argues that dressing

according to cultural and social norms, ideals, or fashions alienate the individual from his or her body. Barthes discusses how fashion brings together two areas: the body and dress (Barthes 1967/1990, 130). Further, Barthes elaborates on fashion's complex relationships and structure:

> [S]ince the garment envelops the body, is not the miracle precisely that the body can enter it without leaving behind any trace of this passage? And on the other hand, to the extent that the garment is erotic, it must be allowed to persist here and disintegrate there, to be partially absent, to play with the body's nudity. (1967/1990, 137)

Introducing a structural analysis for understanding the signs and symbols of Western fashion and the body as a referent, Barthes further provides context for the "desire" created around the latest fashions and styles, negating and obscuring the body while producing a valuable and profitable economic industry.

While Roland Barthes contributes to discussions about the value of dress and how the body is textually and visually evident in fashion magazines, Pierre Bourdieu (1984, 1986) further introduces the ways cultural, social, and economic capital represent power, knowledge, taste, and value. These types of capital include dress and the body as important components in social and culture interactions (Bourdieu 1990). Bourdieu's theories about types of capital are limited in discussion to only an upper-class perspective. This framework, however, is still useful for examining the perceived values of dress and the body.

In general, the nude body is perceived as a taboo in Western culture; thus, there is a limited amount of research about the body being concealed or revealed with dress. Ruth Barcan (2004), Patrizia Calefato (2004), and Anne Hollander (1980, 1994) individually discuss the tropes and contradictions of the nude body for time- and environment-specific modes of dress, style, and fashion. Barcan explores the contradictions, such as the labels of "perverse and innocent" and "abnormal and normal," which are assigned to the body and its changing representations within society over time (Barcan 2004, 199–201). Calefato argues there are differing representations of the nude body, which act as signs and symbols of our prevailing social and cultural mores and environments (Calefato 2004, 76–79). Hollander suggests that the female body is particularly sensitive and reflexive to current fashions and art within Western culture. Hollander further indicates that the partially dressed individual is representative of the dressed and undressed body at the same time, and "skin tight" clothing reveals the body beneath to suggest its nudity (Hollander 1994, 175–76).

Closely related to Barcan's, Calefato's, and Hollander's ideas about representations of the body and dress is the theory of shifting erogenous zones. Psychologist J. C. Flügel (1930, 82–84) introduces the concept of "erogenous zones," and later Dress scholar James Laver (1969) further develops this theory by explaining how a body part can be fashionably emphasized (or hidden) during a given period of time. When a body part is in fashion it is exposed or emphasized similar to fashion trends;

eventually the body part falls out of favor and is then replaced with a different revealed or emphasized body parts. From the forbidden Victorian ankle to the exposed contemporary midriff, the emphasis on a particular body part is ever-shifting. Thus, Flügel's and Laver's theories of shifting erogenous zones have significant implications within subcultural dress. Subculture body modifiers, for example, reveal their tattoos in mainstream society according to the acceptability (or nonacceptability) of the tattoo and bodily locus. As body modifications move from the subcultural to the mainstream realm, subculture members subsequently adopt new modifications and loci.

Additional scholars who discuss the body and dress are Fred Davis, who introduces numerous theories used by Dress scholars in his book *Fashion, Culture and Identity* (1994), and Lou Taylor who reviews a comprehensive collection of Dress scholarship in her books *The Study of Dress History* (2002) and *Establishing Dress History* (2004). Davis limits his discussions about the body to "bodily constraints in fashion" and "body parts accentuated in clothing" (Davis 1994, 82–97). Taylor notes a lack of literature and research about the roles and representations of the body within Dress Studies scholarship (Taylor 2002). My study acknowledges this gap and attempts to address it within the context of subcultures and dress.

In *The Fashioned Body: Fashion, Dress and Modern Social Theory* (2000), Entwistle examines dress and the body as something to be produced and consumed. Entwistle informs this discussion of the subcultural body by suggesting the dressed body participates and engages in social spaces, even if only dressed with tattoos or body paint (Entwistle 2000). She further asserts "no culture leaves the body unadorned but adds to, embellishes, enhances or decorates the body" (Entwistle 2000, 6). In addition to her subtle indications and references to the subcultural body, Entwistle emphasizes the undressed or unclothed body is the nonconforming body. In this way, Entwistle introduces censorship and the body, where individuals choose to defy current social codes, mores, and norms (Entwistle 2000, 6–9). This scholarship assists in understanding how censorship impacts the subcultural body and dress.

In the introduction of *Body Dressing* (2001), Joanne Entwistle and Elizabeth Wilson engage the topic of the body as a component of dress, from which discussions about fashion and dress emerge. The authors present a contentious and stimulating dialogue about the intersections and overlappings of the body and dress. In this anthology, Entwistle and Wilson include scholarship that addresses the "disembodiment" of dress, ranging from theoretical approaches to historical and contemporary examples. Most notably, Entwistle's chapter "The Dressed Body" (Entwistle 2001) surveys scholarship from diverse disciplines to present a theoretical framework for examining the intimate, social, cultural, and dynamic relationships between body and dress. From this chapter, Entwistle launches into an engaging discussion about the structure of social order and dressing (or not dressing) the body. Entwistle (2001) claims:

> Dress lies at the margins of the body and marks the boundary between self and other, individual and society. This boundary is intimate and personal since our dress forms the

visible envelope of the self [. . .] and serves as a visual metaphor for identity; it is also social since our dress is structured by social forces and subject to social and moral pressures. (37)

Entwistle contends that the study of dress "needs to acknowledge the ways in which both the experience of the body and the various practices of dress are socially structured" (55).

Accordingly, Entwistle argues that scholarship is lacking in this area, and how existing scholarship attempting to explore the experiences of the body and its social and cultural structures does not always achieve its goals. Illustrating Entwistle's point is Valerie Steele's *Fetish: Fashion, Sex and Power* (1996). Steele broadly explores the social and cultural relationships between fetish, the body, and dress in order to better understand fetish fashion and the subcultures that wear these types of dress. While Steele's argument in *Fetish* is criticized for not exploring fully the represented groups and its limited and sensationalized representations of "fetish fashion," she provides a more successful argument in *The Corset: A Cultural History* (1998). In the latter book, Steele presents a new perspective on the history of corsets, which includes controversial and illuminating research about women's roles regarding the use of corsets as a way to maintain and control the body, as well as establishes the cultural norms, ideals, and structures. Because Urban Tribal subculture members wear some of these items of dress, such as leather pants and corsets, *Fetish* and *The Corset* inform my discussions about subcultural body style.

Another area of discussion with limited scholarship is the intersection of the mainstream male body and dress, with particular significance to the male-dominated subcultures of the Urban Tribal subculture members. Establishing the male subcultural body becomes difficult without discussions of the counterpart from the mainstream Western culture. Hollander (1994) addresses the roles of men and women and their expected dress throughout history. Exploring the power, sexuality, contradictions, and subversions within historic and contemporary fashions, Hollander contributes to the documentation and acknowledgement that men's dress is far more complex than it is often given credit. With more specificity, Christopher Breward (2001) outlines the history of the male body within the context of fashion, specifically tailoring. Breward examines how "manliness" or masculine identities were represented in Western men's dress during the turn of the nineteenth century, arguing that men's masculinity was threatened due to the increasing commodification of the male body "as a site of desire" (Breward 2001, 180). Although Breward focuses on historic examples, his research has current relevance by acknowledging the ways mainstream and subcultural men have significant relationships with dress.

Anthropologist Ted Polhemus contributes to the scholarship about the subcultural body and dress with numerous highly visual books, such as *Body Styles* (1989);

*Streetstyle: From Sidewalk to Catwalk* (1994); *The Customized Body* (2000); and *Hot Bodies, Cool Styles: New Techniques in Self-Adornment* (2004). Polhemus, in many ways, encourages his readers to be researchers of visual culture and engage in visual analysis of the presented images of the body and dress. Although Polhemus's books are a worthwhile effort connecting the reader with the text and images in new ways, he also contributes to and enhances the exoticism of the subculture members in featured images. His constructed and selective images of subculture members' body modifications create a visually dynamic book but limit the reader from fully understanding the subculture, which Polhemus often notes as a shortcoming in many of his book introductions. Following in Polhemus's footsteps are Charles Gatewood, Rufus Camphausen, and Nan McNab, whose books present extensive visuals and informative but limited text, featuring images of the subcultural body and dress. Each of these books feature images of Urban Tribal subculture members and their body modifications.

## History of the Modern Primitive Body Style within the Urban Tribal Movement

The Modern Primitives are a well-documented post–World War II subculture, which I use extensively to illustrate the subcultural body style. The Modern Primitive subculture is traceable to the early 1950s, and is popularly thought to have spawned the Urban Tribal movement. The history of the subcultural body within the Modern Primitive subculture is not only found primarily within books, but it is also featured in zines, Web sites, songs, museum exhibits, and the like. To better understand the body style of the Modern Primitive subculture and the Urban Tribal movement, it is essential to introduce the life and body style of founder Fakir Musafar.

### Fakir Musafar

Fakir Musafar is a self-proclaimed Modern Primitive, body artist, educator, and subcultural celebrity; in many circles he is considered the "father" of the Modern Primitive subculture and Urban Tribal movement (Camphausen 1997, 114; Musafar 1996, 327; Winge 2003, 119). He borrowed his name, Fakir Musafar, from a nineteenth-century Persian Sufi (i.e., mystic Islamic spiritual individual) featured in a *Ripley's Believe It or Not* periodical (Vale and Juno 1989, 8). The *Ripley's* article highlighted how this Sufi wandered for eighteen years with six daggers in his shoulders, six horseshoes stitched to his arms, six mirrors sewn into his chest, and six padlocks piercing his skin (Vale and Juno 1989, 8). Musafar was so inspired by the Sufi's story that he began a pursuit of the body and bodily experiences.

Musafar participates in numerous body modification rituals, such as the Kavandi-bearing ceremony, Hindu Ball Dance, and Sun Dance (Musafar 1996,

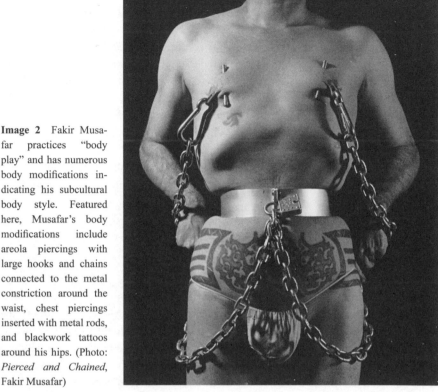

**Image 2** Fakir Musafar practices "body play" and has numerous body modifications indicating his subcultural body style. Featured here, Musafar's body modifications include areola piercings with large hooks and chains connected to the metal constriction around the waist, chest piercings inserted with metal rods, and blackwork tattoos around his hips. (Photo: *Pierced and Chained*, Fakir Musafar)

333–34; Vale and Juno 1989, 14, 34–36). He has multiple piercings, located in his chest, septum, penis, and ears, and blackwork tattoos (e.g., solid black designs created with the use of heavy black inks inserted into the skin) (Kleese 2000; Vale and Juno 1989). The resulting body modifications serve as visual evidence that Musafar is a prominent member of the Modern Primitive subculture and the Urban Tribal movement.

Musafar claims that body modification rituals or "body play" allow him to transcend the associated pain into another realm—"an altered state" (Musafar 1996, 328; Vale and Juno 1989, 12–13). He argues the pain is, in fact, a vehicle to reach this altered state—where there is a separation of body from consciousness, which brings enlightenment (Vale and Juno 1989, 10–11). Musafar further notes that in addition to this newfound bodily experience, decorating the body with modifications is "an expression of the life force" (Vale and Juno 1989, 11). For more than fifty years, Musafar's body modifications and body play have influenced and impacted the Urban Tribal movement, and even gained the interest of mainstream consumers.

Musafar clarifies his (and the Modern Primitive subculture's) perspective on the body:

*Modern Primitives are differentiated from others in our society by their feeling about their bodies: I own my body and have a right to do with it as I wish as long as this does not interfere with the rights of others. My body belongs to me, the one living inside. It does not belong to a God, or God's intercessors or priests, or to a father, mother or spouse, or to a business institution, or to an agency of the state (i.e., government, political entity, law enforcement, medical or educational institution). Those who take ownership of my body are breaking a universal and cardinal law of life.* (Fakir Musafar, personal communication with the author, 2011)

The Urban Tribal movement and the Modern Primitive subculture began in the 1950s and 1960s, when Musafar noticed that a number of like-minded people were becoming aware of and exploring the body in new ways (Musafar 1996). He began to refer to people who participated in bodily practices and rituals as "Modern Primitives" and their activities as "body play" (Musafar 1996, 326; Vale and Juno 1989, 14). Musafar further categorized their body play in the following ways: contortion (i.e., yoga, footbinding, and high-heeled shoes), constriction (i.e., corsets and tight belts), deprivation (i.e., diets and restriction of movement), encumberments (i.e., heavy bracelets and manacles), fire (i.e., sun tanning and branding), penetration (i.e., piercing and tattoo), and suspension (i.e., flesh hook hanging and bondage hanging) (Musafar 1996, 326; Vale and Juno 1989, 14).

During the 1970s, T and P (tattoo and piercing) parties featured body enthusiasts and were often hosted by wealthy individuals, such as Richard Symington, a businessman with an interest in exotic people and body modification practices (Musafar 1996, 326; Vale and Juno 1989, 24). At these parties, the host encouraged guests to get both tattooed and pierced in communal settings for the host's amusement and fascination. Musafar referred to the participating individuals (including himself) as "body players" and their activities at these parties as "body play" (Musafar 1996, 326; Vale and Juno 1989, 15).

The T and P participants lacked the proper body supplements, such as jewelry, to insert into and adorn the freshly made piercings (Vale and Juno 1989, 24). As a result, the participants designed and created the first Urban Tribal and Modern Primitive body jewelry. One of these T and P participants was a jewelry designer named Jim Ward. Ward produced most of the jewelry for the participants (Vale and Juno 1989, 24). These jewelry designs often reflected a connection to primitive cultures and the Urban Tribal movement.

*Documenting the Urban Tribal Movement
and the Modern Primitive Subculture*

In 1983 Musafar proposed that Re/Search Publications, located in San Francisco, California, compile a book about the Modern Primitives (Musafar 1996, 327; Vale and Juno

1989). As a result, *Modern Primitives*, an informative collection of stories about members of the Modern Primitive subculture, was published in 1989 and has been "reprinted, with more than 60,000 copies [. . .] in circulation" (Musafar 1996, 327). This sole publication is accredited with introducing the Modern Primitive subculture, and I argue the Urban Tribal movement, to the world and to each other. The book familiarized the general reader with some of the Modern Primitives' most prominent subcultural members, including Musafar, and their body modifications, rituals, philosophies, and ideologies.

Musafar's commitment to body modifications and associated rituals, inspired by non-Western cultures, is documented in subculture media such as *Body Play Magazine*, *Bizarre Magazine*, and the *Dances Sacred and Profane* (1985) documentary film (Vale and Sulak 2002). Musafar provided Urban Tribals and Modern Primitives with a place to express individual identities and learn about each other in his publication *Body Play and Modern Primitive Quarterly* from 1992 to 1999. He also disseminated information about Modern Primitives and their body modification practices by writing, with Mark Thompson, *Fakir Musafar: Spirit + Flesh* (Musafar and Thompson 2002), which includes photographs of several of his bodily explorations: *Nineteen Inches* (1959, pierced nipples and corset), *Golden Apollo* (1962, covered in gold paint with large nipple piercings), and *Chained* (1978, pelvis blackwork tattoo, chest surface piercings, heavy chains attached to nipples, and metal waist belt). Additionally, Musafar created an educational facility, the Fakir Professional Body-Piercing Intensives School, in California to encourage healthy and safe body-modification practices.

Throughout the history of the Urban Tribal movement and the Modern Primitive subculture there are numerous publications produced by subcultural members and media for the benefit of sharing knowledge with other members, and the mainstream culture as well. For example, from 1948 to 1959, John Willie (aka John Alexander Scott Coutts) published *Bizarre*, a subcultural magazine that often included articles of interest to Modern Primitives and documented the Urban Tribal movement (Vale and Juno 1989, 22–23). An additional example of subcultural media, previously cited, is *Body Play and Modern Primitive Quarterly*, which specifically focuses on body practices and Modern Primitives (and the Urban Tribal movement).

## Modern Primitive Body Style

The Modern Primitives are identified by their extensive use and display of body modifications, such as tattoos, piercings, and implants. Members of the Modern Primitive subculture typically have multiple tattoos; some members may have arm or body sleeve tattoos (i.e., tattoos to cover a portion or all of the body stopping at the neck, wrist, and/or ankles). Their tattoos are often described as being distinct because of their ancient, tribal, and/or primitive inspiration and appearance, such as Egyptian hieroglyphs, Celtic knots, or organic intertwined thorns.

Modern Primitive tattoos function as forms of dress and nonverbal communication, ranging from connections to ancient cultures to commemorating contemporary

life events (Winge 2004a, 2004d). Rituals associated with tattoos may be public or private, and usually take shape within the context of the tattoo studio and licensed practitioner, who observes health codes and government statutes/regulations. Some versions of Modern Primitive tattoo rituals include ancient or historic technologies, such as those that implement sharpened bones and ink similar to tools and devices used by people in Pacific Island cultures. Modern Primitive subculture members also explore ancient tattooing methods and borrow designs from anthropological texts about Other cultures (Vale and Sulak 2002). Some Urban Tribal tattoo practitioners specialize in tribal tattoos, ranging from Celtic knots to blackwork tattoos, and many of these practitioners are trained in body modification practices using both modern or historic techniques and technologies. Some Modern Primitive subculture members favor body practitioners who utilize primitive or ancient technologies including a wide variety of manual tattoo methods, such as those utilizing sharpened bones and ink; bone combs, hammer, and ink; and tatau sticks with soot-based ink. These methods typically require lengthy sessions for even a small tattoo (Siggers and Rowanchilde 1998, 9–11).

Within the Urban Tribal movement, Modern Primitive subculture members are drawn to body practices and experiences, driving them to explore the limits and possibilities of the body and creating new definitions for subcultural body style. Edward "Pan" Stovall, a Modern Primitive, was one such person. In his version of the Sun Dance, Stovall hung by fresh incisions made in his chest, and remained hanging for approximately one minute in two different hanging sessions (Stovall 1999). Similar to Musafar, Stovall claims to experience an altered state of consciousness or transcendence due to the intense pain associated with this ritual (Stovall 1999). In pursuit of transcendence, Urban Tribal and Modern Primitive subculture members make use of body modifications rarely seen, such as scarification, amputation, and splitting, creating a uniquely progressive and controversial subcultural body.

## *Scarification, Amputation, and Splitting*

An example of a rarely seen modification by Modern Primitive members is scarification to permanently modify the surface texture and appearance of the skin; this is achieved with cuttings created in predetermined designs by using body modification techniques. During the healing process, collagen collects into a scar, causing raised areas or keloids. Some types of scarification used by the Modern Primitives are skinning, resurfacing, cutting, and branding. In this way, (designed) bodily scarification is a representation of the subcultural body within the Urban Tribal movement.

Scarification by skinning focuses primarily on large areas of skin, but very small areas may also be modified with this mode (Winge 2004e). A scarifier or knife-style tool outlines a designated design into the skin's surface (T. Winge, unpublished research fieldnotes, 2003). Then, a sharpened instrument is inserted under the skin to lift and cut it away, removing the skin in manageable sections. Due to the complete

removal of skin, the skinning design takes a significant amount of time to heal. Another type of scarification is resurfacing, which uses friction, lasers, or chemicals to scratch or remove the dermis into desired designs or patterns. Scarification practitioners use sandpaper, steel wool, or grinding stones on the surface of the skin (Winge 2004e; T. Winge, unpublished research fieldnotes, 2003). The healing process may have unexpected complications, impacting the visual and textural outcomes, but with great care most designs reflect the subculture member's design.

Members of the Modern Primitive subculture are one of the few Western subcultures to use cuttings as a mode of body decoration or adornment. Some cuttings may heal and become virtually invisible; therefore, cuttings are often applied to the skin frequently and ritualistically (Winge 2004e; T. Winge, unpublished research fieldnotes, 2003). If individuals desire a more permanent appearance and/or texture, inert materials may be placed in an open cut to create a more visible and tactile scar or keloid (Winge 2004e; T. Winge, unpublished research fieldnotes, 2003).

Another scarification method is branding, which is a permanent body modification created with extreme heat or cold. This type leaves a visible scar, sometimes raised, depending on the severity and the amount collagen required for the skin to heal. Brand designs are predetermined and may take months or even years to be shaped out of metal or other material that is exposed to extreme heat or cold and applied to the skin (Winge 2004e; T. Winge, unpublished research fieldnotes, 2003).

Scarification, regardless of the method, is a body modification incorporated into the Urban Tribal or Modern Primitive body ritual. These rituals usually follow the steps established by the cultures that inspired the body modification, or follow health protocol established by the body modification practitioner. Still, these scarification rituals tend to reflect the subculture's ideology and result in altered versions of the original body modification ritual regardless of cultural inspiration.

Beyond scarification, some Modern Primitive members also use splitting and amputation to create their subcultural body. Splitting is the bifurcation of a body part, such as a finger, toe, tongue, penis, or ear lobe, while amputation is the complete removal of a body part. Splitting and amputation are two of the most permanent body modification techniques used by select Modern Primitive subculture members.

### Influence of the Urban Tribal Movement—Modern Primitive Subculture

While members of the Urban Tribal movement, most specifically Modern Primitive subculture members, are quickly identified by body modifications, they also explore ways of temporarily, semipermanently, and permanently reshaping the body with corsets, belts, bindings, and implants. Members of this subculture truly redefine the subcultural body and pioneer new venues in all types of body modification practices and technologies.

The Modern Primitive subculture's long existence in Western culture results in numerous opportunities to (unintentionally and intentionally) influence trends in the mainstream population. The subculture members' distinct appearances have direct and significant impacts on contemporary fashions around the globe. Many subcultural designs surfacing in the mainstream marketplace are referred to as "tribal" and "primitive" because the designs resemble objects from nature, and are directly borrowed or inspired by designs from non-Western and ancient cultures. It is more accurate to attribute these fashion trends to the Urban Tribal movement and the Modern Primitive subculture, reflecting their use of historical and cultural designs within their tattoos, brands, and graphics on their clothing. Within the contemporary mainstream fashion industry, these tribal and primitive designs are printed, silk screened, and embroidered onto T-shirts, bowling shirts, hoodies, baseball caps, and jeans. Wearing clothing with these designs and motifs is a "safe" way to display subcultural style without permanent commitment and affiliation.

Urban Tribal and Modern Primitive body modification jewelry is frequently shaped like horns, feathers, and Celtic knots, or may be made from bone, surgical steel, sterling silver, or coral. The subcultural jewelry styles are carried into many fashionable accessory lines. Many fashion companies incorporate the term "tribal" into the name of the accessory line.

Accordingly, a body modification practice and associated jewelry emerging within mainstream fashion is gauging, or stretching, and capture jewelry. Gauging or stretching is the enlargement of a preexisting piercing hole with the use of a larger-gauged jewelry, while a capture is a length of metal with either a closure or finial attached to each end keeping or "capturing" the jewelry from sliding out of the piercing hole.

Modern Primitive subculture members are continually pushing the boundaries of bodily practices and related technologies—and subsequently, expanding and challenging the Urban Tribal movement. As the Urban Tribal movement redefines bodily practices and modifications, the outcomes for Western culture may be both positive (i.e., improved surgical technologies) and negative (i.e., increased blood pathogen infections).

## Criticisms of the Urban Tribal Movement—Modern Primitives

During the past few decades, the Urban Tribal movement and Modern Primitives are more exposed to the critical gaze of mainstream Western culture. The Modern Primitive subculture members argue that body modification rituals and performances allow participants to experience a variety of physical, emotional, and spiritual transcendences. Modern Primitive subculture members proudly display their body modifications, and openly share body modification experiences, which are the manifestations of their release from the modern trappings of the Western world and efforts

to connect with other cultures through body modification practices. Unfortunately, they cannot truly achieve the Other, nor the Other's way of life. Modern Primitive subculture members must be content with a version of the Other's body modification practices and their specific physical, emotional, and spiritual transcendences.

Due in part to their intentional connections to tribal and primitive cultural practices, specifically body modifications and related rituals, the lifestyle and even the chosen identity of a member of the Modern Primitive subculture comes under some scrutiny and criticism (Taylor 2002, 12; Winge 2003, 127–29). The criticism follows that the act of borrowing specific body modifications and rituals from a group once thought to be a "tribal" culture (most often non-Western) does not necessarily transform the borrowers into members of a tribe or give them tribal or cultural knowledge.

Consider the Hleeta, for example, a body modification once used to represent membership, gender, age grade, and identity for the Ga'anda in Nigeria (Berns 1988; Berns and Hudson 1986). Ga'anda women would begin scarification at a very young age and have portions added at each age grade. The process designs carved into the female's torso were also found on the food storage structure and gourd bowls (Berns 1988; Berns and Hudson 1986), indicating the vital role of women, food, and Hleeta within the Ga'anda culture. A member of the Modern Primitive subculture seeking to acquire the knowledge and experience of the Ga'anda endures the Hleeta torso scarification in a similar body modification ritual. What Ga'anda cultural experiences are transferred to the Modern Primitive subculture member through this body modification process? Does the subculture member acquire a tribal identity, a Ga'anda identity when he or she acquires the Hleeta? What does it mean that the Hleeta has been illegal for the Ga'anda people to practice since the 1970s, but a Western subculture member may legally acquire a similar body modification?

Lou Taylor (2002) argues that according to the anthropological definition of the term "tribe," subcultural groups do not meet the criteria to be considered a "tribe." As a result, more recent discussion of subcultures within the Urban Tribal movement, such as those about the Modern Primitives, are described and categorized as "neo-tribal" subcultures (Winge 2003, 129; Wojcik 1995). My research revealed that these subculture members rely less on the pejorative term "primitive," but more often evoke the term "tribe," and in some cases refer to themselves as members of urban tribes and being part of a tribal movement.

The final criticism leveled at the Modern Primitive subculture compares its members' body modifications and practices to forms of self-mutilation and mental illness (Favazza 1996). The media promotes this criticism by discussing subcultural body modifications as mutilations and, citing mental health professional claims, that this type of activity is the result of mental illness (Pitts 2000). This criticism, however, serves to give the subculture members a larger platform from which to discuss their ideas about the body. Musafar, for example, wrote the epilogue in Armando R. Favazza's (1996) book *Bodies Under Siege: Self-Mutilation and Body Modification Culture and Psychiatry*, where he expressed contrasting ideas (to Favazza and other

critics) about the positive and healthy bodily experiences regarding subcultural body modifications.

## Anthropology and the Urban Tribal Subcultural Body

Anthropology and the disciplines it influences contribute to understanding the subcultural body, while anthropological texts (regardless of the discipline that created them) are used as resources and influences for the Urban Tribal movement and the creation of the subcultural body. Subculture members design their body styles and reenact cultural body modification rituals, for example, based on historical and contemporary anthropological accounts. In turn, researchers like myself document subcultures and their members' (sub)cultural practices, producing ethnographic texts similar to those that served as inspiration for the group.

Accordingly, the Modern Primitives and their body modification practices exemplify a subculture that both inspires and informs anthropological texts. Their body style is primarily inspired by images of dress (i.e., body modifications and supplements) and associated rituals from non-Western cultures. Marianna Torgovnick (1990) argues, in *Gone Primitive: Savage Intellects, Modern Lives,* that primitive cultures fascinate Western culture (and subcultures). Western interpretations of these texts, however, are often romanticized, based on information provided from popular sources such as Edgar Rice Burroughs's *Tarzan* series, the theoretical work of Claude Lévi-Strauss (1958/1968), and ethnographies from scholars including Margaret Mead (1953) and Marla Berns (1988) (see Vale and Juno 1989). These popular and scholarly authors create an episteme for the Other that functions as a backdrop for discussions about subcultural members' use of the primitive in their body style.

The Urban Tribal movement produces a fascination with the primitive, inspiring many of the subcultures' body modification practices and rituals. Torgovnick presents in her article "Skin and Bolts" (1992) the comparison between non-Western puberty rites with body piercing rituals practiced in the United States. She suggests that Modern Primitive piercing rituals have a healing component for the participants, because those who practice these rituals are seeking an experience of spiritual or symbolic death, integral to initiation rites, not commonly found in Western culture (Torgovnick 1992).

As a result, both popular and scholarly anthropological texts frequently inform subcultures about body modifications and related rituals (Musafar 1996; Vale and Juno 1989). Some such examples are the Tiv scarification (Bohannon 1956); Ga'anda Hleeta (female body scarification) (Berns 1988; Berns and Hudson 1986); Yoruba Kolo marks (scars on the cheeks) (Drewal 1988); Maori Mako (facial) tattoos (Gilbert 2001); Tchikrin tattoo (T. Turner 1969); Tlingit facial piercing and tattoo (Jonaitis 1988); and North American Indians' use of piercings, tattoo, flesh hanging, and body paint (Beck, Francisco, and Walters 1995; Mails 1995).

Therefore, subcultures within the Urban Tribal movement, such as the Modern Primitives, claim to practice primitive and tribal body modifications and rituals (Kleese 2000; Torgovnick 1990). Accordingly, the Modern Primitive subculture and its members' body practices are perceived and often self-identified by members as a tribe or tribal identity. In "The Possibility of Primitiveness: Towards a Sociology of Body Marks in Cool Societies," Bryan Turner examines the Modern Primitive subculture and its members' use of "extreme" body modifications (2000, 39–50). He argues that "traditional tribalism," created by compulsory body modifications marked on the flesh of the participants in rituals, results in establishing the insider's identity and subcultural membership (Turner 2000, 39–50). Turner further suggests that the attraction to body modifications is the need to create permanency within an ever-evolving and changing society. Correspondingly, Mike Featherstone points out that "common to many accounts of body modification is the sense of taking control over one's body, of making a gesture against the body natural" (Featherstone 2000, 2). The permanent control over the body through body modification practices has great appeal to individuals wanting to claim a lifelong subcultural identity. This, of course, is only a temporary control since the body will age, reclaiming its natural position and role, albeit modified.

The anthropological and ethnographic accounts about the Modern Primitives and their connections to non-Western cultures are well documented in a variety of sources. Many accounts include numerous visuals that identify types of body modifications and related body practices. For example, *Primitives: Tribal Body Art and the Left-Hand Path* (2002), by anthropologist Charles Gatewood, photographically documents subcultural body styles, such as tattoos, piercings, and brands. Some additional examples of sources where the subcultural body is displayed primarily in pictorials include: *The Decorated Body* (Brian 1979); *Skin Shows: The Art of Tattoo* (Wroblewski 1991); *Tattooed Women* (Wroblewski 1992); and *Revelations: Chronicles and Visions from the Sexual Underworld* (Randall 1993). Some of these books feature many Urban Tribal subculture members from only one group, while others feature an assortment of differing subculture members who modify their bodies. While these types of books are visually informative, they lack analytical and scholarly depth.

Occasionally these highly visual texts include a scholar's introduction or epilogue, often an anthropologist or sociologist, about body modifications used in Western culture. One such example is the introduction of *The Customized Body* (2000), where Ted Polhemus provides an overview of body modifications used globally to inspire subculture members in Western culture. The remainder of the book focuses on brief quotations from members of subcultures about their use of extreme body modifications as aesthetic enhancements, identity markers, and spiritual symbols. (It is unclear if Polhemus conducted longer interviews with the individuals featured in the book.)

There are books still highly visual but that also offer research and insights into the Urban Tribal subcultural experience. Polhemus's *Body Styles* (1989) analyzes different cultures' and subcultures' use of body supplements and modifications as a means of expression and communication with historical evolution charts of body styles in the West compared to non-Western cultures. In addition, Camphausen (1997) and

McNab (1999) not only provide global examples of dress from all walks of life, but also cite historical evidence and offer comparisons between acceptable Western and non-Western body practices. Both authors show connections between subcultural body modifications and non-Western cultural body practices and modifications.

In contrast to the highly pictorial texts, additional publications offer only a few visual representations and include significant ethnographic studies theorizing about (Urban Tribal) subcultures. The Institute for Cultural Research released *Modern Primitives: The Recurrent Ritual of Adornment* (2000), for example, which presents brief discussions regarding possible reasons for Modern Primitive body modifications. These reasons mirrored those given by Musafar in "Body Play" (1996): (1) rites of passage, (2) creating bonds with others, (3) respect for elders, (4) symbol of status, (5) mysticism or magic, (6) protection, (7) opening channels to spirits and spiritual planes, (8) rebalancing the body, (9) physical healing, (10) emotional healing, (11) group or "tribal" healing, and (12) group or "tribal" connections, especially during difficult times. (It should be noted that *Modern Primitives* is a well-researched subcultural publication.) Still, both the Institute for Cultural Research and Fakir Musafar present compelling arguments about the validity of subcultural body practices within the context of a global world.

In addition, there are the journal articles and book chapters by scholars who research subcultures. Daniel Rosenblatt's "The Anti-Social Skin: Structure, Resistance, and 'Modern Primitive' Adornment in the United States" (1997), for example, suggests that body modifications redefine how the body is perceived and understood by the self, the subculture, and outsiders. Eric Gans examines the role of the body further in "The Body Sacrificial," stating "the body becomes a living record of one's personal history" (2000, 163). These accounts suggest that the body modification documents and narrates the ritualized experience within (displayed) physical changes of the subcultural body.

These anthropological accounts, whether scholarly or popular or a combination of both, offer the opportunity for greater understanding of the Urban Tribal subcultural body style. Still, as these accounts move further and further from the domain of anthropology, the opportunity arises for confusion and anxiety over the appropriate use and definition of terms and the validity of accounts. The two terms continually under contention are "primitive" and "tribal," and various versions such as "neo-primitive" or "neo-tribal." In the immediately following discussion, I offer some context for various uses of these terms and understandings that facilitate discussions about the subcultural body.

*Criticisms of the Terms "Tribal" and "Primitive"*

Daniel Wojcik's *Punk and Neo-Tribal Body Art* (1995) asserted that members of the Modern Primitive subculture are part of a neo-tribe. Wojcik, however, does not qualify the use of this term. Toaph (2002) also states that the Urban Primitive or

Modern Primitive movement is strongly aligned with tribalism in "The Urban Primitive Movement," arguing this subculture symbolically rejects the modern technological age, fearing that technology moves humans further from the fundamentals of humanity. Steve Mizrach (2002) concurred with Toaph by stating that the Modern Primitive movement and subculture "involves some sort of strange juxtaposition of high technology and 'low' tribalism, animism, and body modification" in " 'Modern Primitives': The Accelerating Collision of Past and Future in the Postmodern Era."

As previously mentioned, in the *Study of Dress History* Lou Taylor (2002) critiques Polhemus's use of "tribe" and Wojcik's use of "neo-tribe," and by extension Toaph and Mizrach. Taylor further argues that if a label is necessary, "neo-tribe" is the more accurate label, since these subcultures do not fit the anthropological definition of a tribe.

Furthermore, the use of the terms "tribal" and "primitive" frequently results in criticism of not only of scholars but also of the subcultures using these terms as identifiers. Christian Kleese agrees with Torgovnick's discussion of the primitive and its connection with the Modern Primitive subculture, with notable exceptions. In " 'Modern Primitivism': Non-Mainstream Body Modification and Racialized Representation," Kleese (2000) criticizes members of the Modern Primitive subculture because they perpetuate gender and racial stereotypes with their use of the term "primitive" to describe their body rituals and modifications. In addition, Kleese argues that Modern Primitive subculture is not using primitive cultures as reference groups but instead exploiting non-Western cultures, and infers that Torgovnick has romantic ideas about the primitive and the Modern Primitive subculture as well.

Michel Thevoz also discusses the contemporary implications of the "savage body" in *The Painted Body: The Illusions of Reality* (1984). Thevoz provides a detailed psychoanalytic discussion of the "primitive psyche," which indirectly criticizes the Modern Primitive subculture's use of "primitive" and "tribal" to describe their body modifications. Thevoz further suggests that subculture members' reenactment of professed primitive and tribal rituals reflects their desires to obtain the Other, and reveals behaviors of deviance and self-mutilation.

In this research, I qualify and limit the use of the terms "primitive," "tribe," and "neo-tribal" to times when members of subcultures use these terms as identifiers, or in situations where it is a media-assigned label that the subculture adopts or co-opts.[1] This is not with a disregard to the above discussions, but instead in the ethnographic and phenomenological traditions I allow the research participants to identify and describe themselves. I seek to unpack these terms and their meanings within the Urban Tribal movement and the Modern Primitive subculture regarding their subcultural body style.

## *Socialization of the Urban Tribal Subcultural Body Style*

Interpreting subcultural body style correctly is not an easy task, especially in light of its complexities and the contested history and contemporary position of the sub-

culture member within mainstream society. Accordingly, the subculture member is often considered the Other, sometimes by choice, and sometimes as a result of outsiders misreading visual cues present in the subcultural body and dress. An exploration of subcultural body style provides opportunities for cultural agency, political empowerment, and social recognition for members. By examining the sociopolitical and sociocultural aspects of subcultural body style, there is potential to reveal the position of the subcultural body within its parent culture and dominant norms, and further establish its role and status within the subculture.

Female subculture members frequently have the greatest potential for sociopolitical and sociocultural gains and losses by donning subcultural dress. Male-dominant subcultures typically relegate females to the margins of the group and often see them as inconveniences or nuances; at best, females often serve simply as accessories to the male members. Within the female-dominated subcultures, females not only have positions of power but also experience agency, which is difficult to come by otherwise in the male-dominated mainstream world.

Lauraine Leblanc emphasized in *Pretty in Punk: Girls' Gender Resistance in a Boys' Subculture* (1999) that female Punks in North America have a difficult time finding a place in the male-dominated Punk subculture. Female Punks group together for protection and limited power, and their dress reflects the dress established by male Punks. While Dick Hebdige's *Subculture: The Meaning of Style* (1979)

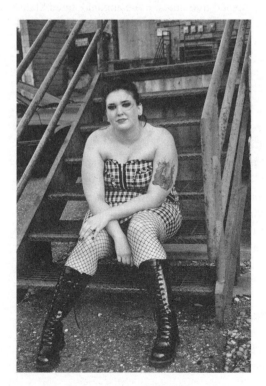

**Image 3** Jay's appearance—with her tattoos, military-style boots, and plaid clothing with a decidedly "feminine edge"—is an example of the Urban Tribal female's dress that subverts the stereotypical male aesthetic often associated with this subcultural movement. (Photo: T. Winge, unpublished research image, 2008)

focuses on the British Punk scene with primarily male examples, his omission of female examples demonstrates the marginal and nearly invisible position of British female Punks.

Even within male-dominated subcultures, some females find ways to break into the center of the subculture. This is readily apparent when the subculture is associated with an activity, such as a sport, that gains a legitimate standing in mainstream society, and that females excel at. Skaters, for example, have a long history, traceable back to the 1970s (McNeil and McCain 1997). The Skater subculture has its connections to the Urban Tribal movement in that it emerged from the Punk (United Kingdom and North America) and Surfer (North American) subcultures (Brooke 1999). In the beginning, British Skaters resembled Punks in dress with an added skateboard— in fact, many were Punks on skateboards—while in North America, Skaters on the West Coast dressed similar to Beachcombers (i.e., unkempt sun-streaked hair, long shorts, T-shirts, and slip-on shoes; skating in a way that is similar to surfing waves [Brooke 1999]). As the Skater subculture spread across North America and Europe, the predominantly male members' dress and styles became more homogenous and conducive to the activity of skateboarding. Accordingly, female members typically donned male attire and at times even tried to pass for males. As females are recognized for their sport-related accomplishments by the mainstream media, the position of female subculture members changed as did their dress and styles (Young and Dallaire 2008). Holly Lyons, for example, a professional skateboarder who won the World Cup Bowl championship and competed five times in the annual United States X Games, proved herself as an equal to the male skateboarders and redefined the female Skater's appearance when she opened her clothing company, SK8GRL ("Supergirl" 2007, 249). Lyons's apparel designs come in a wide range of colors (including pink) and in styles that emphasize the female form, rather than disguise it under male clothing. As a result, Lyons's apparel designs challenge the Skater subcultural standards of dress for both females and males.

The Urban Tribal movement has a prevailing male-dominant position within its subcultures, including Modern Primitive, Punk, Neo-Punk, Skater, and Cyber. Female members tend to establish their position in the movement and subculture with their body modifications. Extending the Skater example, a female's body modifications, whether a scar from a wipeout or tattoo of a broken board, serve as visual representations of membership and commitment to the activity (often only noteworthy to subculture members). Accordingly, this subcultural body example suggests gender is the construct of social and cultural discourses and inscriptions taking place within the body style.

### Phenomenology of Subcultural Body Style

In contemporary Western culture, individuals have series of disembodied experiences such as playing video games, surfing the Internet, and watching television. We

are progressively being removed from empirical interactions with our own bodies. Furthermore, little encouragement exists for the exploration of knowing the body. Some (subcultural) body-related explorations are discouraged in mainstream Western societies, such facial tattoo and penis splitting. In this light, members of the Urban Tribal movement argue that it is difficult to fully experience the body in contemporary Western society, where *being* or phenomenological body is denied.

The phenomenological experiences of the subcultural body are commonly observed but rarely documented due to their ephemeral or visceral nature. Whether it is the safety pin piercing the Punk's nose or the Greek letter branding on a Fraternity member's leg, the subcultural body is evident within phenomenological bodily experiences. For some individuals the mere sight of these body modifications causes a physical reaction, suggesting the phenomenological experience of the individual body can be shared. Adversely impacting the further exchange of these experiences is the fear and anxiety about the body modification that usually accompanies the physical reaction to a subculture member's body modification.

The Modern Primitive subcultural body's experiences with pain are examples of how the subculture members use their bodies to seek out and appreciate sensual experiences and the *being* body. Members argue that by being present and knowing sensual experiences of the body, the subcultural body understands its place and potential in the world. The subculture members pursue bodily experiences with fervor, exploring the body and mind holistically, even seeking spiritual transcendence through body modification practices. The Modern Primitive pursuit of experiencing the body fully through body modifications and associated rituals challenges the Cartesian proposition "I think therefore I am" with the subcultural response of "I feel therefore I am."

Numerous subcultures within the Urban Tribal movement strive to be cognizant of the body in ways that often cause discomfort for mainstream culture. Body modifications are the most obvious examples of the subcultural body experience, which serve to further marginalize the subcultural body from mainstream culture. In the article "Body Modification, Self-Mutilation and Agency in Media Accounts of a Subculture," Victoria Pitts (2000) argues that this marginalization is not the prospect of the different aesthetics that subcultures utilize that bothers mainstream society, but from the perceived pain and violation of the body associated with these more extreme body modifications. Accordingly, subculture members further suggest that the pain involved in acquiring an extreme body modification is as important as the body modification itself (Wojcik 1995), and embrace the possibility that outsiders experience "pain" when seeing a subcultural body modification, too.

## Subcultural Rituals of Pain

During my research studies with Urban Tribal subculture members, I noted numerous occasions when people outside the subculture commented about the perceived pain

they felt by just looking at a body modification. Some people even had visible physical reactions (shuddering, grimacing, or looking away) to the certain body modifications, resulting from either verbally identifying with or rejecting the perceived pain. Fewer were those outsiders who queried the subculture member about the pain associated with initial acquisition of the body modification, placing the question in the present tense despite the modification being healed or even showing age. Subculture members patiently explained about the body modification experience being sensitive to physical clues the outsider gave about their sensitivity to the story. While there was a great deal of care given to not frighten the outsider, the pain of the experience was not diminished in the bodily account.

Within certain Urban Tribal subcultures, members acknowledge that pain is part of the ideology, and experiencing pain extends beyond the physical realm. Modern Primitive subculture members indicated that there is an importance placed on the type and intensity of pain associated with the body modification experience for many individuals (Vale and Juno 1989, 4–5). Despite the subculture members indicating the importance of pain, accounts of their body modification experiences lack details about physical sensations. Vale and Juno, however, provided few details about Modern Primitives and their body modification rituals in *Modern Primitives* (1989). Such details are also limited in Pat Califia's "Modern Primitives, Latex Shamans, and Ritual S/M" (1994).

Shannon Larratt, in her book *ModCon: The Secret World of Extreme Body Modification* (2002), describes a body modification event that she organized and attended during a Modern Primitives body modification convention in May 1999. Larratt provides descriptions of rituals not typically seen by outsiders, such as ritual hook hangings. One such ritual was facilitated by the "I Was Cured" suspension group artists from Toronto, Canada. In the ritual, individuals in this group use large hooks to pierce the flesh of their back, from which they hang suspended in the air above spectators heads for several minutes (Larratt 2002). Still, Larratt lacks details about the physical sensations and most notably the pain.

Many subcultural body experiences are documented with more depth from inside the subculture. Urban Tribal subculture members produce zines, Web sites, music, art, and literature, which often include information about the subcultural body style. Music—that is, song lyrics, for example—provides a way for subcultures to safely communicate with mainstream culture and other subculture members about their chosen lifestyle and ideology. Conversely, music is usually a safe access point into a subculture; music allows an outside listener an opportunity to know about the subculture without having to fully commit to its ideology or body style.

At a time when Punk music was starting to disappear even from underground music sources, The Dead Kennedys,[2] a Punk band, released the album *Frankenchrist* (1985). This album, which represented the continued presence of Punk (and pain) within the subcultural music scene, was noted in its promotional poster: "Putting the pain back in psychedelic music." This poster visually com-

municated that Punk music and by extension the subculture was relevant and how it directly connected to feeling of pain. The Punk subculture created numerous posters, album covers, and lyrics representing not only its ideology but also its exploration of sensual and painful body experiences. A selection of lyrics from The Gits'[3] song "Cut My Skin" indicates some of the body experiences of the early Punks:

cut my skin, it makes me human
scorn your mind
just feel the pain
cuz it's what makes us human. (Gits 1988/1996)

Seen less in the contemporary versions of the subculture, Punks of the 1970s and 1980s promoted the ideology of bodily experiences, especially those related to pain. These early Punks were disillusioned with the world around them and disappointed by their parent culture; subsequently, their ideology reflected their dystopian outlook and sought to experience all that life had to offer—including pain. The Punks' quest for pain often manifested itself as body modifications, such as safety-pin piercings, anarchist tattoos, and razor cuttings. While early Punks did not necessarily want to experience the primitive or tribal body modification experience, they were mimicking the dress and body styles of North American Indians with their Mohawk hairstyles and Pacific Island groups with their tattoos and septum piercings. Over time, Punks gained a deeper appreciation and understanding for the cultures that inspired their body style (Wojcik 1995), and developed significant connections to several central themes of the Urban Tribal movement.

## Subcultural Body Style Labels

Historically, both subculture members and outsiders have labeled the subcultural body. Sometimes these labels served useful in distinguishing one group from another, but more often the labels are negative and seek to set limits on the subculture's existence in mainstream culture. These labels are usually not self-chosen, but are instead assigned to a subculture by figures of authority, such as the media, scholars, and even medical professionals (Thompson 1998). Correspondingly, Mary Douglas (1984) posited that individuals who follow the understood cultural and social guidelines about the body and dress are treated as respectful citizens, but when the guidelines are not followed, disapproval, criticism, denunciation, and exclusion are generated from the dominant culture. William Keenan further illuminates this argument with connections to dress (and body style):

Dress exposes us to social gaze while expressing something of—and only in part—who we are in our own eyes. Observer and observed—the onlooker and the "on show"—play

and artful game of guessing and second guessing how, where and when to get it right as to the correct "look." The interpretation is as much a science as an art form. (Keenan 2001, 35)

Furthermore, Tobin Siebers (2000) asserts how "categories of normal and abnormal, sometimes contaminated by gender and racial stereotypes, dictate whether bodies are fit or unfit and therefore beautiful or ugly" (2). This negative feedback may be the desired response by some subcultures, such as the Punks, who use the mainstream's exclusion and criticism as validation for their continued dress and behavior, which reflexively serves to corroborate their position on the margins of mainstream Western culture. Still, some subcultures are not seeking the disapproval of mainstream culture and find such labels to be limiting and inaccurate.

In contemporary Western culture, an example of mainstream or acceptable body modification is dyeing an individual's gray hair color to another color (i.e. blonde, brown, auburn, or black) in order to disguise an aged appearance. This body modification is normative because a youthful veneer is an acceptable aesthetic standard, recognized and appreciated by dominant Western culture. If a person dyed her hair bright pink (and it is not part of an ephemeral costume or celebration), however, she would likely be labeled nonnormative and subcultural. These examples of modifying hair color with dyes have similar abstract outcomes of dress or body style, in that the dyes modify the hair color temporarily or semipermanently, as well as temporarily modify the texture, scent, and surface design of the hair. Still, hair colors not found "naturally" in human hair are often considered to be a form of subcultural dress (except perhaps during holidays where dyed hair color may reflect a costume or celebration, such as Halloween or St. Patrick's Day, where expectations exist that a return to one's natural hair color occurs after said event expires).

Exploring three comparative examples of global, historical, and current cultural and subcultural body modifications—piercings, skin resurfacing, and implants—that exist in both the mainstream and subcultures illustrates the marginalized yet spectacular position of the subcultural body. Furthermore, the subcultural body is often labeled in negative ways due to standards and mores established for mainstream cultural and social norms and ideals. These examples illustrate how subcultural body practices do not differ greatly from mainstream body practices. The goals and end results, however, determine the designation or labeling of "them" or "us."

*Piercing*

In the latter part of the twentieth century, many people in Western cultures began to pierce their ears, navels, eyebrows, and the sides of their noses (University of Pennsylvania Museum of Archaeology and Anthropology 1998). Although numerous areas of the physical body are pierced, some areas are more normative or acceptable in mainstream society than others. Piercing is the "[p]erforation of the skin and

underlying tissue in order to create a small tunnel in one's skin and flesh" (Camphausen 1997, 114). Since a piercing may heal and close shut in a relatively short period of time, utilizing a body supplement maintains the open piercing tunnel. In contemporary Western society, a piercing hole is created with one of two methods: piercing gun or hollow needle. Subcultural body modifiers prefer the latter method because the hollow needle removes the tissue from the piercing tunnel, reducing the chance that the skin will heal to close the piercing hole. Inserting a body supplement, that is, jewelry, into the piercing tunnel maintains the opening until it heals as desired (Winge 2004a; T. Winge, unpublished research fieldnotes, 2003).

Cultures around the world have historically pierced various areas of the body. One of the earliest examples of earlobe piercing is a four-thousand-year-old clay bust of a female with multiple piercings along the sides of each of her ears (University of Pennsylvania Museum of Archaeology and Anthropology 1998). The Alaskan Tlingit are known for their distinctive labrets or lower lip piercings (Gritton 1988; Jonaitis 1988). Typically, the locus of the labret piercing centers along the bottom lip (sometimes the top lip), either just below the lip line or halfway between the lip line and the upper chin. The Tlingit labret piercings and jewelry styles differed according to gender and age grades (Gritton 1988; Jonaitis 1988). Similarly, piercings practiced by the people of Papua New Guinea included labret and nasal septum (Angel 2009, 11–13). Global examples of piercing rituals and loci as documented in ethnographic texts are often the inspiration for Urban Tribal subcultures.

In contemporary Western cultures, a wide range of people exhibit piercings, and the normative and most conventional locus for piercing is the ear lobe (University of Pennsylvania Museum of Archaeology and Anthropology 1998). "Previously reserved for women only—at least in the Western world—earrings have become very popular among men as well—since the 1960s" (Camphausen 1997, 106). In mainstream Western culture, females generally have both ear lobes pierced and may have additional piercings along the sides of the ears (McNab 1999).

Nonnormative or subcultural earlobe piercings are generally considered to be those that are too many in number, stretched, uncustomary loci, and/or adorned with unacceptable supplements. Since acceptable or mainstream piercings in the late twentieth century are located in the ears, navel, or nose, any other location often creates the nonnormative appearance (McNab 1999). An example of a subcultural body modification is a labret piercing; so designated primarily because of its location.

The labret piercing has historic examples of specific cultural usage, such as the Tlingit of Alaska, who "defined social status among the groups by lip piercing" (University of Pennsylvania Museum of Archaeology and Anthropology 1998). Both males and females wore body supplements (lip plugs) in their lips, called labrets, and it was a common practice to pierce young Tlingit girls prior to marriage (Jonaitis 1988).

Within Urban Tribal subcultural groups in Western culture, both males and females have the labret piercing. Distinctive body supplements maintain and adorn the

labret piercing tunnel. Another popular option to this locus, but still a labret piercing, is positioned above one corner of the upper lip. This type of labret piercing is nick-named a "Chrome Crawford," after the model Cindy Crawford's famous birthmark (Angel 2009, 116).

Generally, the body supplements used in the piercing tunnel present a visual message that the wearer wants to communicate. This is a form of nonverbal communication that takes place between wearer and observer. The utilization of the body modification of piercing and subsequent body supplements may further demonstrate the theory of adornment, suggesting subculture members utilize their the body modifications and supplements "for purposes of display, attraction, or aesthetic expression" (Kaiser 1990).

Although the piercing tunnel is rarely displayed or thought to be an aesthetic expression (unless it is stretched and left unadorned), the choice of locus and body supplement worn in the piercing have certain qualities of adornment. Similar to the historic examples of piercings being used as a sign of social status, both ear lobe and labret piercings provide the wearer the opportunity to display jewelry that represents their aesthetic tastes. Body supplements may be used to adorn piercings, further suggesting aesthetic expressions, as well as symbolize protection "from the elements, animals, or even supernatural forces" (Kaiser 1990). In other words, the

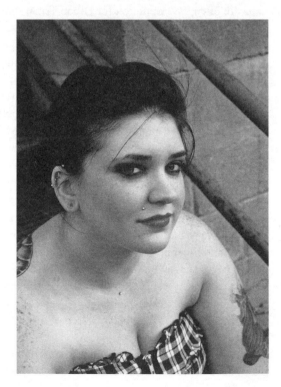

**Image 4** Jay has several piercings, including a facial labret piercing—a Chrome Crawford—adorned with a diamond stud, representing her subcultural and feminine body style. (Photo: T. Winge, unpublished research image, 2008)

body supplement may be utilized as security or protection from a perceived danger (i.e., religious icon or good luck charm). Furthermore, subculture members present the labret piercing and adornment to display or communicate their social status as an "outsider" or nonnormative from the mainstream population in Western society.

## Skin Resurfacing

As previously mentioned, some Urban Tribal subculture members, often Modern Primitives, utilize skin resurfacing to remove the outermost layers of the skin for scarification purposes. Skin resurfacing is actually used more commonly by members of the mainstream population than subculture members. While the resurfacing methods for both groups are usually similar, the resulting appearance and locus usually indicates the label of normative or subcultural. Accordingly, each group's process differs as does their labels. Normative skin resurfacing is typically called "cosmetic surgery," while the similar subcultural body modification is called "scarification."

According to Penny Storm (1987, 24), "[t]he popularity of cosmetic surgery is evident in the increasing rate of such operations since the late 1940s, when about fifteen thousand a year were performed, to the early 1970s, when there were nearly seven hundred times more operations." Correspondingly, in contemporary Western cultures, a form of cosmetic surgery gaining popularity is cosmetic laser resurfacing (Engler 2000). Accordingly, *BusinessWeek* reported that in 1996, "U.S. doctors performed 46,253 laser resurfacing" procedures (Sanders 1997). Since the 1990s, skin resurfacing has become a lunch-hour procedure, where the patient quickly returns to daily activities afterward, with complete healing occurring within days (Engler 2000). Subsequently, cosmetic skin resurfacing has become a normative and commonly accepted body modification for women (and men) wishing to retain a youthful appearance to their facial skin. Cosmetic resurfacing is a relatively new and evolving technology. Commonly, the two types of lasers used for this type of procedure include the $CO_2$ and erbium YAG (named for its components: erbium, yttrium, aluminum, and garnet) lasers (Sanders 1997). Cosmetic laser resurfacing is a noninvasive procedure modifying and resurfacing the outer layers of the skin. This technology is also used to remove skin cells from acne scars, blemishes, wrinkles, moles, and fine lines (Sanders 1997). Laser and chemical peel skin resurfacing uses a laser beam to vaporize the upper layers of skin at controlled levels of penetration (Jones 2008; Sanders 1997). Typically, patients only need local anesthesia and can leave within hours of the procedure. The healing process is quite painful and in extreme cases it may last as long as a few months, but most people return to normal activities and heal within days or weeks (Jones 2008). Pain medications are commonly prescribed for patients recovering from normative skin resurfacing. In direct contrast to the subcultural skin resurfacing experience, pain during the procedure or even afterward is not

a desired portion of cosmetic surgery, whereas subcultures welcome and even seek pain as a commodity to validate their bodily experience.

Scarification is another form type of skin resurfacing, where the desired outcome is a remaining scar; it is a type of corporal adornment modifying the soft tissue and skin (Storm 1987). More specifically, scarification "refers to the creation, by whatever technique, of one or more permanent scars on any part of the skin not by an accident or health-related surgery but by a conscious decision" (Camphausen 1997, 114–15). Essentially, scarification permanently modifies or transforms the texture, surface design, and possibly the color of the skin. Scarification even temporarily modifies the scent of the skin.

Scarification in some cultures functions as a means of protection and social identification or membership. The Ga'anda, for example, is a small West African group located mainly in Nigeria. The elder females performed the Hleeta scarification ritual biannually on the tribes' girls in six stages, starting at the age of six years old (Berns 1988). Although the Hleeta was concentrated on the torso, various areas of the body were scarred. The Hleeta design had symbolic significance and was believed to have protective qualities for the Ga'anda. This design adorned both females' stomachs and village granaries, to protect the unborn child and food supply from harm. Additionally, the Hleeta was only worn by Ga'anda women; therefore, it also signified membership to a specific group (Berns and Hudson 1986). In addition, it was necessary for a female to complete the Hleeta in order to marry. However, in 1978 the Gombi government outlawed the practice (Berns 1988).

Another West African group, the Yoruba of Nigeria, also practiced scarification for hundreds of years. According to the Yoruba, the Kolo marks result from tiny incisions or hash marks in a desired design and are a sign of beauty for both genders (Drewal 1988). Primarily, these scars are found on the face, more specifically the cheeks, but females may cover their entire body. When the Kolo marks adorn a female, they also represent strength because the marks indicate she can endure the pain and discomfort needed to be good a wife and mother (Drewal 1988). Over time and usage by one group, the use of the Kolo marks also signified membership to a specific group—the Yoruba (Drewal 1988).

According to Karmen MacKendrick (1998, 19), "[t]he most enduring modifications, such as scarification, are less popular than those more widely regarded as reversible (though it is undoubtedly relevant that scarification is perceived as more painful as well)." Even among Urban Tribal subculture members, scarification is less common. This is due in part to only limited numbers of scarification practitioners, the permanent qualities of the modification, and the lengthy and difficult healing process. Subcultural scarification typically takes weeks to months to heal, and increasing the area scarified lengthens the healing time and encourages infections and uneven healing. Urban Tribal subculture members secure scarification marks to indicate strength of character and commitment to their subcultural ideology, and in some cases even subcultural membership.

In contemporary Western cultures, visible scarification is generally considered nonnormative or subcultural, even though the same procedures erase minor wrinkles, lines, and unwanted epidermal imperfections. While subcultural individuals practice scarification for various reasons, their ideologies differ from mainstream Western cultural standards and ideals. Scarification as cosmetic surgery is a means of concealing (usually aging skin); even the scars from the scarification are meant to heal without a visible trace. In contrast, Urban Tribal scarification is meant to have a lasting and visible (and often tactile) impact for the wearer and observer.

In this way, both normative and nonnormative scarification is performed and displayed. Historically, scars indicate social status and identity, as well as group membership (Storm 1987). Within the subcultural sphere, scarification is performed typically to show a belonging or affiliation to a subculture and is utilized to decorate the subcultural body uniquely. Scarification among some subcultures is a sign of belonging and commonly represents social rank or identity. Subsequently, a person with numerous aesthetic scars would indicate his or her high rank or standing in the group. While the ways that scarification impacts the cosmetic surgery patient may be less obvious than it impacts the subculture member, the recovered patient continues (and sometimes even elevates) his or her social position by maintaining a youthful appearance. Since a youthful appearance is desired and even revered within Western society, a person with youthful skin could visually communicate his or her continued vitality and productive role within mainstream society.

Both cosmetic resurfacing and subcultural scarification, accomplished with the use of lasers or scalpels, modify the skin's surface to achieve an aesthetic ideal. Scarification's main purpose, however, appears to fulfill the desire to create a new surface design and texture on the skin (nonnormative appearance), while the main purpose for cosmetic resurfacing appears to fulfill the desire to transform the skin back to its youthful appearance, an ideal of beauty in many Western cultures. Cosmetic resurfacing also transforms the texture of the skin into the pleasing texture. Furthermore, a younger appearance in Western culture is desired and directly linked to a person's self-esteem, perceived sexual prowess, and cultural identity.

Skin resurfacing has the potential to establish an individual's place in society or membership to a designated group or subculture. The ways in which a body modification, such as skin resurfacing, is recognized depends on how closely it reflects or deviates from the mainstream Western cultural standards and ideals of beauty. Accordingly, normative or nonnormative labels are assigned, further distinguishing "us" from "them."

## Implants

Both mainstream culture members and subculture members have and/or acquire implants. An implant is a body modification that positions a foreign object subdermally

or transdermally in the skin or flesh of the physical body (Winge 2004a, 2004c). Typically, these types of body modifications require an invasive procedure or surgery, with the recovery and healing process reflecting the body's acceptance of the foreign object or implant.

In the West, breast augmentation is considered a normative implant; the loci of the breast(s) being considered an acceptable location for many types of surgery. Since the early 1960s, when breast implants began to be widely acceptable, an estimated two million American women had their breasts augmented as of 1998 (Lagnado 1998). Throughout the early usage of breast augmentation implants, an ongoing discussion among medical experts occurred regarding the superiority of silicone gel-filled or saline implants (Storm 1987). In time, breast implants were improved and the procedure modified to efficiently augment women's (and men's) breasts to be nearly any size desired. Breast augmentations have led to medical complications, ranging from infections to physiological disorders (Winge 2004c).

Visible implants that differ from the possibilities of the "natural" body are commonly considered to be subcultural, and often Urban Tribal. In 1996 Joe Aylward, a thirty-two-year-old male, "had surgical steel implants installed on his head transdermally (through the skin, rather than completely under it)" (Seeger 1996). The base of each implant was square with a center-positioned threaded opening placed under the skin with the threaded chamber visible. The chamber would eventually hold the interchangeable, threaded metal shafts for a Mohawk-style row of spikes. Another example of subcultural implants is an entertainer named The Enigma, who "had his fourth generation of horn implants installed. A generation is basically equivalent to the gauge system used in wire, gradually getting thicker. The plan for The Enigma's horns is seven generations, or stages, of Teflon of increasingly larger size, allowing the skin to stretch" (Body Modifications Extreme 1997). The Enigma's horns were designed and implanted by Steve Haworth, whose experience as a medical device designer gave him unique insights into body modification practices. Both the metal Mohawk bases and Teflon horn implants required what would be considered minor invasive surgery. When performed publicly, these types of body modification practices are forms of performance art (Body Modifications Extreme 1997).

These two subcultural body modifications are something of subcultural lore, in that some subculture members remark about the "extreme" nature of these types of body modifications (Mercury 2000). In the late 1990s, The Enigma, for example, was hailed for having his sixth generation of Teflon horns removed and his seventh and final generation of "coral horns" implanted (*Extreme Body Modifications-Implants* 1999). Rumors purported that The Enigma chose coral because living human bone would calcify and adhere the coral implants to his cranium. Since the reports of The Enigma's coral horns surfaced on the Body Modification Extreme Web site (BME. com), discussions among subcultural groups took shape around the limits and possibilities of the human body and body modification practices. During my research,

**Image 5** Significantly more subtle than a metal Mohawk or horn implants, Jay's upper chest implant is a diminutive stud with a diamond finial. Still, the body modification procedure is similar among all implants. This type of small implant has a base under the skin and only the stem or jewelry cap adornment is visible. (Photo: T. Winge, unpublished research image, 2008)

I spoke with The Enigma about his horns. He informed me that he did not acquire coral implants, although coral was a possibility being considered; eventually, he secured silicone implants for horns and is pleased with the results.[4]

Both breast implants and three-dimensional implants are body modifications, which result from individuals desiring to change their physical body. These invasive body modifications and reasons for getting them differ, from the normative breast implants for those desiring a more ideal physical form, to the nonnormative subcultural implants for those seeking to create a unique physical appearance. Bodily implants draw attention to a given a body part (Storm 1987); normative and nonnormative implants alike focus on a specific body part or locus. Breast implants augment the size of the natural breast and often attract attention to that specific area. Three-dimensional implants such as a metal Mohawk or Teflon horn implants draw attention to the wearer's head.

This exploration of body modifications whether labeled normative (i.e., mainstream) or nonnormative (i.e., subcultural) within Western culture indicates the importance of the natural and modified human body. The growing interest in body modifications suggests that many human beings want to re-create the physical vessel

in which they reside. Joanne Eicher, Sandra Evenson, and Hazel Lutz (2008) suggest that the body is a canvas for artistic expression, thereby suggesting that all human beings seek to aesthetically enhance their physical appearance. In my research, sub-culture members discussed the body as a blank canvas and further alluded to creating art that has both permanency and fluidity.

Inherently, human beings have the inclination to categorize and label things to maintain order or communicate distinctly with others. Consequently, the lines are drawn and may be drawn over and over again as bodies are relabeled and reordered. Some body modifications have negative connotations and remain so until adopted and co-opted into mainstream culture, in the process gaining new, normative labels. Regardless of the similar reasons for mainstream and subcultural body modifica-tions, social and cultural norms and ideals continually draw the lines between "us" and "them."

Scholarship surrounding subcultures or the subcultural body also notes these dis-tinctions and labels that exist between the mainstream and nonmainstream. Thevoz, for example, aligns with medical literature, which views many subcultural body modifications as at least partly pathological (Favazza 1996; Myers 1992). Although Armando Favazza includes an epilogue written by Fakir Musafar in his book *Bodies Under Siege: Self-Mutilation and Body Modification in Culture and Psychiatry* (Fa-vazza 1996), he refers to Modern Primitive body modifications as "self-mutilation" throughout his book. Correspondingly, James Myers wrote "Nonmainstream Body Modification: Genital Piercing, Branding, Burning and Cutting" (1992), where he suggests that nonmainstream body modifications involve physical pain and are thus repulsive and even psychopathological by mainstream American society mores. His findings were based on his two years of research, which included participant obser-vation and interviews with subculture members during body modification rituals and fetish balls (i.e., body modification parties). Myers concludes with brief explana-tions regarding the motivation and rationale behind the use of nonmainstream body modifications by subculture members, which include sexual enhancement, rites of passage, aesthetic enhancement, affiliation, spirituality, and shock value.

Mass media accounts often reflect the opinion of the medical literature in their assessment of subcultural body modifications. Greg Beaubien (1995) states how the use of extreme body modifications is quite possibly a mental health issue in his news article "Burning Question: Branding Makes its Mark as the Latest Fad in Body Modification, but is it Art or Self-Mutilation?" Beaubien neglects to consider that many of the negative connotations about branding may be linked to branding's use on slaves and animals to mark ownership. Contemporary examples of branding are reclaiming its usage and nonverbal communications. Some Greek fraternities mem-bers, for example, choose to brand their Greek letters into a designated body part to show lifelong fidelity to the ideals of the group.

Scholars outside the medical field tend to be more objective in their assessment of subcultures' use of body modifications. In the introduction to Francis Mascia-Lees

and Patricia Sharpe's *Tattoo, Torture, Mutilation and Adornment: The Denaturalization of the Body in Culture and Text* (1992), the authors suggest that body modifications are positive body experiences. Similarly, Karmen MacKendrick's "Technoflesh, or 'Didn't That Hurt?'" (1998) challenges ideas that body modifications are pathological or negative with the positive body experiences relayed by the participants in her research.

Clinton R. Sanders, a sociologist, challenges labels of "deviance" and "self-mutilation" for subcultures in *Customizing the Body* (1989). Sanders researched the meanings associated with permanent body modifications, specifically tattoos, which members of mainstream culture once found completely repugnant but his research revealed are beginning to gain acceptance. Sanders based his research on participant observation in four tattoo studios and informal interviews with sixteen persons getting tattoos and fourteen tattoo artists, along with 163 questionnaires from a tattoo convention (Sanders 1989). Questioning the psychiatric literature that assigns psychopathology to individuals acquiring body modifications, Sanders explored the processes and meanings of being a tattooed person with the following themes: individual expression, social relations, and rites of passage. In response to these interviews, Sanders warns that if permanent body modifications become popular, the result is an increasing inability for these body modifications to function as establishing membership in a subculture.

Sander Thomas (2002) also challenges the labels assigned to subcultures that practice body modifications in the article "Body Piercing: Reclamation, Enhancement, and Self-Expression." Thomas argues that body modifications, specifically ones focusing on body piercing, provide a way for individuals to reclaim and enhance their bodies while improving their self-image through self-expression. Similarly, Maureen Mercury, in *Pagan Fleshworks: The Alchemy of Body Modification* (2000), states as a scholar and subculture member that "this is not a return to a primitive tribal behavior. We are not those people. We are too diverse a population and geographically isolated to belong to a tribe, and very few Westerners would consider themselves 'primitive'" (5).

Musafar further challenged the notion that members of the Modern Primitive subculture are deviant or practicing self-mutilation in "Body Play: State of Grace or Sickness?" in the epilogue of Favazza's book (1996) and in his interview with V. Vale and Andrea Juno in *Modern Primitives: An Investigation of Contemporary Adornment and Ritual* (1989). Musafar suggests that Modern Primitives are simply responding to a "primal urge" to alter their bodies. This primal urge takes a variety of forms, from tattoos to brands, with a variety of purposes from commemorating the death of a loved one to a rite of passage, and usually involves the sacrifice of pain and blood (Favazza 1996, 328–29).

As a result of labeling body modifications and by extension labeling the person with the modification, some subculture members find that there are occasions when it is necessary to disguise the subcultural body. A full-body tattoo or a series of tattoos

that cover most of the body but stop at the wrist, neck, and ankles is considered non-normative or subcultural. Typically considered nonnormative because the full-body tattoo covers large portions of the body with decorations, this type of tattooing is not in the current aesthetic standard in Western or Eastern mainstream cultures. Some subculture members of the Urban Tribal movement have full-body tattoos, which usually stop at the wrists, ankles, and neck for easy concealment beneath a suit, dress shirt, and tie (T. Winge, unpublished research fieldnotes, 2003). It is not a coincident that the full-body tattoo and the subcultural body is disguised under the standard Western business suit ensemble, which allows the subculture member to exist within mainstream culture for employment and socializing purposes.

The ability to disguise the subcultural body or maintain the mainstream body is evident after spending a few hours with modification practitioners. Tattoo artists, for example, are reluctant to tattoo the body in a place that is not easily covered with clothing, such as the back of the hands, face, or neck, especially if this is a person's first tattoo (McNab 1999; T. Winge, unpublished research fieldnotes, 2003). Piercers are also hesitant to pierce with too large of a gauge or in a nonnormative locus (T. Winge, unpublished research fieldnotes, 2003). Accordingly, people who have indiscrete piercings insert retainers made from clear plastic or fine stainless steel metal clips to keep a piercing hole open when the piercing tunnel or loci is desired to be less noticeable. Within the body modification marketplace, there are normative protections in place for both the mainstream and subcultural member of Western society.

Still, some subculture members establish their place within the Urban Tribal subcultural landscape with body modifications not (easily) disguised or hidden. The facial tattoo is perhaps the most difficult to conceal, and thus communicates a serious commitment to bodily experiences and visible aesthetics. The difficulties in disguising this type of body modification makes it rare; even within subcultures in the Urban Tribal movement, facial tattoos are uncommon. This suggests that while there is a divide between "us" and "them," few subculture members are delineating the distinction further than it currently exists.

## Summary

A background and historic markers establish the context and basis for contemporary discussions about subcultural body styles. The role of dress and the body also contributes to subsequent discussions about the subcultural body. The history of the subcultural body, both inside and outside the Urban Tribal movement, further establishes historical contexts based on shared values and identities within given subcultures. I concluded this chapter with three types of body modifications labeled mainstream or subcultural. In chapter 3 I continue to explore the subcultural body by focusing on the construction and dissemination of subcultural identities.

# –3–

# Subcultural Body Style and Identity

I consist of body and soul—in the worlds of a child. And why shouldn't we speak like children? But the enlightened, the knowledgeable would say: I am body through and through, nothing more; and the soul is just a word for something on the body.

—Friedrich Wilhelm Nietzsche, *Thus Spoke Zarathustra*, 1892/2007

Contributing to the understanding of subcultural body style and associated identities, I draw on the ideas of social psychologist George Herbert Mead and sociologist Herbert Blumer from the Chicago School about the "self" (Fine 1995), from which the concept of "identity" grew (Hetherington 1998). Accordingly, "identity" displaces "self" as a way of discussing the complex facets of an individual (Turner 1996). I also rely on sociologist Erving Goffman's discussions about the everyday life of the body from moral and social perspectives. Specifically, Goffman (1959, 1967) observes and notes actual body practices (such as gestures, movements, and expressions) and face-to-face interactions. He describes how the body produces and embodies spaces (Goffman 1963), and argues that the social body is ritualized and dependent on social interactions, which are symbolic acts and ritualized practices at the micro level (Goffman 1967). Goffman (1981) also suggests that the self is directly connected to the body, which is negotiated and mediated between "self-identity" and "social-identity."

The body plays an important role in the construction of an individual's identity(ies). In many cases, the physical body determines the gender identity for an individual, and individuals "do gender" in Western culture (West and Zimmerman 1987). Parents dress children based on social and cultural connotations related to their physical sex, which results in people outside the family interacting with them in gendered ways based on their dress and physical appearance (Lorber 1994). In time, children assert their identity through dress choices, along with dress decisions based on familial and peer acceptance and rejection (Stone 1962). Furthermore, "[t]he ubiquitous nature of dress would seem to point to the fact that dress or adornment is one of the means by which bodies are made social and given meaning and identity" (Entwistle 2000, 7). In Western culture, from adolescence into young adulthood, dress is the avenue for "trying on" new identities. Consequently, the chosen subcultural body style contributes in significant ways to the development of identity of the individual.

For the subculture member, the body serves as an indicator of subcultural identity, and at the same time the body may act as a disguise for other identity(ies). Subculture members use their body style to visually communicate a shared identity, membership, and ideology within a given group. The subcultural body also has symbolic value and power (i.e., identity, resistance, and agency) conferred on the body (and individual) by the subculture, mainstream culture, professional entities (i.e., medical doctors and scholars), and the media. As a result, the subcultural body has complex and fluid identities, continually evolving and changing in response to external and internal stimuli. Moreover, a subculture member may assume and transition between different subcultural and/or mainstream identities within individual groups in order to achieve and live in the subcultural body.

In this chapter, I focus on the significance of the subcultural identity associated with the subcultural body style, both internal and external to the subculture. To this end, I provide global examples of the Urban Tribal subcultural body, such as the biotechnical Teflon implants of the Modern Primitives and the sociopolitical tattoos of the Punks. To support these discussions, I include firsthand fieldnotes and quotations from research participants. The subcultural body and subsequent identity(ies) are oftentimes disguised when it is deemed necessary to blend into mainstream culture, such as a person with a full-body tattoo donning a business suit that covers the entire tattoo in order to gain employment or secure a bank loan. Understanding the identity(ies) of the subcultural body requires a somewhat artificial but necessary categorizing of its roles and identities. I explore the identity of the subcultural body as it is displayed, performed, commodified, disguised, socialized, narrated, ritualized, spiritualized, and lived by actual subculture members.

## Subcultural Body Style

Each subculture member has individual lived body experiences, which collectively create the generalizations about the subculture's identity. These generalizations are then further extended to collective ideas about identity regarding the individual member, the specific subculture, and the entirety of all subcultures to some degree. The subcultural body becomes an amalgam of experiences—for example, piercings, tattoos, spiky hair, and propensity toward pain. Furthermore, each subculture has unwritten but collectively understood "dress codes" or guidelines (discussed in more detail in chapter 4). In this way, a person can achieve the desired "acceptable" or "unacceptable" body according to specific subcultural standards and ideals. The subcultural body is often associated with being nonnormative. Because what is acceptable and normative is increasingly consumed from subcultural entities, the subcultural body is willingly or unwillingly being pushed further into the fringe, margins, and unknown spaces while still in accordance with its subcultural standards and criteria.

In urban environments, body modifications are typically thought to be a key in-dentifying feature of the subcultural body, yet people not seeking a subcultural iden-tity also have body modifications, many of which are deemed equally nonnormative. Concealed body modifications, such as genital piercings and intimate tattoos, pose little to no threat to a normative identity. Moreover, these same body modifications displayed to certain people and in specific settings would extend a normative per-son's identity, but not necessarily create a subcultural identity. A mother, for ex-ample, may have tattoos of her children's birthdates on her chest; these tattoos are visible when she wears a low-cut top or is in intimate settings or with her physician. Regardless of the setting, her tattoos do not garner a subcultural identity, but instead communicate an extended sense of motherhood.

The body modification experience is a complex composition of technology, ritual, physical and emotional sensations, and the changing body, all of which are not nec-essarily unique to the members of a subculture. In fact, the basic body modification process to acquire a tattoo, for example, is quite similar for mainstream and subcul-ture members alike. The differences in body modification experiences often rest in the resulting subcultural (or mainstream) context and meanings associated with the body modification, as well as specific circumstances where the subculture member modifies the basic process to meet individual and subcultural needs. Subsequently, a body modification is useful as an extended example for discussing what the subcul-tural body is or is not, along with the nonnormative labels often associated with the subcultural body. As discussed in the previous chapter, some methods, media, and loci may be considered normative and more acceptable, while others are nonnorma-tive and less acceptable. The judgment of labels such as normative or nonnormative rests on the communicated, understood, or implied standards of a (sub)culture. In addition, these judgments and labels often assert the delineation between "us" and "them," based on societal and cultural norms and ideals:

> Moral issues regarding dress include the niceties of etiquette relating to what is consid-ered proper and improper to wear and display as well as severe sanctions against break-ing strongly held beliefs [. . .] Similarly, beliefs about the aesthetics qualities of dress (what is beautiful or ugly) can differ appreciably. For example, the body can be modified in many ways (e.g., by cutting, scarring, painting, and piercing), and the technology for accomplishing each type of modification may be simple or complex. However, the ac-ceptability of cutting, scarring, painting, or piercing ranges considerably from society to society depending upon specific moral and aesthetic beliefs. (Roach-Higgins, Eicher, and Johnson 1995, 15)

Regardless of the variety of body modifications, their practice and use are subject to judgment within a society, just as any other element of dress. Accordingly, the dominant culture imposes or implies descriptive terms or labels, such as "normative" and "nonnormative," to delineate the standards and norms from those less desired.

Generally, elements of dress, like body modifications, are judged on a continuum. Still, normative body modifications are those more acceptable and appreciated by the dominant culture of a society. In contrast, nonnormative or subcultural body modifications lack acceptability and appreciation within the dominant culture. Numerous variables determine whether body modifications are normative or nonnormative by the mainstream culture, such as geographical locations, beliefs, values, and aesthetics, along with the standards, mores, and norms of a culture. The following sections explore the ways in which subculture members deviate from commonly accepted mainstream dress and styles.

## Customization

Subculture members customize their bodies in ways that both conform to and challenge the dominant social and cultural norms. This customization often takes shape as permanent body modifications, but may be temporary as in the case of dyed hair or a body supplement, such as ear piercings that stretched the earlobe with plugs of increasing sizes over time. In the end of chapter 2, I discussed how cosmetic surgery is an acceptable form of body modification but also shares many similarities with subcultural body modification. Here, I focus on the physical customization of the subcultural body, using two examples of highly customized bodies and subcultural identities.

### The Lizardman and The Enigma

Erik Sprague, better known as The Lizardman, is a performance artist (Sprague 2008). The Lizardman's act includes eating and breathing fire, swallowing knives and swords, lying on a bed of nails, and hanging from hooks embedded in his flesh (Sprague 2008). While these feats are impressive and demonstrate an intimate awareness of classic sideshow performances, The Lizardman is best known for his unique appearance as a human lizard. He has sharpened teeth, subdermal implants that create eyebrow ridges, tattooed green scales covering his face and portions of his body, and a split tongue (see Image 6).

The Enigma, formerly known as Slug, is a performance artist, actor, and musician (Hill and Hollenbeck 2004). Publically, The Enigma appeared on the North American television series *X-Files* ("Humbug" 1995) and performed in the Jim Rose Circus. The Enigma's body is covered with tattoos resembling jigsaw puzzle pieces, most filled in with blue ink, and has three-dimensional silicone horns placed on his forehead subdermally. The original horns were implanted and subsequently enlarged during the 1990s by body modification practitioner Steve Haworth. In 2011 Howard Rollins from LunaCobra changed The Enigma's horns to silicone (they were previously Teflon) and tattooed the sclera of his eyes black (see Image 7).[1]

The Lizardman and The Enigma are Urban Tribal subcultural celebrities with cultivated and constructed subcultural identities closely tied to and associated with their

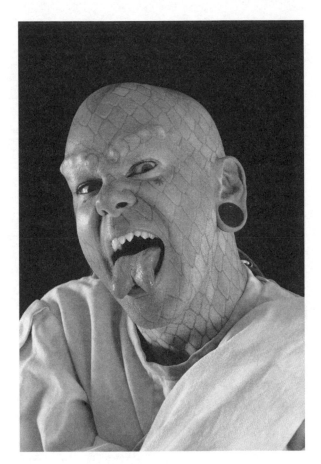

**Image 6** The Lizardman, featured here in a promotional image for an entertainment performance, is heavily modified with green scales and black-work tattoos, split tongue, sharpened teeth, and brow-ridge implants. (Photo: Allen Falkner)

chosen subcultural body styles. The fact that both of these individuals changed their names to reflect their chosen body modifications, display their customized bodies in public performances and photographs, conduct interviews about their body modification practices, and capitalize on their modified bodies suggest that they possess highly cultivated subcultural identities.

A publicity photograph of The Lizardman for his performance acts featured him in a straitjacket with a crazed expression and showing his split tongue. Does this type of imagery contribute to the stereotypes associated with subculture members who heavily modified their bodies? Perhaps, but in these cases the postures and setting reflect an understanding and cultivation of those stereotypical subcultural identities. Furthermore, these portrayals of the subcultural body not only sensationalize the individual and visually associated groups but also eroticize and further popularize body modifications. It should be noted that appearances do not tell the complete story, especially with heavily modified subculture members. The Lizardman, for example, is college-educated, articulate, and contemplative in his interviews. My research with subculture members supports that his is not a unique situation, but rather it is common

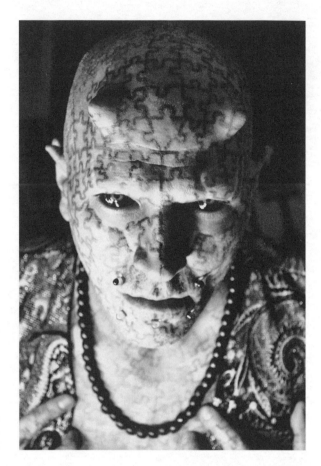

**Image 7** The Enigma is a musician and performance artist. His body is covered in tattoos of blue puzzle pieces, along with black eye tattoos, silicone horn implants on his forehead, facial piercings, and reshaped ears (from cartilage removal). (Photo: Brinny D.)

for Urban Tribal subculture members to be college-educated and employed, which is not surprising considering the substantial cost of body modifications. This may be contrary to the media's portrayal of subcultures as undereducated or unemployed.

These examples of highly customized bodies may seem extreme or extraordinary, and indeed, not all subcultures have such celebrity members.[2] But there is a growing subcultural (and mainstream) interest in body modifications of all types. Subcultures within the Urban Tribal movement challenge cultural, social, and aesthetic norms with their bodies and dress.

## Noisy Aesthetics

The aesthetics of the subcultural body are, of course, particular to a given subculture and the individuals' tastes within a given time period, which makes discussions about individual and group aesthetics exceptionally difficult. Still, some generalizations and discourse can be developed from aesthetic examples of the subcultural body. Dick Hebdige, in *Subculture: The Meaning of Style* (1979), introduces the idea

**Image 8**    The star is a common tattoo design that can be modified in color and style for the designer. The black-outlined red star is associated with "safe passage home" and adopted by various subcultures as a protection tattoo (T. Winge, unpublished research fieldnotes, 2004). (Photo: T. Winge, unpublished research image, 2008)

of subcultural *noise*, which is the visual interference created by subcultural dress, as well as postures, gestures, language, activities, and music (90). Hebdige was exploring the subcultural aesthetics of the British Punk subculture, and in the 1970s, this aesthetic was spiky hair, DIY body modifications (e.g., roughly hand-worked anarchy tattoos and safety-pinned piercings), and distressed working-class clothing (e.g., ripped jeans and flannel shirts). Even within Hebdige's discussions, the subcultural body is frequently dismissed as simply creating noise or having a different-from-mainstream aesthetic appearance, which neglects the deeper context and reasons behind the noise and how it contributes and constructs the subcultural identity.

The subcultural aesthetics guide body modification experiences reinforcing memories, experiences, memberships, and so on, and creating a visual representation of subcultural identity. Subculture members carefully select or design their body modifications and decide where the modifications are placed because they take great pride in the resulting display. Modern Primitives, for example, do not typically choose tattoos from the flash art usually found on the walls of most tattoo studios; instead, they research and design tattoos that reflect themselves as individuals or even their individual commitment to a group or movement. (Flash art is predesigned or preexisting tattoos, usually with

a historic or cultural significance.) During the nineteenth century, U.S. naval personnel returned from overseas with tattoos inspired by their patriotism and travels, such as flags and military insignia (Gilbert 2001). Other inspired images, such as tigers, hula girls, and emblazoned hearts with banners, reminded the naval personnel of home and loved ones. These symbols were some of the first stock art on tattoo parlor walls, and came to be known as flash. Today, flash art tattoos continue to include these historic tattoo images, but they also include cartoon characters and religious iconography.

## Displayed Body

The displayed subcultural body is confrontational and demands recognition, acknowledgement, and assignment of a label of "subcultural" identity. This does not mean the subcultural body is nonexistent when not displayed or disguised; instead, the displayed subcultural body is visually available to be labeled subcultural and assigned a subcultural identity. The subcultural body is easily identified when on stage, as seen with examples such as the Jim Rose Circus performers The Lizardman and The Enigma, who have heavily customized and modified their bodies in ways that are difficult to disguise. The displayed subcultural body creates visual "noise."

The subcultural body is displayed in different ways depending on the subculture and the roles the body plays within it. Some members decorate their bodies in brilliantly colored clothing and hair or elaborate tattoos or scarification, while others use their bodies as visual markers of accomplishments and narration. For these reasons, the subcultural body is noteworthy when displayed and usually includes components of performance.

### Performance

Performance plays an important role in the identity assigned to and sought by the subcultural body. What is performance for the subcultural body? In some instances the subcultural body is on display in a performance because the individual, such as a subcultural celebrity or performer, is in a public setting, while in other instances, the performance of the subcultural body is defined by the activities of the subcultural group, such as dancing.

Subcultural celebrities display subcultural body styles while performing for audiences. Stelarc is an Australian performance artist who explores postmodern notions about the limitations and extents of the body, which he primarily accomplishes through human–machine interfaces and interactions (Farnell 1999). On Stelarc's official Web site flashing on the screen is the phrase "THE BODY IS OBSOLETE."[3] Stelarc argues that the body lasts beyond its usefulness and relies on machines to do even the most basic of tasks. This argument, however, seems contrary to his basic thesis and framework/material—the body and its extents. Still, Stelarc's Web site and artwork give

pause for thought about the role and position of the body (and its relationship with technology) in a postmodern culture. Furthermore, many of Stelarc's performances include activities and ways of dressing that mirror the subcultural body style in the Urban Tribal movement.

During his career, Stelarc created many devices for human-machine interfaces. From 1976 to 1981, Stelarc designed, created, and attached to his left forearm a mechanized hand and forearm. This device, called "the Third Hand," responds to electrical impulses created by muscle stimulators. Stelarc's designs and performances are real-world manifestations of French philosopher Jean Baudrillard's techno-body, or the body as an object instead of a lived entity.

Baudrillard (1995) defines the postmodern tropes of the body, which he argues often lead to the production of the Other and alienation. Baudrillard (1998) presents the body as the "finest consumer object," in contrast to the prestigious object that the medical community perpetuates for its own economic gains. In *Consumer Society: Myths and Structures*, Baudrillard states:

> [T]he ethics of beauty, which is the very ethics of fashion, may be defined as the reduction of all concrete values—the "use values" of the body—to a single functional "exchange-value," which itself alone, in its abstraction, encapsulates the idea of the glorious, fulfilled body, the idea of desire and pleasure, and of course thereby also denies and forgets them in their reality and in the end simply peters out into an exchange of signs. (1998, 132)

Subsequently, Baudrillard suggests that the body suffers exploitation and alienation within the postmodern Western consumer society, which has dire implications for the subcultural body.

Baudrillard also argues that technology can be an extension and at times it contributes to the destruction of the body; in this way he notes the production of the Other and alienation. Accordingly, Baudrillard introduces the idea of a techno-body, and further discusses the techno-body with certain sexual and sensual traits. For this Baudrillard (1998) is criticized that his techno-body is a symbolic representation of mistreatment and exploitation with its pornographic nature and deliberate Otherness. Furthermore, Baudrillard (1998) was criticized for summarizing the body as a machine that exists to seek out (sexual) pleasure, which can be exploited, abused, and alienated. Still, his discussions of the body illuminate the contentious position of the subcultural body in modern Western society.

Similar to Stelarc, the Cyber subculture members (aka Cyberpunk, Cybergoth, and Cyberkid) explore the human–machine interface by attaching temporary, semipermanent, or permanent real and facsimiles of cybernetics to their bodies. Science-fiction literature spawned a subculture obsessed with the possibilities of cybernetics and technologies within a Punk aesthetic. In 1983 Bruce Bethke's short story *Cyberpunk* joined cybernetics and the Punk subculture, or at least the Punk subcultural

aesthetic. Cyberpunk subcultural members mimic visible cybernetic implants and the Punk aesthetic. Today, the members of the Cyber subculture draw inspiration from television and movies, such as the fictional Borg featured on the various *Star Trek* television series and movies; performance artists, such as Stelarc; and writers, such as William Gibson, who writes about "jacked" humans who have cybernetic implants that replace entire organs.

The Cyber subculture visually projects a fantasy lifestyle in a dystopian world, where machines are increasingly part of their lives to the point that they embed cybernetics machines in their very skin (T. Winge, unpublished research fieldnotes, 2003). Cyberkids dance at nightclubs and raves due to their attraction to electronic music, while the Cybergoths and Cyberpunks role-play one of the many cyber-themed games, such as *Shadowrun* or *Cyberpunk 2020*. The Cyber subcultural body is dressed primarily in black and bright neon colors, which are popular with the Cyberkids. Their dress usually incorporates circuit boards and LED lights or screens, along with wires or tubes usually set into the skin with special-effects molding clay and makeup to resemble subdermal implants (T. Winge, unpublished research fieldnotes, 2003). There are very few actual Cybers (i.e., people who have subcultural cybernetic implants); still the subculture is growing in numbers with the popularity of role-playing games, novels, and movies about it. Some contemporary and normative examples of cybernetic implants are pacemakers or hearing aids. Most subculture members wishing to convey a Cyber identity often create jewelry or electronic nodes to attach to the skin through a piercing hole or with adhesive, which has the appearance of a cybernetic device that may be a subdermal implant.

Performance and the bodily experiences were also the focus of Orlan, a French performance artist who is globally known for her work "Reincarnation of Saint Orlan," a series of plastic surgeries. Starting in 1990, Orlan had a variety of plastic surgeries to modify her body in ways that reference significant historic works of art (Jones 2008). Orlan's body modification processes (i.e., plastic surgery) and subsequent results were and are the focus of her performance art, which she uses to critique current conceptions of beauty, technology, and femininity.

The performance artists Stelarc and Orlan exist as unique examples of the intermingling of the body and technology, without necessarily being identified with any specific subculture. Still, these artists demonstrate the curiosity and interest in the modification of the human body, similar to that seen in the Urban Tribal subcultures. Modern Primitive subculture members, for example, stage large body modification spectacles of display, performance art with overtones of subcultural body rituals. Similar to Stelarc and Orlan, some Modern Primitives participate in public performances either as the result of body modification or the act of acquiring body modifications. On several occasions, Fakir Musafar performed a version of the Sun Dance, a body modification ritual similar to the one mentioned in *Black Elk Speaks* (Neihardt 1988). Musafar consulted a Native American shaman and chose some trusted friends

**Image 9** Members from the Cyber subculture often create their subcultural body style and identity through their DIY dress, incorporating cyber elements into their jewelry and clothing (T. Winge, unpublished research fieldnotes, 2009). Cybers exist on the fringe of the Urban Tribal movement, in that this subculture's members use only limited body modifications but are attracted to the body-centric ideology. (Photo: T. Winge, unpublished research image, 2009)

to assist him in inserting hooks into his chest and back; from these hooks Musafar hung suspended from a tree for nearly thirty minutes (Vale and Juno 1989, 34–36). Similarly, the ways that Stelarc and Orlan explore the body and push the boundaries of technology benefit and extend the body styles and experiences possible for subculture members.

## Commodification of Subcultural Body Style

The subcultural body becomes a product that is constantly and continuously commodified by and for subcultural and mainstream consumption. Baudrillard's discourse focused on the idea that the body is the "finest consumer object," which assists in understanding the roles of the subcultural body within mainstream culture:

> The individual has to take himself [*sic*] as object, as the finest of the objects, as the most precious exchange material, for an economic process of profit generation to be established at the level of the deconstructed body. (Baudrillard 1998, 281–82)

It is possible to extend this discourse to the subcultural body as fetish and capital, symbol and object, and representation and commodity. The subcultural body has a

parallel role to the mainstream body regarding the goals of the culture and even economics, incorporating the individual into the culture and subsequent social controls over the body (Foucault 1979).

The media plays a noteworthy role in the commodification and consumption of the subcultural body. Images broadcast on the evening news, printed in daily newspapers, and photographed for monthly periodicals visually communicate the subculture identity to the dominant culture as a consumable object. Frequently the media identify groups as subcultural and then assign sensational and often controversial names or labels. Subsequently, this identification becomes the group's public identity, leading the group to negotiate, validate, and even reject the media's assumptions about its identity.

While the subcultural body is often designed before the media or other external source is able to name the group, the body style changes as it negotiates, validates, and rejects its name and connotations or social controls. Subculture members, in turn, become consumers of the subcultural body styles and aesthetics. In North America, the chain retail store Hot Topic, for example, sells subcultural styles to mainstream and subcultural consumers alike. As products are released and sold at Hot Topic, the co-opted subculture and its members are impacted.

The subcultural member essentially becomes the consumer in the consumption experience (e.g., purchasing Celtic-inspired triskele earrings). Consumers, whether mainstream or subcultural, make purchases based on shared (sub)cultural and social practices and institutions. As a body modification becomes popularized, both the mainstream and subcultural consumers participate in the consumption of these subcultural products, such as tattoos and piercings, as ways of visual expression and identity negotiation. Contemporary cultures place significance on multiple identities, further complicating and alienating the subcultural body modification. The meanings and experiences associated with the body modification are each different and individual, regardless of the incidental shared experiences of the body modification artist and subsequent display.

As a result, the subcultural body exists as a form of visual and material culture that exists as a consumable object, playing a key role in the negotiation and construction of identities. The mainstream and subcultural social and cultural environments contribute to the interpretation of the subcultural body, often extending beyond aesthetic expressions, and play an uncompromising role in identity negotiation. Body modifications, for example, have a certain permanency that may originally secure or maintain the subcultural identity. In time, however, these modifications lack the malleability necessary for the construction or negotiation of differing identities. This is particularly difficult in situations where the subculture changes, causing the body modification that once indicated affiliation to lose its reference point.

The subcultural body is continually evolving and changing due to several internal and external inputs. First, body modification practices change according to

contemporary developments in technology or a rejection of contemporary technology for ancient body modification methods. Second, as the mainstream culture adopts certain body modifications, there is a tendency on the part of the subculture to seek more "extreme" body practices. Third, personal urges, desires, and searches lead to the development of unique practices for individual members of the subculture. Consequently, the commodified subcultural body is an anachronistic fallacy, albeit highly marketable and profitable.

## Fetishized Deviance

Once the body is identified as subcultural, it becomes a representation of deviance from mainstream cultural and social norms. The subcultural body creates tension within mainstream society because it represents an alternative to the normative body and is even fetishized. Within its fetishization, the subcultural body could expect rejection, but instead the subcultural body is often sought after by both the mainstream and subculture members as a commodified identity, as seen in films, commercials, and music videos. In this way, the subcultural body is alienated from its origins, resources, productions, and meanings, and is best understood as a "commodity fetish" (see Marx 1867/1999). Within the Urban Tribal movement, commodity fetishes are common occurrences. For example, a Modern Primitive subculture member with a Celtic trinity knotwork tattoo borrows the symbol from its original culture and gives it a new meaning on her skin within the context of her subculture and Western culture.

The subcultural body is frequently the visible manifestation or symbol of *deviance* from the norm that is fetishized both inside and outside the subculture (see Lacan and Granoff 1956). In Western society, excessive tattoos, for example, are associated with deviant groups and fetishized as styles presented on the skin of the Other. Some subculture members acquire full-body tattoos, extending from the wrists to the ankles to the collarbone. The full-body body tattoo allows the tattooed body to be covered or disguised with a Western business suit or long-sleeved shirt and pants. The ability to disguise or conceal body modifications is part of the reason for the full-body tattoo's growing popularity among the mainstream consumer. Accordingly, subcultural body modifications are further alienated and fetishized from their origins.

The Punk subculture of the late 1970s and early 1980s was the visual personification of fetishized deviance. Members of the Punk subculture were connected closely to the Punk music scene and its dystopian sentiments (McLaren 1990). Members of the Punk subculture promoted the DIY aesthetic and bricolage with their dress (i.e., ripped jeans repaired with safety pins), rather than purchasing their subcultural identity (Hebdige 1979). While Punks were known for displaying DIY body modifications, such as a safety pin through the cheek, often causing the viewer to cringe with

empathetic pain, the Punks were able to purchase Punk clothing and accessories at select subcultural retail stores (McLaren 1990).

Neo-Punks are a contemporary version of the Punks, and their appearance varies greatly depending on resources and geography, but often features body modifications, such as septum piercings, stretched earlobes, and numerous tattoos (Wojcik 1995). The Neo-Punk subculture does not have the same visual impact as the original Punk subculture, perhaps due in part to the desensitized mainstream public who are familiar with the original Punks, as well as the changing and more subdued Punk aesthetic. Also affecting the visual impact of the Neo-Punk subculture is the fact that the Punk aesthetic and dress can be purchased in local malls at retail stores such as Hot Topic.

## Disguise

While there are times the subcultural body is available for public display and open to a variety of interpretations, other times the subcultural body is reserved for intimate viewing and serves as a private narrative. Thus, there are times when the subcultural body is disguised. In fact, the subcultural body itself may serve as a disguise.

**Image 10**  A single body modification (and its display or disguise) on the subcultural body, for example, has multiple layers of visual or nonverbal communication. Jay's most intimate and personal tattoos are easily disguised under long pants or her military-style boots. (Photo: T. Winge, unpublished research image, 2008)

Hebdige's concept of subcultural noise also relates to the ways subculture members disguise or hide behind or inside their chosen dress and body style. While the outside observer is distracted by the subcultural body styles, the individual beneath is left unnoticed, invisible, and protected.

Several of my research participants shared how their body modifications were placed on areas of the body less likely to be viewed by the public when wearing common garments or work clothes. These individuals conceal the indicators of the subcultural body because their body modifications are not acceptable at their place of employment, while others disguise their bodies because the body modifications represent highly personal information. Several Modern Primitive subculture members who spoke with me admitted that their first body modifications were in discreet areas of the body, in case the reactions from family, friends, and coworkers were disapproving or even volatile (T. Winge, unpublished research fieldnotes, 2003, 2008).

## Social Body

Subcultural body style may be mistaken for an antisocial body, but it is frequently the contrary. The subcultural body is relegated to the margins by its visual defiance of social and cultural codes. The margins, however, are continually in flux and highly reactive to the mainstream social world. The subcultural body's social world is complex in its belonging in both subculture and mainstream culture, as well as the visual narration. The subcultural body interacts with its subculture members, and even finds ways to engage the mainstream observers with the subcultural social body.

Anthropologist Mary Douglas in *Natural Symbols* (1973), intrigued by the social body, introduced the idea of the "two bodies": physical and social (see also Douglas 1984). Douglas argues that the body is constrained by cultural and social guidelines, negotiating between the physical body and the social body (Douglas 1973, 93). While in the social world, the body is managed and maintained according to social and cultural guidelines or rules or it suffers ridicule. As a result, the individual's identity forms within these social and culture contexts and boundaries, and moreover the individual learns to display and perform these identities at appropriate occasions and environments. The display and performance of the subcultural body style are significant to the ways the body is managed and maintained, revealed in this study as themes of belonging and narration.

### Belonging

A sense of belonging is created when individuals who have common objectives and/ or commonalities are able to establish connections with each other. Subculture members share commonalities related to their body modification experiences, such as

researching a design, choosing a suitable practitioner, and having outsiders reacting to a body modification. As a result, the subculture creates a symbolic and actual space for belonging, which individuals can join by constructing the desired subcultural body.

Historically, body modifications indicated group affiliation and social status (Storm 1987). This is also the case for Urban Tribal subcultures, although there is rarely a single designated body modification required for all members of a specific subculture. In fact, the subcultural body is difficult to categorize or assign to one subcultural group based on specific body modifications. Neither the individual nor even the group defines the subcultural identity; instead the subcultural identity relies on understood visual cues that result in recognition, interpretation, and reinforcement.

For the remainder of this chapter, I draw on examples from interviews I conducted with Urban Tribal subculture members to illustrate and inform themes critical in understanding the subcultural body style. Participants in this study self-selected pseudonyms as identifiers or monikers (instead of using their actual names). I also include images of these subculture members' body styles.

Blackie,[4] a subculture member whom I interviewed, humorously commented on his thoughts about a body modification indicating group affiliation:

*Having a tattoo is like sewing platform shoes to your feet. . . . You have to really want platforms for the rest of your life. I need to find some tribe that I can relate to or feel akin to . . . my tattoo will symbolically align with that tribe. But I am not going to get TAZ* [the Warner Brothers' Tazmanian Devil cartoon character] *on my left bicep! What tribe is that a symbol for? Looney Tunes tribe?!* (Winge 2004a; T. Winge, unpublished interview transcripts, 2003)

Since acceptance and approval are essential to feeling a sense of belonging, subculture members also do not belong (or fit in) to the mainstream culture in which they live and work. Subculture members often feel misunderstood by, alienated from, and treated with suspicion by people within a general community due to lifestyle differences communicated through their body modifications. Jester, a Christian youth minister, shared a story about a time when a woman scolded him about his subcultural body style: "*It is blasphemous and a degradation in the face of God, because you have desecrated his temple* [the body]" (T. Winge, unpublished interview transcripts, 2003). While his response was clever (Jester's response: "*The only difference between your temple and my temple is that mine has stained glass*"), the situation demonstrates how subculture members contend with being judged as not belonging to mainstream or even another subculture, as suggested here, because of their body modifications (T. Winge, unpublished interview transcripts, 2003).

Some of the subculture members I spoke with had acquired body modifications that represent connections to an individual's heritage, frequently based on romantic

notions of an ancient culture. Subsequently, these individuals are unable to truly belong to a culture that no longer exists, despite having that culture as a part of their ancestry. Babycakes discussed how her Irish ancestry was the inspiration for the Celtic cross tattoo on her calf (T. Winge, unpublished interview transcripts, 2003). Although she lives in an apartment and works in an urban corporate office in a highly populated metropolitan city in North America, the Celtic cross tattoo (see Image 13, p. 70) visually communicates to outsiders Babycakes's deep affection for, and heritage with, the Celtic culture. This tattoo also visually signifies to those who know her well the importance of Babycakes's ancestral culture.

Many subculture members have body modifications that visually suggest a connection to the culture of the Other, which gives them a sense of belonging to an ancient culture, or "the past" and a "simpler way of life." Correspondingly, James Saunders states:

> *As far as what it* [tattoo] *represents, I am not certain, maybe the simplicity in design harkens me to wanting to live in a simpler time. It could likely be a representation of my disgust with individuality in our society. There's hardly enough of it. All these Nike*

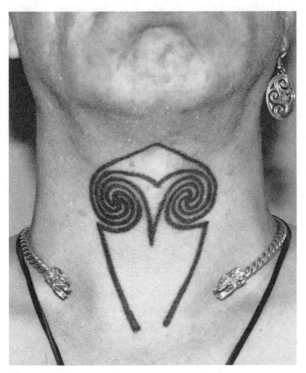

**Image 11**  Thomas Potter has an ancient Pict-inspired protection tattoo on his throat, which reflects his appreciation for historic body modifications and his personal heritage. (Photo: T. Winge, unpublished research image, 2003)

*swooshes, Calvin Klein jeans, Coca Cola, a myriad of corporate whatever, is very dis-heartening and meaningless.* (T. Winge, unpublished interview transcripts, 2003)

Furthermore, Thomas Potter comments:

*I saw the design in a book outlining Celtic art decorations, and I felt a kinship to the symbol. I altered it a little to fit my neck. Later I found out the design came straight from a Pictish piece of jewelry, so I was proud to make that connection with people long since gone. . . . Part of the lure of getting an ancient design for a tattoo is to make a conscious leap to connect with history. I have always been fascinated by things in the past, and this was one way I had to connect with those ideals.* (T. Winge, unpublished interview transcripts, 2003)

Still, subculture members who modify their bodies to represent an ancient culture do not truly belong to these Other cultures (Winge 2003). The experiences of belonging or not belonging seemed to indicate that the subculture members lacked a true sense of belonging within mainstream culture (or even the subculture, at times). As a result, the Urban Tribal subculture member has a fragmented group identity, impacting his or her personal identity as well, which is often symptomatic of the surrounding postmodern culture.

## Narration

Subcultural body style as a narrative directly relates to the idea that body modifications are a form of nonverbal communication (Eicher 2000). Subcultural body modifications communicate multiple nonverbal messages or narratives. The tattoo, for example, is a narrative for the experience of actually being inked, as well as being a narrative for the meaning behind the tattoo. Blackie claims:

*They* [body modifications] *say who I am, what I like, where I have been . . . it is my history and my future.* (T. Winge, unpublished interview transcripts, 2003)

Thomas Potter states:

*My tattoos are an attempt to portray the spiritual in a language that other people can see and understand.* (T. Winge, unpublished interview transcripts, 2003)

Potter also affirms:

*People ask me if it hurt getting the tattoo, and usually I am thinking they really have no clue, so I tell them it hurt. I never tell them about how rewarding I think it is, and that it is a part of me that reflects an experience of spirituality I have had in my life.* (T. Winge, unpublished interview transcripts, 2003)

In "The Body Sacrificial," Eric Gans states, "[T]he body becomes a living record of one's personal history" (2000, 163). Subculture members share this idea and express how the body is a narrative or record of their lived experiences. Some subculture members literally have narratives inked on their bodies.

On one of Violet's forearms is tattooed the phrase *vita brevis* and on the other forearm is *ars longa*—"Life is short," and "art endures"—which is a Latin translation of a famous quotation by the Greek physician Hippocrates (T. Winge, unpublished interview transcripts, 2003; T. Winge, unpublished research fieldnotes, 2004). Violet, a ceramics artist, remarked that the tattooed narrative reflects her personal ideology as an artist (T. Winge, unpublished interview transcripts, 2003; T. Winge, unpublished research fieldnotes, 2004). What is most notable about these tattoos is their orientation on the insides of Violet's forearms, positioned so that she can read them while throwing clay on a wheel. This set of tattoos is not meant to be a narrative for others/outsiders, as much as it is meant to be a narrative for the artist/wearer.

Many subcultural body modifications are representations of significant accomplishments. At times, the accomplishment is nothing more than the body modification experience, and still other body modifications indicate the birth of a child, or membership to a subcultural group. Babycakes has a mandala tattoo that represents her starting a new phase in her life. Thomas Potter has multiple Celtic knotwork and spiral tattoos, symbolic of commitment to his family and commemorating his marriage. James Saunders's piercings were the result of finding a new sense of self and a place in the world.

In addition, body modifications act as narratives for the pain experienced during the process of acquiring them. Sometimes, outsiders can recognize the narrative of pain present in the subculture member's body modification. Jester shares:

*People often categorize me until they get to know me . . . I have heard everything from "white trash" to "satanic." There are some benefits to the negative characterizations and generalizations though. Sometimes people assume that if you have all of these tattoos you must be tough . . . after all; you sat through all that pain. When I am far more likely to give someone a hug than to hit them* [laughs]. (T. Winge, unpublished interview transcripts, 2003)

James Saunders suggests how subcultural body modifications may be expressive of internal dialogue and narration:

*I did this act for me. I think about it and say, I maimed my own body. I did something to it to make it stand out physically, but I think I really wanted to do something to my mind and make it stand out. Well, what's on the inside is not necessarily on the outside, but it can be a direct reflection of what goes on in the inside.* (T. Winge, unpublished interview transcripts, 2003)

Similarly, Blackie, Thomas Potter, and Christina told me that people regularly ask if their body modifications hurt. Their responses were all the same: "*Yes, it did!*" (T. Winge, unpublished interview transcripts, 2003).

These subcultural members' similar answers are definitive, that indeed body modifications hurt, but their responses also discourage individuals who are seeking the latest fashion statement by acquiring similar body modifications. Still, there is a negative aspect to the subcultural body as being perceived as tough or being able to endure significant amounts of pain. Jester admits he did not anticipate the negative impact the tattoos would have on his life at the church as a youth minister, and modified his dress accordingly. Individuals inside and outside the subculture interpret the visual messages inherent in body modifications in different ways. These interpretations are time-sensitive; that is, as fashions change, body modifications once taboo may become fashionable or at least are interpreted as something other than ominous or frightening.

These examples suggest that the subcultural body style communicates visual and even empathetic cues about the pain experienced during the process of acquiring the modification. Moreover, an observer may also feel empathetic pain for the subcultural body modification. In some cases, this empathetic pain functions as buffer, creating a tangible space between the subculture member and the mainstream. Blackie comments:

*I like the distance it* [body style—black clothes, facial piercings, dreadlock hair, spiky jewelry] *creates. It keeps 'em away from me. They know better than to get too close or they'll get poked* [laugh]. (T. Winge, unpublished interview transcripts, 2003)

Body modifications often represent an autobiographical experience and individual identity. Body modifications similar to other intimate forms of visual culture assist subculture members in constructing, negotiating, and establishing identity. Moreover, subculture members use body modifications as visual expression of their subcultural and individual identities. Still, subculture members are not completely able to influence the accurate interpretation of their subcultural body style. Subcultural body modifications are frequently acquired in order to socially and culturally, as well as visually, assimilate into a chosen subcultural group or community.

The permanency of some subcultural body modifications decreases the flexibility in appearance and solidifies subcultural membership. Many subculture members seek out negative reactions as a source of validation and empowered resistance. Active resistance becomes the key to negotiating the subcultural identity. While the negative reactions (from nonmember viewers) to the subcultural body style may be desired within the subculture, it may be less desirable if from an individual within the subculture.

## Social and Cultural Context

Meanings associated with subcultural body modifications depend on the point of reference and the structures within the subcultural or mainstream social and cultural context. Subculture members construct identities from the resulting meanings based on the complex interchanges and the visual narrations between varying social groups. Furthermore, these identities rely on individual expressions and

interpretations of the visual symbols nonverbally communicated by the s
body style. As a result, the subcultural body is visually and symbolically interpre
according to its context, time, and cultural signs and symbols.

Interpretation and subsequent identification of the subcultural body is highly
dependent on the cultural and social contexts. In various surrounding cultural and
social contexts, there may be altered interpretations of the subcultural body. As a re-
sult, the subculture member frequently and defensively negotiates his or her identity
when the interpretations and reactions are negative. Negative reactions from outside
the subculture are easier to deal with than negative reactions from within the subcul-
tural group, where the expected response is positive reinforcement.

The identity of the subculture member results from the social interactions within
the subcultural group and the understood observations from outsiders; both interac-
tions imply the viewer has context for reading the signs and symbols of the sub-
cultural body. Accordingly, the subculture member does not have complete control
over the interpretation of her or his body style and subsequently her or his identity.
This explains, to some degree, the confusion between similarly dressed subculture
members' identities and subsequent activities, as well as broad generalizations about
individuals who do not dress according to the norms of Western culture. This confu-
sion tends to happen in two ways. First, similarly dressed subculture members are
mistaken for one another or misidentified by outsiders. Modern Primitives, Goths,
and Punks, for example, tend to dress in dark colors and have numerous tattoos and
piercings. Close examination of the tattoo motifs and designs, as well as the quality
of tattooing skill, often reveals specific subcultural affiliation. Second, since some
subcultures occupy the same spaces, such as dance clubs or coffee houses, other sub-
cultures are immediately accessible. In this way, members from individual subcul-
tures move fluidly between groups, resulting in shared influences and characteristics
that manifest in dress or body style choices.

Social context and interactions construct the subcultural situated identity, which
involves the individual seeking social support from one group even if it means rejec-
tion from another. Still, interpretations and meanings associated with assigning and
constructing identities vary according to the unpredictable and unstructured nature
of most social contexts and related interactions. A supportive social reaction to the
subcultural body reinforces the subcultural identity; a negative social reaction results
in the individual defending or negotiating her or his identity in order to acquire the
needed support (Stone 1962). Another consideration is how mainstream rejection
may support membership and identity within the subculture.

## Primal Body

The subcultural body may be associated with a primal identity because of the way
it is dressed, modified, or displayed. Fakir Musafar indicates that beyond the visual
identification, all human beings have the desire or need to modify the body, which

originates from a "primal urge" (Musafar 1996; Vale and Juno 1989). Musafar further suggests that there is a connection between subcultural body style and the primal awakenings in some individuals who respond to these urges by modifying their bodies.

Christina provides an example of primal urge when she shares her childhood desire to have wings (T. Winge, unpublished interview transcripts, 2003). As an adult, Christina acted on this wish by having wing designs continually cut into her back. Eventually, Christina had the wings branded on her back. Crow also comments about her desire to have wings, only her wings resembled dragon wings (T. Winge, unpublished interview transcripts, 2003). Crow's impetus took form as a dragon tattoo between her shoulder blades. Jay expresses a desire to fly, and had feathered angel wings tattooed on her back (T. Winge, unpublished research fieldnotes, 2008).

Thomas Potter's desire for his tattoos was "*the result of something* [spiritual] *that has transpired*" (T. Winge, unpublished interview transcripts, 2003); he also describes this desire as a "lure" and "kinship" with the chosen tattoo designs. James Saunders states how self-piercing his nipple was an expression of his "*innate desire*" to change his physical being (T. Winge, unpublished interview transcripts,

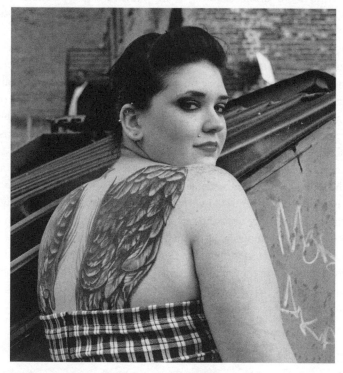

**Image 12**   Wings are a common motif for Urban Tribal tattoos and brands, often representing a desire to fly or be free (Winge 2004a). Jay's "angel" wings are multicolored tattoos covering more than half of her back. (Photo: T. Winge, unpublished research image, 2008)

2003). Similarly, Samerena shares how she felt an internal urge to modify her body (T. Winge, unpublished interview transcripts, 2003).

Violet expresses her desire to modify her body as:

*I hadn't had a tattoo yet and I just knew that it was time to get them. Something inside of me . . . it is hard to explain . . . but I had to do it.* (T. Winge, unpublished interview transcripts, 2003)

Similarly, Blackie expresses his desire to get pierced as:

*I had to . . . it is hard to explain but something inside of me was ripping to get out . . . to be heard.* (T. Winge, unpublished interview transcripts, 2003)

Correspondingly, Babycakes communicates that her body modification desire reflects a visual expression of an *"energy"* (T. Winge, unpublished interview transcripts, 2003). Babycakes comments:

*I believe that the energy of a tattoo lives in your skin and when it is ready to come out it is when I go to the tattoo shop and reveal it.* (T. Winge, unpublished interview transcripts, 2003)

Perhaps the desire or urge to modify their bodies was best expressed when Jester was asked why he gets his tattoos. Jester claims in his interview:

*I am not really sure why. It was like an itch that had to be scratched. I just felt it deep inside and had to get another tattoo. The feeling that this is all very intentional . . . that there is not anyone else who looks exactly like me . . . this is me and my desire to do this.* (T. Winge, unpublished interview transcripts, 2003)

The Urban Tribal subcultural member responds to urges and/or desires to modify his or her body. Exactly where these urges and/or desires originate from is often unclear, even to the subculture members themselves. Still, the subcultural member acts on these urges/desires, and the result is unique body modifications that frequently having connections to the Other, which takes shape as kinship with or exoticizing the Other.

## The Other

Some subculture members are seeking to attain and better understand aspects of the Other via their body modifications. Modern Primitives, for example, often choose body modification designs that mimic or resemble Other cultures' body modifications, such as Maori-inspired facial tattoos and Tlingit-inspired labret piercings.

Some Modern Primitives also utilize ancient or primitive technologies, such as sharpened sticks and soot-based inks, similar to those of Other cultures, to create their body modifications. The use of the Other's technology and body modifications indicate identification with and seeking aspects of the Other. For example, Thomas Potter asserts he most closely identifies with the ancient Celts and Picts. Regarding his Celtic knotwork tattoos, Potter states:

> *I really do dislike pain, but getting a tattoo is a spiritual experience for me, and the pain really helped in affirming that this process is not of the ordinary world. It is a connection to another culture, another place.* (T. Winge, unpublished interview transcripts, 2003)

Another example is how Blackie is seeking the Other with his choice for a tattoo. Blackie claims:

> [I want a] *fully traditional tribal tattoo . . . the marks that you get on your way to manhood. A lot of the tribes of the Pacific practiced traditional tattooing. The stuff that mimics that is not traditional, cause they changed it somehow. I want the real thing. I want to be able to tell people that I endured the pain of a traditional tattoo. I want reactions to be based on something real, too. I want what those tribes in the Pacific had!* (T. Winge, unpublished interview transcripts, 2003)

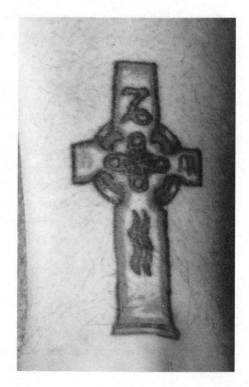

**Image 13** Subcultural tattoos are sometimes inspired by or directly borrowed from Other cultures in an attempt to gain some qualities from the idealized and romanticized culture. Babycakes's tattoo of a Celtic cross on her calf represents her connection to her cultural heritage. (Photo: T. Winge, unpublished research image, 2003)

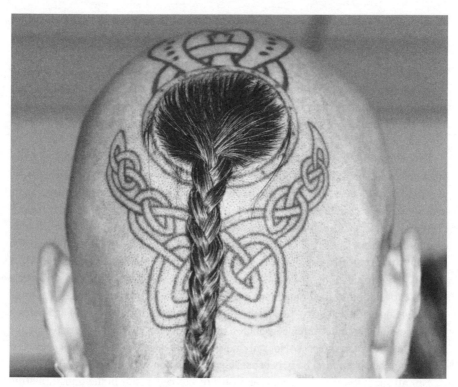

**Image 14**  Thomas Potter has several tattoos on his scalp, including Celtic knots around his Native American scalplock and Celtic spirals under his scalplock; he also wears a Viking braid on the top of his scalp. All of his tattoos represent his cultural heritage (Winge 2004a). (Photo: T. Winge, unpublished research image, 2003)

It is doubtful that anyone is able to attain actual knowledge of the Other by participating in similar body modification practices because the body modification does not occur in the same sociocultural context. In *Discipline and Punish*, Michel Foucault (1979, 27–28) presented pain and knowledge as intertwined, which is useful when exploring the role of pain in the Modern Primitive subcultural body modification experience. Modern Primitive subculture members seek to gain the cultural and spiritual knowledge available from the endured pain associated with the body modification process. In an attempt to attain the knowledge of the Other, Urban Tribal subculture members, especially Modern Primitives, use body modifications inspired by the Other.

## Ritualized Body

Cultures of all kinds have rituals regarding body styles, not usually defined as such due to the informal and nonverbal ways in which the ritual is communicated to its

members. Subcultures also have rituals regarding their body styles, some of which are more clearly recognized as rituals than others. These rituals usually focus on the subculture member's desired appearance. Urban Tribal subcultures rely heavily on body modifications to achieve the desired subcultural appearance. Modern Primitive subculture members, for example, secure body modifications in a ritualized manner and, upon completion, the person transforms into the embodiment of the subcultural body. Unfortunately, limited information is available about subcultural rituals regarding appearance and style.

Subcultural body style takes shape within its subvertly and overtly ritualized body practices and experiences. Sir Edmund Leach and later Victor Turner defined "ritual" as a predetermined set of behaviors that relate to cultural customs of the participants and serve "to communicate information about a culture's most cherished values" (Turner 1982, 79). A ritual is a set of actions with symbolic significance, which may or may not be part of a rite of passage. Arnold van Gennep (1982) established the structure of a rite of passage as having three steps: pre-liminal phase (separation), a liminal phase (transition), and a post-liminal phase (reincorporation). Victor Turner's (1969) explanation of the liminal phase, as a "betwixt and between" space where the individual does not belong to the society she or he was previously a part of and has not yet successfully completed reincorporation into that society, is useful in discussing the subcultural body experiences. Not only do many subcultures exist in these between spaces, but the subcultural body is in constant negotiation with these liminal spaces.

Not all subcultural bodily rituals and rites of passage result in the transformation of the body. Skaters (i.e., Skateboarders), for example, experience a bodily ritual and rite of passage when they ride their first board or attempt their first half-pipe. This bodily experience is a sensation of being in their subcultural body, and the acquisition of this knowledge does not necessary leave a lasting mark on the flesh of the body, but is instead mentally recalled every time the body is propelled through space on a skateboard. And perhaps one of the most often unexpected rites of passage is that of the bodily injury, which usually results in a permanent body modification. The Skaters, a subculture in the Urban Tribal movement, whom I spoke with were proud of their scars (i.e., body modifications) from skateboarding mishaps, and some even showed me places on their bodies while sharing the related story where the scar had faded (T. Winge, unpublished interview transcripts, 2003).

Rituals and rites of passage are significant milestones for subculture members and often include body experiences. Designated rituals are associated with a specific body modification process, including piercing, tattooing, and branding processes. Blackie gave a description of a contemporary piercing ritual (process) that ranged from his anticipation while waiting for the appointment to filling out the required paperwork and getting pierced. Babycakes allowed me to visually document the ritual she experienced with the acquisition of her mandala tattoo.

Urban Tribal subculture members are reluctant to use the term "ritual" when referring to the subcultural body practices. Anne, a tattoo practitioner and artist

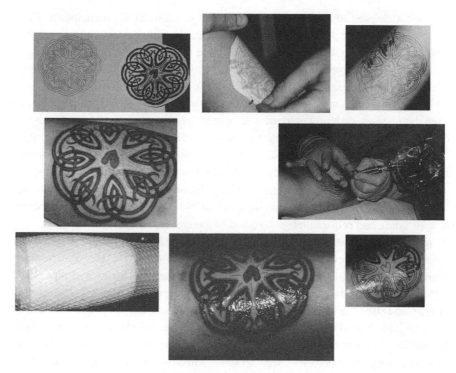

**Image 15** The tattoo process becomes a significant ritual for the subculture member, from selecting the design to enduring the pain of the tattoo to displaying the tattoo for others to see. These images (clockwise; beginning at the top left) represent the tattoo process: creation of design; transfer of the design onto the skin; inking the outline of the design; coloring the design; adding additional colors; completed tattoo cleaned and treated with medication to ensure proper healing; tattoo bandaged; and tattoo several hours after inked. (Photo: T. Winge, unpublished research image, 2003)

from North America who has many subcultural clients, however, views the body modification process as a ritual (Winge 2003c). Those who write about subcultural body modifications also recognize the ritual aspects of these body modification experiences. Charles Gatewood (2002, 42) compares Modern Primitive body modifications to "ritual wounding," and Musafar (1996, 328–29) discusses how body modification practices are also rituals and rites of passage absent from much of Western culture.

## Sun Dance

The Sun Dance is an example of a Native American hook hanging ritual. Originally, this ritual was an eight-day spiritual event practiced by North American Plains aboriginals (Beck, Francisco, and Walters 1995). The Sun Dance began with the participants fasting and dancing for three days and nights. On the fourth day, pieces

of wood were pierced into the flesh of the backs or chests of the participants. These pieces of wood were then connected to leather straps and tied to a sacred pole. The leather straps were pulled until the dancers were lifted off the ground and forced to gaze into the sun; this portion of the ritual was called "Gazing at the Sun"—the focus of the ritual (Beck, Francisco, and Walters 1995).

While tied to the sacred pole, participants attempted to rip free the pieces of wood from their bodies, enduring extreme pain in order to have a vision (spiritual transcendence) (Mails 1995). It often took days before dancers ripped free from the piercings. During the ritual, participants would seek to have visions that might aid the community. The remaining scars (i.e., body modifications) were evidence of the suffering and subsequent transcendence experienced during the Sun Dance (Beck, Francisco, and Walters 1995). The Sun Dance was outlawed in 1910 because the ritual was viewed as self-torture and self-mutilation by the U.S. government (Francis 1996, 266).

In 1983 Fakir Musafar and Jim Ward were the first Modern Primitive subculture members to participate in the Sun Dance (Vale and Juno 1989, 34–35). Musafar's knowledge of the ritual came from the North American Indians he met on a South Dakota reservation and from the George Catlin book *O-Kee-Pa: A Religious Ceremony; and Other Customs of the Mandans* (1867). The Modern Primitive version of this ritual was filmed in the *Dances Sacred and Profane* (1985) documentary. Musafar and Ward went to Devil's Tower in Wyoming, a place Musafar considered to have powerful energies, to perform the Sun Dance. Musafar and Ward pierced their flesh and tied themselves to a tree; about four hours later they ripped free (Vale and Juno 1989, 35). Musafar comments that this ritual was "truly transformative" (1996, 328).

The Modern Primitive Sun Dance ritual highlights how a culturally specific and tribal body modification practice was reinvented in a modern and unique way. Originally, the Sun Dance was performed as a sacrifice ritual for warriors captured by enemies, and also to induce personal visions for the betterment of the community at large. In Modern Primitives' versions of the ritual, participants focus on themselves and their personal spiritual needs.

Still, many Urban Tribal subculture members indicate that they have a framework for their body modification experiences that suggests a ritual process. Thomas Potter, for example, shares the routine he goes through before being inked with a tattoo. Potter takes a shower in the morning and shaves the area to be tattooed, he finds a spiritual place in his head to resonate throughout his being, he requests specific Celtic music to be played during his tattoo session, and he is vocally silent and "in the moment" while being tattooed (T. Winge, unpublished interview transcripts, 2003).

A key factor of the subcultural body ritual is trust. This factor is most likely key to many types of rituals throughout history, but is glossed over, if addressed at all, in anthropological or ethnographic texts. First, there is the trust of oneself, specifically in knowing and understanding one's own body. For example, Blackie states: "*I know my body; I know how much pain I can stand*" (T. Winge, unpublished interview transcripts, 2003).

Second, there is the trust that a person has in his or her body modification practitioner, such as the tattoo artist, piercer, or brander. Christina comments about her

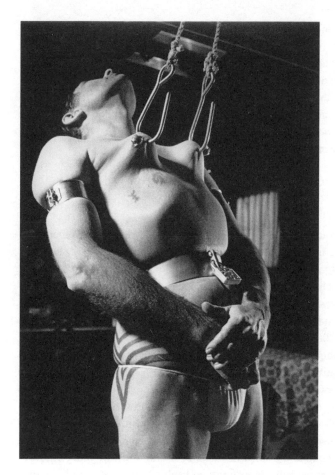

**Image 16** Fakir Musafar taking part in a Modern Primitive version of the Sun Dance. Musafar hangs from hooks inserted into his chest piercings while also having constrictions around his biceps and waist. (Photo: *Sun Dance,* Fakir Musafar)

trust in her practitioner by discussing the peaceful feelings she had while getting the extensive brand on her back:

> *Much of what I mean is that I was relaxed; the room was warm, the artist was pleasant and respectful, and I had solved a problem of how to preserve a piece of body art of which I was very fond, which had seemed in danger of disappearing.* (T. Winge, unpublished interview transcripts, 2003)

Christina further emphasizes her trust in body modification practitioners by stating:

> *A surprising proportion of my piercers and tattooists in recent years have been straight-edge[5] and I admit that there's a certain comfort in knowing the person working on you is not chemically altered—though this isn't really something about which I'd ever been nervous.* (T. Winge, unpublished interview transcripts, 2003)

Trust in the practitioner is further evident in the fact that there is no malpractice insurance for the practitioners, who do not work with trained doctors, nurses, or EMTs

(emergency medical technicians). Urban Tribal subculture members frequently seek a practitioner they trust, often getting referrals from friends. Thomas Potter states how he found a tattoo artist whom he could trust through friends who had well-done and expressive tattoos in a style he appreciated performed by this person. Potter further stresses his trust in this particular practitioner by stating how during the tattoo process on his throat when the pain was very intense and he thought of stopping, he did not, because *"the tattooist was very reassuring, and I trusted her skill"* (T. Winge, unpublished interview transcripts, 2003).

## Spiritual Body

The subculture body frequently exists as a spiritual body; moreover, the subcultural body is evidence of the individual subculture member's journey to find, become, and meld with the spiritual. The history of the spiritual subcultural body is lacking documentation in both scholarly and popular media.

The publication *Modern Primitives* (Vale and Juno 1989) lacks a significant discussion of the spiritual side of the subculture, which led V. Vale and John Sulak to write *Modern Pagans* (2002). This book addresses the spiritual view of the Modern Primitive subculture using interviews with subculture members who directly address their search for spirituality. Musafar and Mark Thompson attempt to address the role that the spirit plays in the Modern Primitives' body modification experiences in *Fakir Musafar: Flesh + Spirit* (2002). Musafar and Thompson explore the flesh-spirit connection through visual evidence of the Modern Primitives' body modification experiences. Maureen Mercury (2000) also makes a connection between the flesh and body as they relate to the spirit of the subcultural body. Mercury explores the spiritual dimensions of the subculture body and subcultural use of body modifications through interviews and ethnographic research.

In *The Urban Primitive: Paganism in the Concrete Jungle* Raven Kaldera and Tannin Schwarzstein (2002) suggest that the Modern Primitive (or Urban Primitive) subculture is Pagan in nature with both ancient and spiritual overtones. As evidence, the authors discuss this group's subcultural body modifications as spiritual protections. Jesse Singleton (1997) also discusses a spiritual connection to Modern Primitive body modifications in his online article "Piercing and the Modern Primitive." Singleton states how piercing provides a means for personal and spiritual expression and exploration within a subculture, such as for Modern Primitive subculture members.

Many of the subcultural body modification experiences have direct connection to transcendence and spiritual pursuits for the subcultures' members. The Modern Primitives' body modification rituals and subsequent pain, for example, give members reason to believe they are able to attain transcendence and define their own spirit (Mercury 2000; Musafar 1996; Vale and Juno 1989). This spiritual transcendence is often attributed to the associated pain of the body modification experience.

Attaining spiritual fulfillment or transcendence is a complicated endeavor in mainstream culture, where science and media are dominant. Some Urban Tribal subcultures, however, found ways of being spiritual along a unique path. Many of the subcultures within the Urban Tribal movement recognize music as spiritual, and dance as prayer. This is not a new perspective considering the dancing of the Whirling Dervishes from Turkey or Pow Wow dancing of the North American Indians. Similar to members of other such cultures who observe music and dance within spiritual events, Urban Tribal subculture members utilize their bodies as instruments of the spiritual through dance. Industrial music nightclubs, for example, have a regular congregation of dancers (worshipers) who fill the dance floor and move rhythmically to the beats of the music and the spirit (Vale and Juno 1983; Winge 2001, 2004a).

Urban Tribal subculture members such as Modern Primitives continuously remain involved in the process of seeking the spiritual in order to enrich and improve their lives. Musafar explains that Modern Primitives are seeking transcendence (spiritual), healing (from physical and/or emotional ailments), magick and protection (from evil spirits), and connection to the "primitive Other" (1996, 328–29). Musafar also discussed his own body modification experiences as seeking the duality of pain and pleasure (Vale and Juno 1989). In addition, Gatewood agrees with Musafar that Modern Primitives are seeking magick to ward off unwanted energies and reach transcendence with their body modification practices, which Musafar refers to as "sacred time" (Gatewood 2002, 24).

## Transcendence

Additional points of view about transcendence range from Descartes (1911/1967), who thought that transcendence is a purposeful and intentional act performed freely, to Simone de Beauvoir (1949/1972, 379), who considered transcendence a benefit only given to men, to Sartre (1956, 196–98), who conceived transcendence to be a source of freedom. Furthermore, Descartes and de Beauvoir assert that the human mind is the source of transcendence, while the body is simply the vehicle. And both Sartre and de Beauvoir relate transcendence to the experiences of the lived body (Appignanesi and Bennington 1989; Beauvoir 1949/1972; Descartes 1911/1967). These differing points of view construct the complex and contradicting positions of the mind and body regarding transcendence. Accordingly, Urban Tribal subculture members seeking transcendence through body modification practices attempt to resolve these complications.

The Modern Primitive subculture members believe that bodily pain is a primary method to achieve (spiritual) transcendence (Mercury 2000; Vale and Juno 1989; T. Winge, unpublished research fieldnotes, 2003). This subculture believes transcendence begins in the body with pain, which establishes the certainty of *being* (alive). With this belief, Modern Primitives then meditate and attempt to progress

through the associated pain, thus through the certainty of the body. Once past the intense sensation of pain, the Modern Primitive transcends to a realm of the collective unconscious, which Carl Jung called the "psychoid" (Jung 1972, 1977).[6] A psychoid realm is a space existing between physical and mental reality. In this temporary, even momentary, space, neither pain nor pleasure exist, and transcendence takes place.

Jung's theory on the psychoid suggests that this transcendence takes place in the mind, specifically the unconscious. The way in which pain is present in Modern Primitive body modification practices defies the Cartesian mind/body dualism; instead, these bodily practices indicate how physical pain is intertwined with mental and possibly spiritual components. Jung's theory lends validity to the claims of many Modern Primitives who compare the pain endured during body modification rituals to a sacred or spiritual transcendence (Mercury 2000; Musafar 1996).

Urban Tribal subculture members I interviewed discussed their body modifications as the modifications related to transcendence. Thomas Potter discusses a general transcendence that occurs with getting a tattoo:

> *Just that this experience of getting tattoos transcends the normal, day-to-day experience of life, and that it is difficult to put into words what I all felt and experienced.* (T. Winge, unpublished interview transcripts, 2003)

Babycakes also explains how she is seeking and expressed her spirit (and transcendence) with body modifications:

> *A body modification is a self-expression of one's own spirit and soul and sometimes is looked down upon those who either don't appreciate, don't understand, or who are afraid of it. I am proud to be a person, who is open-minded enough and who is not afraid to express my soul in the form of a "body mod." It is simply parts of our soul being expressed visually. Body mods are how I connect to my spirit.* (T. Winge, unpublished interview transcripts, 2003)

## Magick

Some subculture body modifications represent a belief in magick (the occult), which is directly related to (magickal) protection. Magick and protection are significant reasons for subcultural body modifications.

Crow states, for example, that she chose a dragon tattoo because she believes the dragon is a sign of protection and strength (T. Winge, unpublished interview transcripts, 2003). Similarly, Thomas Potter asserts:

> *My neck tattoo is a symbol of protection, as I value my voice, and want to communicate clearly and strongly.* (T. Winge, unpublished interview transcripts, 2003)

Jester also discusses how one of his tattoos could be misunderstood to mean something negative, but it actually has a positive meaning:

> *There is a cat with a dagger* [tattoo] *through its head on my leg. I could see someone finding offense with it, but it really has positive meanings behind it. First, it was a gift from my tattoo artist for my wedding. Second, it is an "old skool" symbol to ward off evil—to kill a black cat.* (T. Winge, unpublished interview transcripts, 2003)

Musafar offers insights into the use of body modifications as expressions and connections to magick:

> *Body rituals open the door to Spirit, rearrange energy circuits inside an individual, allow access to unseen worlds that coexist with the seen world and have profound influence over the physical world. For example: in many other cultures where the custom originated, tattoos are "magic" marks whose main purpose is not to decorate but to change the individual who bears them. Western Judeo-Christian culture borrowed the custom of the tattoo that is the making of marks that do not wash off, but neglected to borrow the purpose of the tattoo in island cultures: the magic.* (Fakir Musafar, personal communication with the author, 2011)

## Healing

Healing is primarily thought of as a physical and biological activity occurring after receiving a body modification. Christina discusses how the healing of her wing brands was quite painful, as the new skin resurfacing hurt her when she wore clothes or even when she slept; Thomas Potter was unsure that he would ever get another tattoo after his first one because of the extent of the pain and discomfort experienced during the physical healing process (T. Winge, unpublished interview transcripts, 2003).

There is, however, another type of healing that relates to spiritual, psychological, and emotional healing, which may be represented in the chosen body modification or associated ritual, or even occur during the body modification process. Charmed, for example, secured a tattoo on her bicep to commemorate the untimely death of her husband due to complications with a liver transplant; the tattoo symbolizes her husband's love of music (guitars) and her desire for him "*to be in heaven . . . out of pain*" (T. Winge, unpublished research fieldnotes, 2009).

Babycakes also shares an emotional healing experience connected to the one of her tattoos, which represented the loss of a loved one:

> *It is a goddess in the center of an upside-down Celtic triangle. It represents me—a phoenix coming out of the ashes. . . . My emotional state was all over the place because this tattoo represented more to me than a symbol on my body; it represents part of who I truly am.* (T. Winge, unpublished interview transcripts, 2003)

**Image 17** The commemorative tattoo is common among Urban Tribal subculture members. This tattoo represents a deceased husband, father, and guitarist and the hopes of his widow to heal from her loss of a loved one. (Photo: T. Winge, unpublished research image, 2009)

James Saunders shares another example of healing:

*Also a reason for wanting to do this* [tattoo and piercing] *was I sensed somewhat of a sadness, as I felt I was losing a sense of self. I had to prove to myself that I was still in control and that I was making my own personal decisions. Doing the piercing engaged me in my self-identity. The piercing was like an awakening of the self, myself. I was afraid of becoming something or someone that I couldn't see as myself. I believe this awakening was occurring as I was feeling the psychological effects of aging in my early thirties, and I was ready to make a personal statement. The way I see it, as a person grows older their ideals tend to evolve, they get wrapped up in their lives, they get lost in the fabric of living life on different terms or society's terms, in either case, not one's own terms. I didn't want to lose my life to that mundane humdrum existence that many people settle into as they grow older. I still don't.*

*The reason for the tattoo and the piercing was based upon the self-reflection of who I wanted to be versus what I felt I was becoming. I succeeded in making several marks on my body, and I supported it passionately with what was going on in my mind and in my life at the time. I am happy about these events in my life. I have no regrets whatsoever. They remind me every day that I am "me" and that "I am alive."* (T. Winge, unpublished interview transcripts, 2003)

**Image 18**  Babycakes's tattoo is symbolic of her surviving the death of her fiancé. Her tattoo, positioned low on her back for privacy, incorporates the couple's shared appreciation for the Celtic culture and female symbols. (Photo: T. Winge, unpublished research image, 2003)

Samerena spoke about seeking a spiritual connection and eventual healing related to her body modification experiences. For several years, Samerena suffered from mild depression and began to brand her forearm in an attempt to "feel something." Samerena states:

> *Well, I have been continuing to brand my arms over the last three years, less and less lately. I think I found what I was looking for . . . I was searching for some peace and I think I have found it. I feel whole with my brands, and they remind me how far I have come and where I want to be.* (T. Winge, unpublished interview transcripts, 2003)

Also, Samerena discusses how the scars on her arms were reminders of being in a *"dark place*," and how she found her way out to different possibilities and hope through her branding practices (T. Winge, unpublished interview transcripts, 2003). Today, Samerena shares her branding experiences with others as inspiration for their own healing.

Some subculture members seek spiritual fulfillment within their body modification experiences for possible transcendence, protection, and healing. These experiences contribute to the understanding of the phenomenological body and construct the Urban Tribal subcultural identity.

## Phenomenological or Lived Body

The identity of the subcultural body is embodied in knowing the phenomenological, or *lived*, body. Moreover, when considering the subcultural body as the phenomenological body, it is possible to discuss the body's role in intentionality, resistance, agency, and identity (Merleau-Ponty 1962, 1969), establishing a framework for understanding the marginalized place of the subcultural body. Phenomenologist Maurice Merleau-Ponty opposes the Cartesian's mind/body dualism, and embraces the ideas of the lived body. Merleau-Ponty (1962) recognizes that the body is intrinsically connected to the mind, and the body is neither a machine nor a mere object to be studied, but instead it embodies opportunities for bodily experiences. An interest in the perception of the experience and intentional consciousness is lived or experienced through the body (Merleau-Ponty 1962). Credited with introducing the concept of the "lived body," Merleau-Ponty (1962) postulates that the body is not just present but it is alive, it is being; the body is flesh aware of, part of, present in, and active in the world.

The phenomenological body is flexible and fluid, allowing for the continual development of new body images and identities (Winge 2003). The relevance of the phenomenological body is in its approach to understanding the lived subcultural body. Thomas Potter talks about the phenomenological bodily experience of seeking a connection to the past through his tattoos:

> *Part of the lure of getting an ancient design for a tattoo is to make a conscious leap to connect with history. I have always been fascinated by things in the past, and this* [tattoo] *was one way I had to connect with those ideals.* (T. Winge, unpublished interview transcripts, 2003)

Moreover, the identity conferred on the Urban Tribal subcultural body can be understood as the lived phenomenological body presented within the subcultural community and, alternatively, within media images.

## Sentient Body

The sentient body is explored fully within the Urban Tribal movement, from body modifications to dressing the body with clothing that confers and constructs subcultural meaning. These subcultural *sentient* bodies experience (and visually communicate) pain in the creation of the Urban Tribal subcultural body. Subsequently, the subcultural body and pain are difficult to separate due to their reciprocal and dependent relationship to each other. Some subculture members are actually seeking the pain/pleasure connection with their body modification experiences. Violet expresses how the more pain she tolerates while getting her tattoo, the more empowering the

experience is for her personally. Violet later discusses how there is an aspect of pleasure in pain during the process of getting a body modification (Winge 2004a; T. Winge, unpublished interview transcripts, 2003). Blackie also discusses how he enjoys the pain of getting a body modification:

*Pain is the reason you go through it . . . ya know? The result. . . . The piercing* [indicating his eyebrow] *is just a bonus. I mean I like the way it looks.* (T. Winge, unpublished interview transcripts, 2003)

Babycakes describes in detail how the pain is pleasurable for her while getting a tattoo:

*The adrenaline rushes are a wild ride, like a roller coaster. Sometimes I feel intense pain zeroing in on the spot and other times I feel numbness, joy, exhilaration, and emotional outbursts where I want to cry or scream but mostly laugh. It is almost like multiple orgasms but without the intense pain of course. It is a continuous cycle until the process of the tattoo is finished.* (T. Winge, unpublished interview transcripts, 2003)

Physical pain is broadly defined in Howard Fields's book *Pain* as "an unpleasant sensation that is perceived as a rising from a specific region of the body" (1987, 2). However, David Clark, MD (1999), a pain specialist, suggests that pain must be understood as something more complex than a simple biological sensation. Clark further argues that pain is located and experienced at the intersections of body, mind, and culture, leading him to recognize that significant connections exist between pain and meaning (1999, 727–28).

David Morris adds to Field and Clark's definitions of pain by stating that pain is an opportunity to gain meaning from the bodily experience. The use of ritualized pain is often an attempt to formulate symbolic meanings from the Other (Morris 1991, 39–40). Furthermore, Page DuBois's *Torture & Truth* (1991) discusses how pain and the search for its meaning has associations with the Other. Specifically, DuBois argues that torture is a method to find the truth through the Other's experiencing and connecting to pain. Roselyne Rey's book *The History of Pain* states "pain involves a codified form of social behavior which sets the parameters of allowable overt manifestations and regulate the expression of such innermost personal experiences" (Rey 1995, 4). Rey implies there is an understood narrative for the role pain plays in some body modification practices.

Urban Tribal subculture members attempt to use the pain associated with body modifications as a means to connect with the Other, hoping to find a truth missing from their culture. Modern Primitives, for example, gain an enormous amount of meaning from the pain endured during the ritual of acquiring body modifications. By braving and acknowledging their pain, subculture members attempt to equate themselves with a member of a tribal or the Other culture.

Urban Tribal subculture members spoke with me about the negative aspects of pain involved in getting a body modification. Certain individuals, however, had a positive perspective on the pain and its meaning. For example, Christina explains how her branding experience was painful and peaceful:

> *Still, the pain was never excruciating. I may have flinched once or twice, but felt no need to ask for a break or re-gather my forces. Afterwards, I was a bit light-headed, which is usually the case for me after any modification, but very pleased. Through the process I felt quite peaceful.* (T. Winge, unpublished interview transcripts, 2003)

Babycakes had a similar reaction to her body modifications:

> *To feel positive pain is to be emotional or physical, which includes intense positive sensations* [associated with body modifications]. (T. Winge, unpublished interview transcripts, 2003)

## Being in the Moment

The physical body is an essential component to the subcultural body modification practices. Moreover, the physical body must submit to the bodily experiences of the modification process. The pain the body experiences while receiving a body modification reinforces and establishes the certainty of the body being present and elucidates the temporal nature of the experience. Elaine Scarry states in *The Body in Pain: The Making and Unmaking of the World*, "To have pain is to have certainty" (1985, 13).

Clarifying the relationship between pain and the body modification, Babycakes claims:

> *I not only like body art, but I also like the feeling that these adrenaline rushes gave me. They made me feel human and alive!* (T. Winge, unpublished interview transcripts, 2003)

Furthermore, Thomas Potter states:

> *And since the pain was very personal and intense, it reaffirmed the belief I placed in the symbolism of the tattoo. By allowing the pain to continue, I was affirming that the symbolism of the tattoo was real to me, so real that I was willing to lay through hours of getting needles stuck into my scalp.* (T. Winge, unpublished interview transcripts, 2003)

Samerena asserts how she felt during her first brand: "*I felt alive!*" (T. Winge, unpublished interview transcripts, 2003) Jester also explains the pain of getting a tattoo:

> *It is an absolutely bright pain. . . . In the sense that it is very localized and very immediate. Not like a punch in the arm that slowly spreads. It very much captures your attention . . . it*

*is so immediate, you can't ignore it. It draws your attention to just that. So you are thinking, I really should be thinking about something else, but you can't. You think . . . I should go to my happy place, but your mind keeps getting drawn back to that spot and the immediacy of that sensation.* (T. Winge, unpublished interview transcripts, 2003)

## Bodily Awareness and Knowledge

The Urban Tribal subcultural members whom I interviewed indicated that they are acutely aware of their bodies during the body modification process. These subcultural members discuss experiencing a variety of sensations with many of their senses, such as hearing the buzzing of the tattoo gun, feeling the coolness of the needle, and seeing the design on their skin. This awareness of the body is later insightful for some. Accordingly, Thomas Potter asserts: *"I guess I learned more about myself through the pain of the tattoo"* (T. Winge, unpublished interview transcripts, 2003).

And Jester comments on why the pain of his first two tattoos was exceptionally difficult to tolerate:

*I really think that I was not in tune enough with my body to know how to deal with the pain of those first tattoos. I didn't know what to expect. I didn't know where to go, mentally. There was a lack of bodily awareness. . . . A lack of control. It took until my third tattoo to find that "happy place." That third tattoo was a cakewalk.* (T. Winge, unpublished interview transcripts, 2003)

The bodily awareness did not end with the process of getting the body modification. After achieving the body modifications, many participants also discuss how the healing process reminded them of the modification. Accordingly, Samerena states:

*It hurt a lot . . . not just when I was doing it, but it also hurt when I put my clothes on or took them off. The healing process was long and painful, but pretty uneventful.* (T. Winge, unpublished interview transcripts, 2003)

Thomas Potter expresses:

*I was not expecting the amount of pain I would be in afterward, and for days after, as I expected only the initial pain to be the only discomfort felt. Hah! While healing, I thought I would never get another tattoo, but when I was all done healing, I was already plotting my next tattoos.* (T. Winge, unpublished interview transcripts, 2003)

Christina also had experiences with a painful healing process relating to her brand wings:

*Because of the placement of the brand, it was impossible to move without pulling on some part of it. The pulling itself might not have been too painful, except that invariably*

*it tore the tightening scabs from the edges of the lines. An additional painful factor was clothing and as it was December in upstate New York, light minimal clothing was not an option.* (T. Winge, unpublished interview transcripts, 2003)

## Tolerance and Control

Urban Tribal subculture members recognize their tolerance for pain while getting a body modification; others spoke about the importance of being in control of their bodies while experiencing the pain related to getting a body modification. James Saunders, for example, was able to pierce his own nipples, because he understood his own tolerance for pain. Another example was shared by Thomas Potter:

*It is an intensely personal experience, as the pain is all your own, and I was the one that could stop it, but I chose to go through with the pain, as I felt like I knew how much I could tolerate—pain wise—after it was all said and done.* (T. Winge, unpublished interview transcripts, 2003)

Jester attributes the extreme pain he felt with his first two tattoos to "lack of control" of his body during the process. Another example is Babycakes, who discusses how she felt about getting a tattoo:

*I guess in some way you could say that because I am in control of my body, I can beautify it anyway I feel.* (T. Winge, unpublished interview transcripts, 2003)

These revelations further suggest that pain has a language, which select scholars refute. Elaine Scarry (1985), Byron J. Good (1992), Thomas Szasz (1975), and others argue that pain defies or resists language; some researchers, however, question this idea. One such critic is Lucy Bending (2000, 82–115), who argues in *The Representation of Bodily Pain in Late Nineteenth-Century English Culture* that pain does have a language, and Westerners are taught not to hear it. Bending (2000, 109) directly criticizes Scarry and others for their limited understanding of the metaphoric modes and expressions of pain obvious within non-Western cultures.

Morris also questions the idea that pain defies language and how this idea can lead to nonmembers of a culture assigning meanings and understandings to pain without real bearing in the culture. Morris states that pain links the modern world with the primitive, which is vanishing, and our modern Western culture

has succeeded in persuading us that pain is simply and entirely a medical problem. [. . .] Certainly we can take comfort in believing that pain obeys general laws of human anatomy and physiology that govern our bodies. The fact is, however, that the culture we live in and our deepest personal beliefs subtly or massively recast our experience of pain.

[. . .] The story of how our minds and cultures continuously reconstruct the experience of pain demands that we look beyond the medicine cabinet. (Morris 1991, 1–2)

For the Urban Tribal subculture members, it would appear that pain not only has a language, but it also plays a significant role in the process of creating the subcultural body. Conceivably, Western misgivings about pain cause difficulties when objectively considering its role in subcultural body practices.

The subcultural bodily experiences intentionally differ from those of mainstream individuals while still sharing common components of the basic body modifications practices. One significant difference is how subcultural body modification experiences are lengthy and even span decades, from the initial body modification until, often, the death of the wearer. The subcultural body modification experience typically begins with an urge or desire to modify the body. Subculture members often have a loyal, trusting, and personal relationship with the practitioner/artist who performs the body modifications. Still, some members of this subculture may perform their own body modifications. Regardless of who creates the modification there is almost always a set of predetermined steps or a ritual followed in order to create the desired subcultural body style.

The displayed subcultural body style tends to be the identifier of a subculture member. Consequently, subcultural body modifications are forms of dress that nonverbally communicate belonging to the subculture. Moreover, the subculture member does not belong to the Other (from which the modification was inspired) or the mainstream culture. Pain from acquiring a body modification creates a sense of being in the moment, bodily awareness and knowledge, and tolerance and control. Body modification experiences also allow subculture members to seek transcendence, pain/pleasure, magick and protection, healing, and the Other. Urban Tribal body modifications are powerful visual indicators of the subcultural body style, communicating and displaying subcultural accomplishments and related visual narratives. While body modifications are associated with a certain amount of permanency, there is fluidity in the way modifications change over time as the physical body ages. Additionally, some subculture members are continually adding new body modifications, so the body functions as a fluid canvas of subcultural body style.

The fluctuating and evolving nature of the subcultural body is reflected in its style, where body modifications are typically permanent but flexible in their combinations and designs. The subcultural body is continuously transformed with each additional body modification and/or supplement. Furthermore, Urban Tribal body modifications are not fixed transformations of the surface or skin of the body: tattoos fade, piercings close, cuts heal, and scars lighten. While many body modifications mark the body in some way—permanently—they do not remain unchanged or static. Thus, there is a temporal and fluid nature to the act or ritual (of getting a body modification) that resonates on the skin.

Urban Tribal subculture members have a finite space (on the body) in which they create their subcultural body style. Subculture members are not likely to have a tattoo removed or allow their piercings to close without a good reason. Their body modifications have permanency, as illustrated by this comment from Thomas Potter:

*Since the design was going to be permanent in my skin, I wanted a design that I was happy with and that I would like to see every day until I died, and that had significant imagery for me.* (T. Winge, unpublished interview transcripts, 2003)

Still some modifications feel more permanent than others. For example, Christina states: "*Oh, yes. Scars* [from the brands] *are, of course, probably the least removable of modifications*" (T. Winge, unpublished interview transcripts, 2003). Moreover, some subculture members gain a sense of belonging via the appearance created with the subcultural body. Subcultural body styles, often body modifications inspired by past cultures, create a distinct appearance for the members of Urban Tribal subcultures. When the body modifications are visible, these persons are identifiable to both insiders and outsiders. At the same time, subculture members are able to distance themselves from the more mainstream culture because of their distinct appearances.

Body supplements also play a role in the appearance of subcultural body style. Subculture members often choose body supplements, such as jewelry, that further communicate connection to the Other or non-Western cultures. Sometimes these designs take shape in choices of materials, such as bone or wood, and sometimes it is in the design itself, such as earlobe stretching or labret jewelry designs. Other times, the designs are organic in nature, reflecting the Urban Tribal movement and their inspirational cultures.

The purpose of Urban Tribal subcultural body modifications appear to be personal and unique to each individual, while having overarching subcultural implications. A unifying purpose exists in the visual connections created with others with similar types of body modifications and body style. These body modifications also provide visual clues and create a communal space based on the shared bodily experiences. While pain proves to be an integral part of the body modification experience, it was not the entire purpose of the modifications for every participant. Still, there were participants who sought pain for an associated pleasure or perceived pleasure.

Subsequently, there is not one single meaning behind or represented in the subcultural body style. Some of the meanings shared by subculture members include the following: sense of self (e.g., nipple piercings), healing (e.g., brands and mandala tattoo), connection to the past (e.g., Viking design tattoo and Celtic cross tattoo), protection (e.g., Pictish spiral tattoo and dragon tattoo), and commitment (e.g., Celtic knot tattoo). In addition, Urban Tribal subculture members create meaning with bodily experiences and resulting body style. Depending on the viewer, the meaning connected to the subcultural body modification varies. An insider may read the nonverbal meaning of the subcultural body modifications as a connection to past

cultures and a communal member, while an outsider may read the meaning of the same modifications as something to fear or to distrust or as a curiosity.

## Summary

Interviews with subculture members suggest that the subcultural identity is integrally connected to the subcultural body style, which is understood differently in how it is displayed or disguised. The subcultural identity is constructed as it is displayed, performed, commodified, disguised, socialized, narrated, ritualized, spiritualized, and lived and then conferred on the body. The Urban Tribal movement, more specific to this study the Modern Primitive subcultural body style, reflects the subcultural identity of the member and by extension the subculture as a whole. In chapter 4, I explore subcultural body style and fashions.

# –4–

# Subcultural Body Style

They paint their faces so differently from ours.

> —Gogol Bordello, "Illumination," *Gypsy Punks:*
> *Underdog World Strike*, 2005

The subcultural body and its varied styles and fashions is complex and disjointed within its own subcultural sphere(s), and at the same time is associated and connected with its parent culture. Due in part to the media's portrayal of subculture members in the news, television series, and films, each subculture conjures a distinct visual culture that communicates its style. This style is further disseminated by the subculture's visible presence in the world and, of course, by the media. Even within the guidelines of a specific subcultural style, however, it is possible to have numerous variations. Subcultural body style is further complicated by the nature and nuances of mainstream fashions and styles, with its copious layers creating plurality and multiplicity in fashionable trends (and antifashion). Many new mainstream trends borrow directly and indirectly from subcultural styles, which result from subverting mainstream cultural symbols and styles. This not only suggests a cyclical nature and interconnectedness in all things concerning styles, but the movement may follow an infinite number of patterns and vectors, where the subculture is referencing the mainstream culture, albeit subversively, and the mainstream culture is referencing the subculture, usually in style (fashion) only.

In "Anchoring the (Postmodern) Self?" Paul Sweetman (2000, 51–76) discusses contrary and complex ideas about body modifications as subcultural fashion, styles, and dress. Sweetman draws on Tseëlon (1995) and Wilson (1990) to establish the postmodern perspective regarding the fragmentation within contemporary culture resulting in diverse arrays of fashions and not a single dominant fashion. Taken to its logical conclusion, there cannot be a subcultural or counterculture fashion if there is not a dominant fashion (Sweetman 2000, 52–55). To present an alternative perspective, Sweetman cites Gottschalk (1993), Lind and Roach-Higgins (1985), and Polhemus (1994) to contend that regardless of the fragmentation and diversity of dominant culture and its fashions, this does not necessarily negate the existence of subcultural fashions and styles, even if the results are redundant and cliché (Sweetman 2000, 53–55). While this is an oversimplification of these dichotomous perspectives, both

are useful in framing the discussions involving the difficulties and intricacies regarding the sometimes less-than-apparent subcultural body styles.

Sweetman's discussions begin to address the diversities and complexities of mainstream styles and fashions, which have intimate and symbiotic relationships with subcultural style. I contend that the postmodern culture, however, is not unified or predictable in its fragmentation and it should not be limited to Western examples. The global postmodern environment is one where subcultures flourish from the fragmentation and draw visual attention to their division with their dress. An exploration of global subcultural dress, styles, and fashions examples may reveal there is subcultural sartorial resistance and agency. In this chapter, I build on previous discussions of subcultural styles and fashions in order to explore the possibilities of subcultural body styles within a global context where binary distinctions are obsolete. I explore the understood, often unspoken, subcultural style guidelines and ways of dressing the subcultural body. I discuss the visual culture and material culture of subcultural body styles with examples from subcultures within the Urban Tribal movement. I also provide an extended example of the Modern Primitive subculture's body styles, the body renaissance, and its influence on contemporary trends.

## Subcultural Body Style Guidelines

While it may seem contrary to the individualistic nature of subcultures, these groups have style guidelines expected by members. Subcultural groups subtly and visually communicate acceptable dress and styles to current and future members, as well as to outsiders and posers (i.e., individuals who purposefully mimic subcultural dress). Accordingly, Ted Polhemus and Lynn Proctor (1978) state:

> The dress code of a social group prescribes limits, not absolute uniformity. To suggest that social identity is expressed in terms of stylistic identity is not to say that all members of a given group will look identical. [. . .] Most social groups establish only basic guidelines as to what constitutes appropriate dress, and within such a framework a certain degree of variety is permissible. (76)

While the distinctions are sometimes subtle and intentionally obtuse, these guidelines make it possible to identify and differentiate a Punk from a Modern Primitive from a Skater, if the subcultural body style is being displayed.

The display of the subcultural body visually establishes territory and the specific style guidelines based on the nonverbal communication of dress. These guidelines are also frequently disseminated through images seen in the media, magazines, zines, Web sites, and the like, as well as by being present in expected (and unexpected) urban locations. Subcultural guidelines are also present in retail venues that cater to specific subcultural groups. Hot Topic, for example, features music, clothing, and accessories appealing to many subcultural aesthetics and guidelines, along with

mainstream consumers. Subculture members tend to have a complex relationship with both media representations of subcultures and stores subsequently determining a specific subculture's style guidelines. TC, a female Skater, shares her commercial (subcultural) shopping experiences:

> *I hate to admit it but I shop at the "GAP for Goths"* [nickname for Hot Topic]. *They actually have some cool clothes, and I love their sales racks. Some of their stuff is idiotic. They think they have us all figured out. What self-respecting person is going to buy a t-shirt that says "PUNK" on it? Punks surely won't. What would be the point?! Sometimes I wonder why I shop there. Whatever . . . I hide the bag in my backpack before I leave, it is just too embarrassing and I am not advertising for them.* (T. Winge, unpublished research fieldnotes, 2004)

While subcultural style guidelines allow for visual identification of specific subcultural groups, it is not always possible for outsiders to understand all of the dress cues. In the 1980s, Punk females, for example, tended to dress similarly to the males of the subculture or they dressed in highly provocative clothing, such as torn fishnet stockings, short skirts, and heavy makeup, as almost a parody of the media portrayal of women in rock music (Leblanc 1999, 46). Inside the subculture these style cues are read somewhat accurately, and more often misinterpreted by outsiders and the media. Inevitably, there are elements of most, if not all, subcultural dress and style that are hidden or less obvious to outsiders. Often these hidden elements are the most fertile with information about the subculture and, more specifically, the individual member. Thomas Potter, a Modern Primitive subculture member, keeps one of his tattoos under his scalplock (i.e., long, isolated lock of hair at the back of head). During interviews for this study, Potter revealed that the tattoos hidden under his hair have personal connections; his series of Celtic knots represent his intimate family members (T. Winge, unpublished interview transcripts, 2003).

The guidelines for subcultural body style are rarely set out in a formal manner or text. Exceptions to this happen when the media or corporations co-opt and capitalize on the dissemination of the subcultural style guidelines. Periodicals feature subculture members for reasons beyond subcultural identity and do not prescribe or illustrate how to dress; this still promotes and establishes the subculture dress and style guidelines. Sports magazines, featuring skateboarders, for example, identify, promote, and establish the current appearance and styles of the Skater. Moreover, with the prevalence of extreme sports (i.e., high-action and physically dangerous sports), skateboarding has become recognized as legitimate sport, and as a result Skaters' appearances are more commercial than subcultural (i.e., donning sponsors' hats, T-shirts, bags, and gear). Stores such as Hot Topic, Pacific Sun, and Gadzooks feature Skater (and other sports-related subcultural) dress and style for purchase. Thus anyone can wear a Vans hat, Independent T-shirt, and Airwalk shoes with dark jeans or long shorts, and subsequently be identified as a skateboarder, even without

the skateboard in hand. Subcultural body style is marketed and sold to posers and mainstream consumers simply wanting to own a portion of the subcultural style.

Blackwork tattoos, for example, are purchasable by mainstream and subcultural consumers alike. Accordingly, interpreting subcultural body style correctly is difficult even for subculture members. Further complicating these interpretations are the shared body styles resulting from crossover between differing Urban Tribal subcultures.

Furthermore, female members of the Urban Tribal subcultures have difficulties with their body style being interpreted correctly. Since the majority of these subcultures are male-dominant, female members are often not recognized as equal subculture members. A female Skater may be mistaken for the girlfriend or tagalong of a male skateboarder, even when dressed within the Skater style guidelines. TC comments about this misinterpretation/misidentification:

> *Even if I am at the skateboard park, dressed to skate, skateboard in hand . . . ERRR . . .*
> *they treat me like . . . like I am someone's girl. I have to fight for a position at the wall.*
> *I am not great on the board, but neither are most of the guys at the park. But I have to*
> *prove myself . . . I have to skate and hope I don't hit a stone and fall on my ass. It don't*
> *get ya anywhere, really. They still think you are a poser or looking for a boyfriend. Even*
> *girls with the chops are pieces of meat.* (T. Winge, unpublished research fieldnotes, 2004)

TC discusses how she considers getting a tattoo of a broken skateboard on her calf to signify visually her commitment to being a Skater but a well-placed scar would work just as well, and she speculates that either would have some kind of positive outcome on the male Skaters treatment of her (T. Winge, unpublished research fieldnotes, 2004).

The ways gender is performed and conferred on the subcultural body vary greatly depending on the subcultural style guidelines and the individual members. The guidelines for a subculture's dress and styles are frequently established by the gender that dominates the group. Within subcultures in which one gender dominates, the other gender relinquishes or rebels in order to have or to find a space to exist and manage a visual identity. In situations where the individual member rebels against the dominant subcultural image, it is still done within the subcultural style guidelines. TC argues that she is not concerned with maintaining a feminine image; she simply wants a turn to skate and be treated as an equal to the male Skaters (T. Winge, unpublished research fieldnotes, 2004). Leblanc (1999) also noted the struggles for females to find their style within the male-dominated Punk subculture.

Another example of the gendered subcultural body style is Christina, a female in the male-dominant subculture of the Modern Primitives. Christina discusses wanting a subcultural identity that maintains her femininity:

> *I suppose it sounds like a lot, but my appearance is not at all "extreme" to most people.*
> *Part of the reason, I suspect, is that my modifications are all rather "girly"—I don't*

*have any huge jewelry, and the tattoos, though they* [body modifications] *cover a lot of territory, are somewhat delicate and flowing in appearance.* (T. Winge, unpublished interview transcripts, 2003)

In addition, the subcultural body style guidelines may supersede or suppress in order to meet multiple criteria and identities. Consider the Modern Primitive subculture member who has a full-body tattoo that stops at the wrists, neck, and ankles. This style of tattooing can be openly displayed at the MODCON convention (i.e., gathering for body modification enthusiasts) and yet discretely hidden beneath a Western business suit during the workweek (Larratt 2002). Accordingly, the permanency of body modifications may require a disguise of subcultural identity in certain situations, suggesting that there are limitations regarding the ways and places subcultural dress and styles are displayed, performed, lived, and known both inside and outside the subcultural group.

Furthermore, subculture style guidelines are not stagnant; the guidelines evolve and incorporate new elements as subculture members are exposed to novel stimuli, which is most visually evident with subcultures that exist for a long period of time. Consider the changes that have taken place in the Punk subcultural style guidelines since the 1970s from the DIY styles of John Lydon (aka Johnny Rotten), the lead singer for the Sex Pistols, to contemporary style guidelines reflected in the image of Billie Joe Armstrong, the lead singer for Green Day. Subsequently, the current Punk or Neo-Punk styles meet with the criticism that they are not "authentic" or "genuine" (Moore 2004). Neo-Punks have a unique ideology, one that reflects their rejection of their parent culture's ideology, but differs from the original Punk ideology. Accordingly, this new generation of Punks needs different but reminiscent styles and dress to visually represent both the old and new ideologies. Does the contemporary Punk who listens to Green Day want to create space by wearing spiky clothing and hairstyles? Or can the contemporary Punk garner some of the past subculture's reputation by wearing similar hairstyles, such as the faux-hawk (i.e., short Mohawk hairstyle created with hair products and does not require shaving the sides of the head) and a store-bought anarchy symbol on a T-shirt?

The Urban Tribal movement's subculture members adjust their style guidelines over time. Throughout the past five decades, Modern Primitives' body modifications are increasingly more elaborate and exploratory for three primary reasons: (1) technologies, both ancient and contemporary; (2) globalization; and (3) mainstream culture adopting subcultural body modifications. Between exploration of ancient technologies and advances in contemporary technologies and procedures, as well as exposure to cultures from around the globe, Urban Tribal subculture members collectively acquire a wide array of body modification knowledge and experiences. Exposure to these stimuli prompt some subculture members to adopt new body modifications that reflect a more global perspective. Of course, mainstream culture is exposed to these same stimuli. Consequently, over time, body modifications, in general,

become less subcultural and subculture members increase their use of lesser-known and more innovative body modifications.

Also consider the variations in the subcultural styles as they move from one culture to another, or how the adoption of subcultural body styles changes in different geographic locations. In the 1970s the North American Skaters had distinct appearances connected to their geographic location. West Coast Skaters, for example, resembled beachcombers or surfers (Brooke 1999). In contrast, the East Coast Skaters adopted a British Punk body style with tattoos, piercings, and distressed clothing (Leblanc 1999). Eventually, Skaters adopted the loose, casual-fitting clothes and tennis shoes from the West Coast and the body modifications and distressed clothing from the British Punks. Skaters, regardless of their geographic location, could access the latest body styles from emerging Skater zines and periodicals.

Style guidelines exist in all subcultures as visual ideologies but tend to be confined to prevalent technologies and available styles and ways of dress. Subcultural style guidelines allow for variation, as suggested with the gender and time evolution examples, while maintaining the subculture's overall appearance. These style guidelines contribute to the overall visual culture of the subculture body style.

## Subcultural Body Style as Visual Culture

The visual diversity, complexities, and iterations of the subcultural body style are better understood and explored through the lens of visual culture:

> The study of the structure and operations of visual regimes, and their coercive and normalizing effects, is already one of the defining features of "visual culture" as distinct from traditional art history; and to the extent that this is so, it is an area in which sites and occasions for cultural analysis, resistance, and transformation are bound to proliferate and multiply, in tandem with the regime's own expansive tendencies. (Bryson 2003, 232)

In other words, "Visual culture [. . .] focus[es] on the visual where meanings are created and contested" (Mirzoeff 1999, 6), which in subcultural (dress) research allows for decoding identities and ideologies on multiple levels. Since the visual is continually polluted and interrupted by nonvisual experiences (i.e., text, sound, and movement), it is sometimes necessary to fix the visual representation within a medium such as photography. These limitations often intensify within the subcultural experience because the visual representation enmeshes within hidden layers, all of which respond to continual stimuli that is introduced and negotiated until adopted, resisted, subverted, or dismissed. Despite these limitations, visual culture is useful in unpacking subcultural aesthetics and noise in order to better know the Urban Tribal subcultural body style.

While a given subculture's visual culture may appear to be haphazard bricolage, this is not the case. Dick Hebdige (1979) used the term "bricolage"[1] to describe the

ways Punk subculture members gathered various items (i.e., safety pins, work boots, denim jeans, and denim work jacket with the sleeves removed over black leather jacket) and assembled them into what is now considered the Punk signature style. In essence, *bricolage*, when used to describe subcultural body styles, refers to the assemblage of various and unexpected items into a desired "alternative" appearance with intentionality on the part of the subculture member. Subcultural dress is indeed far more calculated and constructed than it may appear due to its bricolage appearance. After all, subcultures establish their visual identity and roles with their chosen dress. The visual culture of the subcultural body styles indicates the subculture's aesthetics and nonverbal communication within their chosen dress.

## Subcultural Body Style Aesthetics

The aesthetics of the subcultural body reflect the subculture's ideology and construct its visual culture. Subcultural aesthetics echo in the members' choice of music, clothing selections, body modifications, and geographic backdrops. The subculture's aesthetics and visual culture frequently contribute to associated generalizations and misunderstandings, commonly communicated by the media, with lasting ramifications for the subculture. A subculture's aesthetics also embody its style guidelines, and at times spawn additional subcultures that share similar aspects of visual culture, such as Modern Primitives, Punks, and Industrials. The aesthetics displayed within the subcultural body styles reflect and contribute to the construction of the subculture's visual culture. Subculture members are careful to cultivate the appropriate ideological aesthetics through the use of dress in order to maintain the continuity of visual culture.

## Noise: Subcultural Body Style Nonverbal Communication

Again, Hebdige's concept of subcultural "noise" is useful in understanding the visual culture of subcultural body styles. Hebdige (1979) states:

> Subcultures represent "noise" (as opposed to sound): interference in the orderly sequence which leads from real events and phenomena to their representation in the media. [. . .] The signifying power of the spectacular subculture not only as a metaphor for potential anarchy "out there" but as an actual mechanism of semantic disorder; a kind of temporary blockage in the system of representation. (90)

Subcultural noise is most conveniently associated with subcultural music and language, but it is also a useful concept when discussing the subcultural body style. Subcultural dress delivers a cacophony of nonverbal messages both inside and outside the subculture. The subcultural body styles function as a visual language that

communicates affiliation, status, and even fashion within the subculture. Specific body styles, such as body modifications, communicate more specific visual messages, such as documenting accomplishments, narrating autobiographies, and commemorating loves and losses. The aesthetics of the subcultural body styles express innovation, membership, and agency, which suggest active resistance and subversion of social and cultural norms and values relating to aesthetics, identity, and gender. The subcultural body styles often function as narratives for the individual and the subculture—as aesthetic noise.

## Subcultural Noise: Body Modifications

Body modifications are the hallmark of subcultural body styles, from Skaters to Bikers to Punks. Furthermore, subcultural body modifications range from dying or cutting hair to amputation or implants, the latter of which are typically associated with pain. As a result, body modifications, such as tattoos, are used to identify subculture members. Since the tattoo[2] is considered a permanent way to inscribe an ideology on the skin, it has become a common body modification for members of certain subcultures. Accordingly, Jester shares about his subcultural body style:

> *I can take my jewelry out and essentially hide my piercings, I can change my hair. But these tattoos are here to stay and I can only cover them up for so long.* (T. Winge, unpublished interview transcripts, 2003)

While the subcultural body is frequently associated with body modifications, both body modifications and body supplements construct the visual culture of styles of the subcultural body. Subculture members also dress the body with supplements chosen to accentuate or conceal their body modifications. Subcultural body supplements range from body paint and cosmetics to prosthetic fangs and corsets, and due to the temporary nature of supplements, these subcultural dress items are frequently incidental and unimportant. The hairstyle of the Punk or dark clothing of the Industrial is no less part of the subcultural body style than the blackwork tattoo of the Modern Primitive. The perceived differences between body supplements and body modifications are evident at the levels of permanency a body modification visually and viscerally communicates both inside and outside the subculture. Thomas Potter, correspondingly, expresses his awareness of his body modifications and supplements:

> *My mods are a symbol of what I believe and have experienced. Sometimes I get weird stares or stupid questions in public, but mostly I am not conscious of my mods. If I don't have my nose ring in, I feel almost naked without it.* (T. Winge, unpublished interview transcripts, 2003)

The example of the female Skater, TC, discussed earlier in this chapter, illustrates the ways body modifications, such as a tattoo or even a scar, nonverbally communi-

cate membership and commitment in ways recognized beyond body supplements or even subcultural activities. Body modifications are visual representations of the disruption of the natural body, which visually and intentionally communicate and confer the associated pain or assumed pain on to the body. Subsequently, subculture members frequently use body modifications to dress and style their bodies, perpetuating the associations between subculture members and body modifications. Body modifications are well established as the noise of the Urban Tribal subcultural body style.

Furthermore, there is a history of associating subcultures with body modifications that stems from exoticizing and romanticizing the Other. As previously discussed, the subcultural body has deep connections to rituals, rites, aesthetics, identities, and membership associated with the group, in some ways comparable and similar to those of Northern, Central, and Southern Native Americans, Aboriginals, and other indigenous groups, and even of historical cultural groups. As a result, many contemporary Western Urban Tribal subcultural body styles include body modifications resulting from social, cultural, and spiritual rituals and ceremonies inspired by non-Western cultures.

## Subcultural Noise: Body Supplements

Sweetman (2000, 62) refers to body supplements as "free-floating" commodities—in contrast to tattoos, which are "fixed"—but this term is problematic within a broader discussion of elements of subcultural style. Body supplements as free-floating commodities imply that body supplements—clothing and accessories—are without permanency and lack any real connection or attachment to the subcultural body and member (Sweetman 2000). In many cases, the body modification loses meaning and emphasis without the appropriate body supplement. Consider the reasons and meanings associated with the body supplement chosen by a Punk to adorn his or her piercing versus the jewelry selected by a Sorority girl to adorn her piercing. Consider the distinct subcultural noise created by each piercing.

## Black Leather Jacket

One of the most significant body supplements used to adorn the subcultural body is the black leather jacket. The origins of this article of dress exist with pilots and motorcyclists, who are associated with risk taking, rebelliousness, and individualistic behaviors. Perhaps these connotations are the reasons the black leather jacket continues to be worn by subcultures. Additionally, the black leather jacket serves as a blank slate that subculture members can decorate according to specific ideologies and aesthetics. Many Urban Tribal subculture members wear black leather jackets. Punks often add anarchy patches and metal studs to the black leather jacket, while Modern Primitives decorate it with tribal symbols.

For most subculture members, the leather jacket increases in visual and material cultural value with (actual or apparent) age, especially when the jacket shows

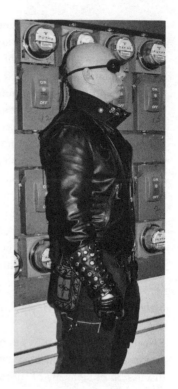

**Image 19** Urban Tribal subculture members modify the black leather jacket to suit the specific needs of the individual while still meeting understood subcultural style guidelines (T. Winge, unpublished interview transcripts, 2003). The black leather jacket often functions as a subcultural "uniform." (Photo: T. Winge, unpublished research image, 2003)

signs of being worn and distressed, because such deterioration suggests authenticity through long-term commitment. (Conversely, a brand-new leather jacket suggests the wearer is a poser, trying to "purchase" her or his identity.) The black leather jacket is the standard subcultural noise to the degree that it has practically become cliché. Still, the black leather jacket endures and has become synonymous with characteristics typically associated with subcultures.

## Subcultural Noise: Music

Some subcultures employ subcultural noise more literally through music, including concerts and music videos; it is a means of communicating ideology, aesthetics, and visual culture from which individual members are able to construct the subcultural identity. A subculture spawned from a musical movement relies on the music to function as subcultural noise, which also establishes the roles, appearances, and behaviors of the members.

## Industrial Music

The Urban Tribal movement found in North America, South America, Europe, and Australia includes several distinct subcultures that share commonalities, such as

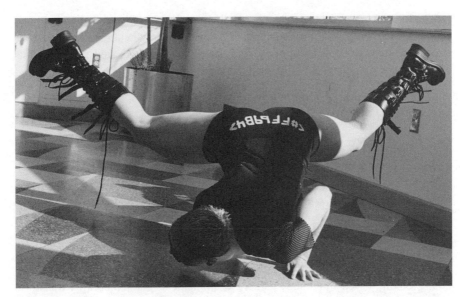

**Image 20** While the body is an amazingly flexible medium, it remains finite in body modification possibilities. At Industrial music nightclubs, Urban Tribal subculture members display their body style with bodily displays of modifications, adornments, and dance. (Photo: T. Winge, unpublished research image, 2009)

Industrial music and dance clubs. The genre of Industrial music includes EBM (i.e., electronic body music), noise, and electronica, and bands such as Godflesh, Nine Inch Nails, Nitzer Ebb, and VNV Nation. Industrial music enthusiasts recognize the connection between the body and the music; the observer's gaze is drawn to the body's undulations and performance to the dominant drumbeats. This music is not commonly played on syndicated radio stations; fans seek venues for the music on Internet radio and at subcultural dance clubs. As a result, dance clubs that play Industrial music attract an array of subculture members. These dance clubs are the gathering places where the Urban Tribal members experience their own subcultural body style, as well as influence each other with their dress and visual culture.

The visual culture of the subcultural experience has multiple enmeshed layers resulting from the continual introduction and negotiation of new stimuli into the already complex existence of the subculture and its members. The visual meanings of the subcultural body and its dress can be read or decoded for the created and constructed identities and ideologies of the subculture. Moreover, the visual culture of the subcultural body is constructed from aesthetics and noise, evident within the style of dress. The visual culture of the subcultural body is closely related to its material culture.

## Subcultural Body Style as Material Culture

The term "material culture" refers to human-made objects inherently inscribed with patterns and processes resulting from and reflecting the culture that produced them

(Miller 2005). Subsequently, elements of subcultural body style, including clothing, cosmetics, and body modifications, are all forms of material culture. Exploring the material culture of subcultural body style reveals the patterns and processes that establish subcultural styles, antifashion, and commodification.

## Subcultural Body Style

While subcultural body styles occupy spaces beyond the basics of dress, it is useful to discuss basic elements and ways of dress in regards to the subcultural body. Utilizing the definition and classification of "dress" to discuss subcultural body styles highlights the ingenuity, complexities, and layers of subcultural dress conferred and at times literally inscribed on the body.

In a very tangible sense, subculture body style is composed of two basic elements: body supplements and body modifications. The body supplements are often used to emphasize, complement, and draw attention to or away from a body modification. Clothing, jewelry, and body paints are supplements that temporarily transform the subculture member's body, whereas body modifications can semipermanently or permanently alter an individual's body to construct a more enduring subcultural appearance and identity. Subcultural body styles range in type and purpose, from cosmetics to tattoos to scars from a hook hanging. While most subcultural dress is ritualized in one way or another, subculture members strive to create a visual identity with their subcultural body styles.

## Fetish

The Fetish subculture exists along the edges of the Urban Tribal movement. Some Fetish subcultures, such as Bondage-and-Discipline and Sadomasochism (i.e., subcultures that focus on the use of pain, discipline, and/or bondage as part of sexual stimulation), rely more heavily on body supplements than modifications to achieve desired aesthetics. These supplements usually emphasize the body by contouring or reshaping it, and may have fetishistic qualities that appeal to individual members. Corsets, for example, are used by some Fetish subculture members to constrict and reshape the torso for a desired silhouette. Throughout human history, both males and females have used corsets as body-shaping garments. Corsets are available in various colors and shapes to emphasize areas of the body beyond the waist, such as the breasts or hips, and are available in rubber or leather for the tactile sensations.

Some Fetish subcultural individuals use body paint—such as liquid latex, a commercially manufactured fluid rubber—which is applied in layers on the skin and allowed to dry into body-contouring garments. Liquid latex is used to create costumes for performances and fetish appearances and body practices, and temporarily alters the texture, color, and smell of the skin.

The Urban Tribal subcultural body is also associated with performance, where a subculture member uses his or her body as a medium and mode for expression. Although not always apparent, the subcultural body is being subculturally performed when displayed accordingly. This performance is more obvious when subculture members actually use their bodies in public exhibitions, such the Jim Rose Circus or a Fetish party.

## Subcultural Body Style Processes

The process of dressing the Urban Tribal subcultural body is frequently as important as the individual elements used or even the final appearance of the subculture member. For some subculture members, the process is a rite or ritual, while for others it is the experience.

The subcultural body is decorated, adorned, emphasized, and transformed in temporary, semipermanent, and permanent ways with the use of body modifications and supplements. The subcultural body styles emerge from modes of dressing utilized within subcultural style guidelines. These styles serve a range of purposes, from indicating social and cultural status to commemorating special occasions, from displaying daily aesthetic adornment to performing. Whether temporary adornments, semipermanent adaptations, or permanent modifications, subcultural body styles visually communicate the identity, resistance, and agency of the individual subcultural member, as well as confer those meanings back on to the individual subculture and the Urban Tribal movement.

Accidental or intentional, subcultural body modifications inherently communicate visceral information about the process of getting the body modification. For some subculture members, the process itself is equal to or more significant than the resulting body modification. A member of the Modern Primitive subculture, for example, acquires body modifications for both the result and the experience of the process.

Are the incidental and accidental elements that contribute to the overall subcultural body style valid forms of dress? Is the scar on the once-broken wrist a body modification and part of the Skater's dress and style? Accidental elements become not only accepted within the subculture but also temporary or permanent elements of dress visually communicating, if visible and understood, the individual's subcultural identity. In some cases accidental body modifications are lasting reminders of the Urban Tribal subcultural process or experience.

## Does That Hurt?

As Karmen MacKendrick (1998) argues in her article "Technoflesh, or 'Didn't That Hurt?'" body modification practices tend to result in the viewer asking the partici-

pant about the perceived pain associated with the process of the creation of the modi-
fication. Similarly, Thomas Potter notes:

> *I am constantly asked if my tattoos and piercings hurt when I got them. Since some did*
> *and others were not so painful, it requires some explanation. My throat tattoo was painful,*
> *very painful. Most people seem to want me to say all of them hurt, and sometimes I do. It*
> *is the easiest answer. Some people even seem pained by my body modifications, especially*
> *about my nose* [septum piercing]. (T. Winge, unpublished interview transcripts, 2003)

Pain in dress is not unique to the Urban Tribal subcultural body. Accordingly, Pol-
hemus and Proctor (1978) acknowledge, "Beauty knows no pain. The need to adorn
the body often takes priority over the needs for bodily comfort, safety, movement,
and health" (52).

Still, this quotation is particularly accurate for subculture members who have
body modifications displayed as badges of honor for enduring the process and pain
while also achieving the subcultural ideals of beauty. A Punk, for example, might
wear a safety pin in a cheek piercing not only to communicate his or her DIY aes-
thetic but also to visually represent the physical and visual pain closely associated
with this subculture's ideology.

The perceived pain associated with Urban Tribal subcultural body practices
and resulting dress is a byproduct of the group's and the individual's dress ideals,
and may even be significant to the desired visual communication. Thus, there is
intentionality on the part of the subculture member to secure and display the body
modification that represents the "painful" process of permanently dressing the body.
Furthermore, the body modification then becomes a piece of the subculture's visual
culture and a representation of the material culture of the body practice and process.

## Subcultural Antifashion

Why are subcultural dress and styles so closely associated with the term "antifash-
ion"? According to Polhemus and Proctor (1978): "Antifashion refers to all styles of
adornment which fall outside of the organized system or systems of fashion change"
(16). Polhemus and Proctor further cite J. C. Flügel to discuss how fashion is "mod-
ish" and changeable, while antifashion is "fixed" and stationary (Flügel 1930).
Moreover, Polhemus and Proctor give examples of non-Western cultures that exhibit
antifashion adornment because of the permanency of their body modifications or the
apparent lack of change within the culture. Accordingly, David Curry (1993) and
Paul Sweetman (2000) suggest that body modifications, such as tattoos, could not
be designated fashion due to their permanency and, therefore, must be antifashion.

Highly contested is the definition of "antifashion," because this term implies that
styles not within the Western fashion system are against fashion. For example, in
*Fashion, Culture and Identity*, Fred Davis critiques Polhemus and Proctor's defini-
tion of "antifashion" and its inclusion of traditional and folk dress, and suggested

that "nonfashion" would be a more appropriate descriptor (Davis 1994, 161–62). Similarly, Sandra Niessen, in her book *Re-Orienting Fashion: The Globalization of Asian Dress* (2003), suggests it may be more prudent and less pejorative to refer to non-Western dress without an obvious fashion system as "nonfashion" rather than "antifashion." In *Alternative Femininities: Body, Age and Identity* (2004), Samantha Holland argues that the term "antifashion" is not useful in her research about women who have alternative ideas about their own femininity, which manifests itself in their choice of dress. Holland (2004, 16, 77–79) notes that her study's participants are resistant to even acknowledge the word "antifashion," and instead discusses how they are less interested in fashion and more interested in comfort.

This definition and resulting discussions of antifashion are problematic, based as they are on outdated assumptions and binary Western perspectives about fashion. Body modification technology, for example, progresses to meet the needs of the users, both mainstream and subcultural. As a result, the development of tattooing technology is more health conscious and includes semipermanent inks. Even tattoos created with standard inks are not always permanent; the tattoo's longevity depends on the location and age of the tattoo, skin pigmentation and surface, exposure to natural elements and abrasion, and the specific ink colors. Currently, if a permanent tattoo is no longer desired, it may be removed or significantly lightened with laser treatments. Tattoos may also be modified with additional body modifications, such as additional or concealing tattoos, piercings, and brands. Piercings are even less permanent, in the sense that the holes close over time if not maintained with a body supplement. Even body modifications, such as cuttings and brandings,[3] do not always have permanent appearances, a result of the body's natural healing ability, skin pigmentation, and depth of the modification.

As the distinctions between cultures blur and cycle back to become more distinct again, the connotations of fashion change to address the global story instead of only the West's version. The term "antifashion" (Polhemus and Proctor 1978) is applied to any niche group at any given time, as well as to those groups or cultures whose fashion systems differ from that of the West. Consequently, antifashion is a complicated and problematic term because of its inherent Eurocentric bias.

In addition, the term "antifashion" has popular and contemporary connotations commonly associated with dress that exist intentionally in opposition to current fashion, resulting in its close association with subcultures. Only in this way is "antifashion" a useful concept when exploring subcultural body style because subcultural groups often have their own fashion systems that move at unique speeds from commonly acknowledged Western fashion cycles.

## Fashion Designers

Subcultural body style is rich with signs and symbols representing rebellion and agency without regard for fashion. Ironically and most marketable, fashion designers

draw on the limitless varieties, spontaneity, and creativity found within subcultural dress for fashion lines. And on rare occasions, subcultural dress is directly impacted by fashion designers, such as how the Punk aesthetic was impacted by fashion styles of the 1970s credited to Vivienne Westwood and Malcolm McLaren (Leblanc 1999). Still, it should be considered that Westwood and McLaren may have been influenced by street styles seen in London and simply marketed plaids and safety pins as subcultural dress, creating a visual and material culture around those working-class items.

In the years since the emergence of the Punk subculture in the 1970s, fashion designers have drawn inspiration from the plaids, safety pins, and even hairstyles of the Punk aesthetic. In 1994 Gianni Versace designed a black evening gown with oversized jeweled safety pin closures, which Elizabeth Hurley wore to the movie premiere of *Four Weddings and a Funeral*. Additionally, Betsey Johnson designed a dress made entirely of safety pins; it was photographed on a model whose hair was styled into a Mohawk. In recent years, Westwood designed a line of jewelry— Hardcore Diamonds—that included safety pin jewelry reminiscent of the 1970s Punk aesthetic.

Alexander McQueen, inspired by all things British, often borrowed from the British Punk aesthetic to create his one-of-a-kind fashion aesthetic (Steele and Park 2008). One may assume that McQueen appropriated plaids from the Punks, but this is not the case. Both McQueen and Punks rely on tartan fabrics to communicate an understood recognition of the Other cultures that the British have dominated, albeit it is romanticized and commodified (Entwistle and Wilson 2001; Goodrum 2005). McQueen was influenced by the Punks' irreverent use of the British flag (e.g., distressed Union Jack coat for singer David Bowie), combinations of fabrics and textures (e.g., smooth black leather jacket with red, yellow, and black coarse wool plaid), and elaborate silhouette (e.g., feathered hair pieces from fall 2007 that resembled Mohawk haircuts/styles). McQueen not only drew from the British Punk subculture, he constantly tapped into the street styles of contemporary subcultures, and innovatively translated aspects of subcultural dress into his contemplative and reflective couture fashion designs.

Recognizing the connection between subculture street styles and fashion, in 2009 the Fashion Institute of Technology in New York City held an exhibit titled "Subculture and Style" with a related symposium. The symposium included subcultural scholars such as Paul Hodkinson, Yuniya Kawamura, Ted Polhemus, and David Muggleton, as well as fashion designer Anna Sui, who is highly influenced by North American subcultural street styles.

These types of recognitions celebrate the relationship between fashion designers and subcultures, but rarely address the problematic nature of this relationship. Attempting to address this issue, Sweetman (2000) states: "Truly 'postmodern' or not, contemporary fashion thus problematizes the notion of sartorial strategies of resistance" (54). That is, as subcultures reject aspects of current culture and create a subcultural zeitgeist, fashion designers interpret these street styles and attempt to

predict the next zeitgeist. Moreover, subcultural body styles reflect the innovative nature of subcultures, drawing fashion designers to their dress (and ideologies) for inspiration. Co-opting subcultural street style creates a scenario where the subculture is rendered powerless, even if the subculture dress is only a catalyst. Consequently, subculture members are left to reconsider their street styles, which are meant to visually communicate their identity and resistance to mainstream culture.

## Marketing the Subcultural Body

A further result of the relationship between subcultures and fashion is fashion marketing, or branding, of subcultural body style. There are instances when the marketing happens from within the subculture, but more often, subcultural dress and aesthetics are selectively borrowed from outside without regard for the subcultural ideology or style guidelines, and redesigned and branded in a way to become a commodity for the mainstream to consume. In the 1980s Tommy Hilfiger, for example, borrowed directly from black urban youth and the beginnings of the Hip Hop and Rap subcultures for some of his most successful fashion lines (Hilfiger 1997). Hilfiger's fashions were so popular even within these subcultures that the subcultural music celebrities incorporated his fashions into their music videos.

As subcultural body modifications and supplements are detached from the originating subculture and distilled for mainstream fashion consumption, subcultural street styles become commodity fetishes (Marx 1867/1999). In other words, the resulting fashions are fetishized and purchased for their fashionable qualities and estranged from their original subcultural context, process, and presentation. As a result, the mainstream fashion is assigned new meaning and often temporary value, whereas the borrowed subcultural dress has a diluted meaning (less subcultural) and is devalued as a result.

There are numerous examples of Urban Tribal subcultural body styles being co-opted and marketed to the mainstream consumer, as well as fashion designs inspired by elements of the subcultural body, such as body modifications (e.g., piercings and tattoos) and fashions (e.g., Gothic ankh jewelry and corsets) (Winge 2001). Body modifications are commodified in several ways. Urban Tribal tattoos, for example, are available to the mainstream consumer as knit fabric tattoos on pull-on transparent sleeves and temporary and semipermanent tattoos.

The subcultural body is complicated in its visual and material cultures, and it contributes to their unique aesthetics and identities. The relationship between the subculture and the fashion industry is not always reciprocal and has long-reaching consequences for the resistance and agency of the subculture. The following is an extended example of Urban Tribal and Modern Primitive subcultural body styles influencing contemporary and mainstream trends and fashions and creating a body renaissance.

## Subcultural Body Style: Modern Primitives and the Body Renaissance

Victoria Pitts (2003, 12, 80) makes reference to how the "fashionalization" of subcultural body modifications contributes to their popularity among the mainstream consumer culture, which has both positive and negative consequences for the impacted subcultures. The Urban Tribal movement, specifically the Modern Primitive subculture, impacted current body fashions and contributed significantly to the current body renaissance in Western culture.

### Body Renaissance

Arnold Rubin identifies the "tattoo renaissance" taking place in the late twentieth century in *Marks of Civilization: Artistic Transformations of the Human Body* (1988). While Rubin notes the fine art and creative expressions happening in the area of tattoos, labeling it the "tattoo renaissance," this was but the mere beginnings of a larger movement—the body renaissance. The *body renaissance* encompasses the holistic awareness of the body in all its forms and how it manifested in body practices, especially those including body modifications. My research indicates that the body renaissance is a reclaiming of the body as an expression of self and agency, and in cases of Modern Primitives there is a seeking of spirit, magick, and even bodily experiences such as pain.

In recent years, body modifications are mediated from the "primitive and exotic" to "authentic, uncommodified [. . .] in opposition to the corruptions of mainstream society" (Benson 2000, 242). Body modification practitioners are elevated from backstreet deviants to sophisticated artists whose canvas is skin and whose paintbrush is a needle gun. With this newfound respectability of body practices once considered subcultural, if not criminal, it is not surprising that the heavily modified bodies of the Modern Primitive subculture made an impact on mainstream cultures and consumers.

The public displays of Modern Primitive body practices and modifications create an interest in similar body modifications within mainstream cultures. Some Modern Primitives argue that the growing popularity of body modifications emerges from the universal need to reconnect with spirit and rituals (Mercury 2000). This reasoning is easily extended to more mainstream examples of body modifications and related rituals in Western culture, such as branding Greek letters into fraternity members' flesh for initiation, the piercing of a young girl's earlobes to commemorate a designated birthday, and tattoos of religious iconography. In the new millennium, body modifications are not taboo and in some cases even function as fashionable dress, unencumbered by the negative connotations from past generations about the body and body practices.

In 1936 *Life* magazine surveyed United States citizens and reported that approximately ten million people had at least one tattoo ("One Out of Ten" 1936); in com-

parison, a 2003 Harris Poll reported that nearly forty million people have at least one tattoo (Harris Interactive 2003). According to the September 2003 issue of *American Demographics*, the use of body modifications, such as tattoos and piercings, continues to grow at a significant rate (Fetto 2003, 48; Wohlrab et al. 2007). Reality television shows, such as *Miami Ink*, *LA Ink*, and *Inked*, further suggest the interest in tattooing and the modified body by mainstream viewers. A 2007 research article states that approximately ten percent of individuals from Western cultures have some type of body modification that is not the result of medical procedures (Wohlrab et al. 2007). These statistics reveal an increased interest in body modifications and further suggest that Western culture is experiencing a body renaissance.

The same memes that allow potential and new subculture members to understand the Urban Tribal subcultural body style are also transmitting information to the mainstream public seeking a bodily experience or a new facet to their visual identity. Many fashion trends relating to the body and dress in mainstream Western culture draw inspiration from subcultural dress. In recent years, the Modern Primitive subculture has significantly impacted contemporary fashions and trends. The Modern Primitive subculture members continue to push the boundaries and extremes of their body modifications and related practices and rituals; this may be in reaction to mainstream culture co-opting aspects of their visual appearance, or it may be a natural evolutionary step for this subculture and may even explain the Modern Primitive subculture's longevity. Accordingly, the Urban Tribal movement and specifically the Modern Primitive subculture are leading the way for the body renaissance.

## Summary

Subcultural body style appears as complex and independent structures, while also having a cohesiveness that visually communicates the overall subcultural aesthetic. The subcultural body style is created by more than just haphazard bricolage; the subcultural body style is accomplished by following the subcultural style guidelines. Mainstream fashions and trends often result from borrowing directly and indirectly from subcultural styles; this has recently included Urban Tribal body modifications and the body renaissance.

The current subcultural body style results from the postmodern and globalized culture(s) that impact and interact with it, evident in the subcultural body's visual and material cultures. The extended example of the Modern Primitive subculture's body styles indicates the dramatic impact the subcultural body style has on both the subculture and mainstream communities. Furthermore, the subcultural body leads the way in the body renaissance, whose influence on contemporary trends and fashions goes beyond simply the subcultural body. In the next chapter, I discuss possible futures for the Urban Tribal subcultural body style and the body renaissance.

# Future of Subcultural Body Style

Our culture has become something that is completely and utterly in love with its parent. It's become a notion of boredom that is bought and sold, where nothing will happen except that people will become more and more terrified of tomorrow, because the new continues to look old, and the old will always look cute.

—Malcolm McLaren, "Punk and History," 1990

Does the unmodified body exist? Susie Orbach states, "There has never been a 'natural' body"; Orbach further argues that the body is always acted on by cultural movements and at the same time reflects them (Orbach 2009, 165). Subsequently, most everyone has a modified body style in one way or another, from circumcision to piercings to dyed hair. While the body is an amazingly flexible medium in its own right, it remains finite in its possibilities. The body does not have defined limits but, instead, elucidates the challenges, boundaries, and possibilities facing the future the subcultural body has to confront, cross, and explore in order to continue to be subcultural—a visual representation of resistance and agency within the dominant cultural and social context.

In the past few decades, subcultures stimulated a bodily awareness—the body renaissance—in Western culture, highlighting the importance of subcultural identities that confront and test the understood social and cultural conventions and norms of aesthetics, gender, and spirituality. Subculture members exploit the body as a means of expressing beliefs, narratives, experiences, and ideologies, which, in turn, re-create, redefine, reclaim, and recognize the body. To this end, subcultures primarily rely on body modifications to visually stimulate a body renaissance.

Within this body renaissance, subcultural body modifications function as both a resistance to and reflection of the commodification of the body and reveal the exploitation and expanse of contemporary body practices and experiences, while simultaneously indicating possible individual, subcultural, social, and cultural meanings. Body modifications are generally permanent, but their meanings are not fixed and may change over time for individuals and groups. For many subcultures, body modifications communicate belonging and identity to the group, which is in a constant state of flux as individuals add body modifications and change body adornments and supplements, as well as maintain multiple identities from one group to another. Additional body modifications contribute to the collection of individual elements

and modify the overall appearance of the subculture member. The emphasis of the subcultural body style often establishes group membership, while complete or selective disguise of the subcultural body allows for the individual to pass as a part of mainstream culture or into another subculture.

As individuals negotiate roles within and between the subculture and mainstream culture, they construct and deconstruct their subcultural identity. This continuous negotiation creates a space where subculture members have agency to challenge social and cultural norms of mainstream culture, and also the ability to redefine and evolve the subcultural body. Furthermore, as subculture members introduce or subvert body modifications, supplements, technologies, practices, and rituals inspired or directly borrowed from Other cultures or even mainstream culture into the subculture, the visual messages alter the embedded nonverbal communication of the subcultural body style.

Although body modifications similar to those seen on subcultural bodies have been practiced throughout the world for thousands of years, they are only recently considered fashionable body adornments by mainstream cultures in North America, South America, Europe, and Australia. By the 1990s tattoos and piercings were practiced in strip malls and seen on individuals regardless of background, social group, or age. Now in the twenty-first century, tattoos are common and tribal designs are even incorporated into clothing, such as a knit shirts or leggings with tattoo-like designs (reflecting the body renaissance).

Urban Tribal subculture members argue that body modifications and related bodily experiences are prevalent in contemporary Western culture because the collective unconscious drives the individual's decision to acquire body modifications; there are also a lack of concrete Western rites and rituals resulting in the adoption of body modifications to commemorate age grades and accomplishments for subculture members and mainstream individuals alike. In my research, while it was clear that these factors played a role in Urban Tribal and Modern Primitive body modification decisions, it is still unclear as to what degree these reasons are factors in the acquisition of body modifications by the mainstream. Still, it is difficult to dispute the impact of the subcultural body style on mainstream adoption of body modifications and other subcultural dress. All forms of media contribute to this exchange of information. As various forms of new media continuously stream images and information about subcultures to the masses, the subcultural body is further romanticized and exoticized. As a result, the subcultural body provides significant impacts on and contributions to the current body renaissance; however, this has both positive and negative consequences for Urban Tribal subcultural communities.

The mainstream popularity of subcultural body style provides revenue and awareness for body artists and practitioners, as well as moderate acceptance and recognition for subculture members. But what happens to the resistance and agency of the subculture and its individual members once the mainstream adopts permanent and formerly taboo forms of subcultural dress? Urban Tribal subculture members tend

to seek out more extreme and exotic body modifications in order to maintain their fringe existence, as well as to explore new arenas regarding the body and technology. In this final chapter, I explore the current and possible futures of subcultural bodies. Further discussions are developed about the relationships between subcultural body style and fashion trends, and the resulting reactions from both the mainstream and subcultures are voiced. Throughout this chapter, I summarize significant points presented previously about the subcultural body and the body renaissance.

## Fashioning the Subcultural Body Style

Many Western subcultures contribute to and influence contemporary examples of fashion. The Hippie subculture influenced numerous fashion trends, such as embroidered jeans, shawls, and use of the peace symbol. The Punk subculture is credited with many 1980s fashion trends, such as distressed jeans, safety pin accessories, and band buttons or pins. During the past few decades, the Urban Tribal movement influenced contemporary body fashions with the use and display of body modifications, technologies, and practices.

Subcultural body style continues to have a significant impact on the fashion world in its trickle up and around one direction and then trickle down and around the other direction, creating a cycle of consumption (see Davis 1994). First, fashion designers seek inspiration from subcultural dress and incorporate elements into designs for runway shows. Then, celebrities and the elite purchase fashions from the runway shows. Next, the fashions are photographed on the backs of the fashion-forward and trendsetters, creating a market from those who want to follow particular fashionistas. From this arises highly marketable, lower-price-point clothing lines featuring distilled versions of the original design that inspired the high-end fashion. Designers such as Tommy Hilfiger and Alexander McQueen used subcultural inspiration to transform urban street styles into designs intended for mass-market consumption (Hilfiger 1997; Steele and Park 2008).

While only subtly indicated in this fashion cycle overview, the media plays an important role in the dissemination of both fashionable and subcultural looks. Formerly, images and stories about subcultures were distributed through television news shows, radio broadcasts, magazines, and newspapers. Today, however, the Internet is the primary means of dispersing the latest information, especially about subcultures. In some cases, subculture members have become the media reporting on their own and other subcultures (see BME.com, uscobm.com, and PMYCA.com).

As a result of the interactions between Western fashion cycles and the media, subcultural dress, albeit in distilled form, is made acceptable, wearable, marketable, and consumable for the mainstream consumer. Since many urban subcultures choose their dress to delineate and separate themselves visually from normative society, and/or as a means of communicating group and individual identity, main-

stream consumers dressing in similar ways significantly reduce the amount of resistance visually communicated in the subcultural appearance. Subsequently, the co-opting and consumption of subcultural dress results in consumer-driven subcultures that take dressing cues from such sources as Hot Topic stores; perhaps more notably, subcultures are now adapting new and reactive guidelines to reinforce their distinction from mainstream. Accordingly, Urban Tribal subcultures are exploring more distinct body modification practices, such as hook hangings, amputations, and brandings.

Body modifications create a haven in which the subcultural body resides and find its style. Still, in the past few decades, pierced ears, navels, and noses, as well as tattoos on most areas of the body, have grown in popularity in mainstream Western cultures (Mascia-Lees and Sharpe 1992; Rubin 1988; Sanders 1989). With the rise of the Urban Tribal movement and the body renaissance, the impact of the subcultural body style is evident in the placement, design, and even application of these body modifications on mainstream consumers. Furthermore, subculture members are participating in the dissemination of body modifications and related practices. It is often Urban Tribal subculture members who are body modification practitioners or who are working with various forms of new media to disseminate their subculture body style. This dissemination is the cornerstone of the body renaissance, where mainstream consumers first become aware of and then explore the body with basic body modifications and where subculture members then push the body to new limits with ancient and invented body practices and modifications.

This increased interest in and awareness of the body is thought to draw on the collective unconscious regarding human beings' past experiences with marking the body (Camphausen 1997). Correspondingly, Musafar indicates that all humans have a "primal urge" to modify their bodies, which also compels them to explore and experience the body and its physical sensations through body modifications and related rituals (Musafar 1996; Singleton 1997; Vale and Juno 1989). This primal urge is the essence of the body renaissance and is at the heart of the Urban Tribal movement. Accordingly, the Urban Tribal subculture members I interviewed further argue that mainstream consumers purchasing a band of thorns or barbwire tattoo to be placed around the bicep are also responding to their primal or collective unconscious (T. Winge, unpublished research fieldnotes, 2003, 2004).

Youth in many contemporary Western cultures are missing rituals and rites of passage that reflect age grades or life accomplishments, and are therefore creating them within body modification practices, such as pierced ears for an eleventh or twelfth birthday or a tattoo to commemorate joining a sports team. The body modification practitioners I interviewed state how it is common for mainstream consumers to get a tattoo or piercing to commemorate a birthday, birth/death of a loved one, or a life milestone (T. Winge, unpublished research fieldnotes, 2003). Individual meanings of modifications both inside and outside the subculture range from marking a rite of passage (e.g., tattoo of a date to commemorate turning eighteen or getting married),

to membership (e.g., tattoo of military insignia when completing military basic training), to reclaiming the body (e.g., tattoo to cover mastectomy scars). Furthermore, body modifications communicate multiple messages and narratives to multiple viewers. Viewing a body modification does not necessarily visually communicate the "real" reason behind it; the body modification is open to interpretations beyond that of the wearer.

## Tattoo Today, Gone Tomorrow

Much of the current mainstream appeal of body art and adornment, once only in the domain of the subcultural body, is due to contemporary technological advances that allow for fads and fashionable changes in body modifications. The variety and increasingly temporal nature of tattoos makes them a useful example for illustrating the ways that advances in technology not only provide more accessible methods of acquisition but also expand the mainstream market with the creation of tattoos that can be temporary or semipermanent.

Temporary tattoos are inexpensive compared to more permanent versions and are available in a limited range of designs. These tattoos are burnished onto the skin with an adhesive and easily removed at home with the appropriate materials (i.e., soap and water, or acetone). Another type of temporary tattoo is henna or *mehndi*, borrowed from India and Africa, where a paste made from the powder of dried and ground henna plant leaves is applied according to designated designs on the surface of the skin (Roome 1998). After the paste dries, it is removed, leaving behind a reddish-brown stain on the skin, which fades as the skin exfoliates (Roome 1998).

Cosmetic tattoos typically replicate the appearance of certain types of makeup that accentuate the lips, eyes, and eyebrows. These types of tattoos are typically semipermanent and fade after a few years due to the nature of the inks used and superficial skin penetration (Winge 2004f). Tattoo or cosmetology professionals apply cosmetic tattoos with a tattooing process called micropigmentation (Vaughan, Asbury, and Riordan-Eva 1999).

In the past few decades, tattoos increased in popularity among people of all ages and cultures. As tattoos gained popularity, so did tattoo removal, such as laser technology tattoo removal (Winge 2004a, 2004e, 2010). Despite advances in tattoo removal, some tattoos may not be completely erased; removal is highly dependent on the specific circumstances of each tattoo, such as its age, size, and color, as well as the individual's skin pigment. This failure to completely eradicate traces of some tattoos results in more research and development into the inks and techniques needed for semipermanent tattoos (Winge 2004a, 2004f).

Similar to the appeal of temporary or semipermanent body modifications is the attraction to the temporary nature of body supplements. The ability to dress in specific body supplements, that is, to wear the subcultural identity for a period of time and

eventually remove it, is a well-known practice for many subculture members who need at times to exist outside of their subcultural identity. In recent years, mainstream consumers also experience these sensations. In some cases, this results in fringe groups, known as posers, who mimic subcultural dress and hang out in subcultural spaces. Because subcultural dress is easily donned or doffed, body modifications still hold a certain amount of authenticity for the subcultural body style.[1]

## Fashionable Fetish

As one might expect, some subcultural dress styles are borrowed and subverted from the mainstream. This is the case with many items of dress from the Fetish subcultural communities, a group that exists within the Urban Tribal movement. The corset, for example, originally functioned as a mainstream undergarment that modified the shape of the torso into a fashionable silhouette.

For many decades, the combination of corsets, stiletto shoes, and leather garments have been part of the many Fetish subcultural communities and are not part of the mainstream and fashionable worlds. As celebrities embrace risqué fashion designs inspired by fetish garb and accessories, so does the mainstream fashion world. Accordingly, Valerie Steele comments:

> [T]he fashion industry has recently stolen a great many items from the fetishist's wardrobe [. . .] this is part of a more general process whereby subculture styles are assimilated into mainstream fashion, after having been pioneered by small producers catering to "kinky people." Once fetish fashions achieve a certain "style factor" among trendsetters, they are picked up by internationally famous fashion designers whose work is then "knocked off" by mass-market clothing manufacturers. (Steele 1996, 55)

Steele's argument is readily apparent when Jean Paul Gaultier designed the show-stopping cone bras and corsets for Madonna's Blonde Ambition tour in 1990. Bras and corsets were no longer undergarments to be seen only in intimate settings; they quickly gained status as fashion accessories. Today, bras and corsets of all colors, shapes, and forms are sold at department stores and are worn by young and old as fashionable items of dress.

## Subcultural Reactions

When the mainstream co-opts subcultural body style, the subcultural reactions vary depending on the impact. While some groups enjoy the attention and encourage and facilitate the co-opting, others may find ways of making revenue from the co-opted dress. For example, Fetish groups hold events that charge admission to attend and feature not only fetish performances but also fetish dress vendors, who also pay

admittance fees or are charged a percentage of their sales (T. Winge, unpublished research fieldnotes, 2003). Still other subcultures reevaluate and often redesign their appearances to be something more distinctive from the mainstream and, at times, less likely to be mimicked or borrowed again. Modern Primitives, for example, moved from the tattoos and piercings of private T and P parties to public performances of hook hangings. These examples are subtle and less obvious reactions to the mainstream co-opting and consumption of their dress, while providing the subculture with exposure and revenue. Furthermore, these Urban Tribal subcultures set new trends in music and fashion, due in part to their marginalized existence; in time, the members of these groups realize that people outside of the subculture are capitalizing on the subcultural dress and diluting its visual messages, causing the subculture to adapt and modify dress guidelines that retain the message of authentic subcultural identity. Accordingly, the body renaissance also challenges Urban Tribal subcultural identities and body style.

Perhaps the inevitable change in subcultural body style is a predictable evolution of subcultures, but the Urban Tribal subculture members also appear to be reacting to mainstream consumers encroaching on the space once only occupied by the subcultural body. Meanwhile, the Modern Primitive subculture, the most distinct Urban Tribal subculture, strives to create one-of-a-kind subcultural bodies. In recent years, their body explorations accelerated in severity and revenue. Is it any coincidence that as Western culture embraces piercings and tattoos, Modern Primitives adopt brandings, skinnings, and Teflon implants?

Modern Primitives, similar to the Hip Hop and Rap subcultures, find ways to contribute to and gain from the mainstream co-opting and eventual adoption of their subcultural style. Fakir Musafar, for example, owns a body modification studio in California, where he trains body modification practitioners and gives demonstrations of subcultural body practices. In addition, Musafar holds body modification seminars where he allows anyone from novice to expert to participate in body modification practices and rituals. Along with documentation and public displays of his own body modifications, Musafar disseminates the Modern Primitive ideology and subcultural body for global audiences, and demonstrates that there is revenue in the subcultural body—the demand increases the supply. Due to Musafar's and Modern Primitive subculture members' exploration and dissemination of bodily practices within this current incarnation of the body renaissance, the Urban Tribal movement provides significant contributions to mainstream culture in body technologies, practices, and modifications.

## Body Technologies Old and New

Many Urban Tribal subculture members and mainstream consumers alike utilize modern technologies and methods to modify their bodies. The Urban Tribal

**Table 5.1**   Urban Tribal Body Modification Technologies

| Body Modification | Modern Technology | Historic Technology |
|---|---|---|
| Tattoo | Tattoo gun<br>Autoclave<br>Sterile needles<br>Manufactured colored pigments | Sharpened bones or sticks<br>Plant-, ore-, and mineral-derived inks |
| Piercing | Sterile and hollow needles<br>Piercing gun | Sharpened bones or sticks |
| Brand | Electric cautery brand<br>Laser | Fired or heated wood, stone, or metal |
| Keloid | Razor<br>Scalpel | Sharpened bone, stone, or metal |
| Cutting | Razor<br>Scalpel | Sharpened bone, stone, or metal |
| Body reshaping | Corset (torso)<br>Binding cloths (footbinding) | Boards and vice (head)<br>Binding cloths (footbinding) |
| Implants | Scalpel<br>Teflon, surgical steel, and silicone implants | Sharpened bone or metal<br>Pearls or shells |

*Source*: Winge 2004a.

movement, however, introduced both modern and historic technologies for modifying the body (see Table 5.1).

Modern technology refers to contemporary late twentieth- and early twenty-first-century Western technologies, while historical technology refers to those technologies used by ancient cultures (primitive or tribal body modification practices). An example of modern technology and related method(s) is the motorized tattoo gun that uses needles sterilized in an autoclave; a corresponding example of historical technology and related method(s) includes sharpened sticks or bones dipped in inks made from natural materials to puncture the skin and create the desired design (i.e., tattoo, brand, etc.). Either form of technology and method is remarkably reliable, but some individuals consider the latter more authentic. Still, practitioners of primitive or historical methods are difficult to find and secure for tattoos, making their artistry costly and more exclusive.

Urban Tribal subculture members actively investigate and design modern body modification technologies. Steve Haworth is a photographer of subculture members and their body modifications, but he is best known for being an accomplished three-dimensional body modification implant practitioner and artist (Mercury 2000, 65–68). Haworth is the focus of numerous newspaper and magazine articles, television programs, and documentary films (Mercury 2000, 64). The *Guinness Book of World Records 1999* recognized Haworth as the "Most Successful 3-Dimensional Artist" in the world. Haworth is also the inventor of three-dimensional rigid implants

and the technology used to install them (Mercury 2000, 65–68). These Teflon, surgical steel, and silicone implants are designed in a variety of shapes and sizes (Winge 2004a, 2004c; T. Winge, unpublished research fieldnotes, 2003). Haworth also designs the surgical instruments used to insert three-dimensional rigid implants, both subdermally (i.e., entirely under the skin) and transdermally (i.e., partially exposed outside the skin) (Mercury 2000, 65). In recent years, Haworth designed the electrocautery unit, similar to an arc welder, for cautery branding (Winge 2004a, 2004b). With this, branding practitioners have more control over the branding mark to create more intricate and elaborate designs.

## Precision Piercing

Many contemporary subculture members have multiple piercings adorned with jewelry that reflects the group's and/or individual's ideology and aesthetics. The most effective and preferred technology for creating a standard piercings is a hollow needle, which removes a channel of skin in the flesh. Urban Tribal subculture members may pierce numerous loci of the body and wear specially designed jewelry specifically to accentuate and maintain their piercings (T. Winge, unpublished research fieldnotes, 2003). Cheek piercings, for example, use a body supplement with a corkscrew end that is inserted into the piercing a circular motion to secure the body supplement in place, while a pectoral piercing uses a pocket (concave scoop design) as capture jewelry (T. Winge, unpublished research fieldnotes, 2003).

Another type of piercing utilized by Urban Tribal subculture members is multiple temporary piercings called precision piercings or play piercings. During my research, I commonly saw precision piercings that resembled the appearance of a corset being laced up along the back, with needles arranged along either side of the back and laced with ribbons (T. Winge, unpublished research fieldnotes, 2003, 2004). When the needles are removed only small marks remain, which heal quickly with only trace evidence on the subcultural body. The purpose of these types of piercings is about public displays and performances, demonstrating tolerance for pain and modification of the human body as an expression of artistic pursuits. Some subculture members who participate in precision piercings thought that they reached an altered state of consciousness or transcendence from the continuous pain (Larratt 2002; Musafar 1996; Winge 2003). Subsequently, precision piercings are often public performance body practices, which can lead participants to partake in more intense displays of body practices, such as hook hangings (Musafar 1996; Winge 2003).

## Hook Hanging

Comparable to precision piercings, hook hangings, also known as hook pulls, are also temporary piercings. This body practice, however, impacts the body in more significant ways by using large hooks to pierce the skin and then attaching the hooks

to a suspension device. The hooks hold the entire weight of the body. It is therefore essential that the hooks pierce through large areas of flesh, such as the chest, back, and/or thighs. Once the hooks pierce the portions of flesh, the hooks are attached to a rack, and then the suspension device is hoisted into the air.

These types of piercings often happen at hook hanging parties, where guests may watch or "safely" experience this body modification practice with the assistance of a suspension group, such as Mind Over Flesh or Life Suspended (Larratt 2002). Members of suspension groups are experts in hook hanging and provide all the needed equipment for the performance. Guests are encouraged to observe the members of the group demonstrate how to properly perform a hook hanging, and after the demonstration to partake in the body modification experience.

A trained piercer who is also a member of a suspension group uses large sterilized hooks to pierce through the skin, usually at the top of the participant's back (Larratt 2002). According to weight-bearing requirements (i.e., participant's weight evenly distributed over a given number of hooks), the necessary hooks are placed into the flesh of the upper back and then the hooks are attached to a suspension rack. The piercer then raises and suspends the rack over the guests, and the participant sways gently from the hooks. The participant may be lowered when the pain becomes intolerable, the participant loses consciousness, or if a hook rips free from the flesh (throwing the suspension rack off balance). When the hook hanging concludes, the participant is lowered to the ground, the hooks are removed from the skin, and if needed, the participant is revived.

Participants who are released from the suspension rack circulate throughout the party, with freshly cleaned wounds, sharing their experience. Participants I encountered frequently mentioned having feelings of being out of the body and reaching states of altered consciousness due to the intense pain. Urban Tribal subculture members comment that the experience is "an attempt to touch god" and "truly spiritual" (T. Winge, unpublished research fieldnotes, 2003). In addition, many participants of hook hangings are anxious to repeat the experience, in order to again experience the pain-induced transcendence (T. Winge, unpublished research fieldnotes, 2003).

## Three-Dimensional Rigid Implants

The most modern technology utilized for body modifications is three-dimensional rigid implants and related surgical instruments. This body modification practice requires that the shaped objects that are inserted into the body be of a high-quality materials, such as 316L surgical stainless steel and virgin grade Teflon, to prevent the body from rejecting the implant or becoming infected (Mercury 2000, 67; Winge 2004c).

Urban Tribal subculture members' three-dimensional rigid implants include Teflon horns inserted under forehead skin, capture jewelry inserted through small in-

cisions (part of the jewelry may be left partially exposed), ribbed shapes inserted under the skin of biceps, and metal Mohawks inserted into the scalp (Mercury 2000, 64–68). Three-dimensional rigid implants are not considered cosmetic plastic surgery by mainstream Western standards, as these implants do not reconstruct specific areas of the body for cosmetic reasons. Instead, these types of implants construct a subcultural identity for members who have them. Three-dimensional rigid implants have not yet surfaced as a Western fashion trend within the current body renaissance, and thus they still provide the Urban Tribal and Modern Primitive subculture member a unique visual appearance.

## Needles, Hooks, and Blood—Oh My!

Some subcultural members' reactions to the mainstream encroaching on their subcultural space and body rely on the subcultural standard—shock 'em! While this statement is an oversimplification, the *noise* created by subcultures with their dress is meant to have a shocking impact on outsiders; this noise not only provides a visual space for identities and ideologies within the group but also creates a subcultural space in which members can safely exist and resist the mainstream. Since spiky hair and black leather jackets have been co-opted by the mainstream, as well as piercings and tattoos, subcultures need to explore other avenues in order to remain distinct and distinctive.

In recent years, subcultural body practices draw audiences to witness bodily performances of flesh and blood. Precision piercings and hook hangings are most notable in their temporal nature and visible expressions of pain and the body. While an observer may query about the pain associated with a tattoo on the neck or piercing through the septum, the actual pain is safely removed from the encounter with the body modification. This buffer is removed in the cases of precision piercings and hook hangings; in order to view these body practices it is necessary to observe the blood and note the grimaces of pain. The viewer is empathetically drawn into or viscerally repelled from the body experience, despite his or her physical disconnection from the viewer. Still, precision piercings are a gateway for the mainstream viewer to participate in an Urban Tribal subcultural activity for an evening.

In the early 1990s, at a Jim Rose Circus performance, I stood near the stage watching a performer, Zamora the Torture King, swallow swords and breathe fire. A shirtless man with dreadlocks leaned over to me and said: "I have seen this act three times. You are about to witness the parting of the freaks from the fools." I looked around to see a mass of onlookers and then back to the stage just in time to see Zamora pushing long meat skewers through his flesh. I applauded and looked around again to realize there now were only a handful of people still near the front of the stage, including myself; most of the audience retreated to a "safer distance." The same parting of the audience happens at a precision piercing or hook hanging:

the initiated sip drinks and converse with and about the person whose flesh is pierced with hook or needle, but for the noninitiated the visceral response is to pull away and for some the only recourse is to leave the event (T. Winge, unpublished research fieldnotes, 2003).

Body-focused sideshows and circuses had a brief livelihood in the 1990s but are practically nonexistent today. Currently, body modification events are still hosted publically and privately, such as MODCON where the media is prohibited. Admittance to MODCON is by invitation for those with existing body modifications or practitioners, with nondisclosure agreements being signed before entering. Some Urban Tribal subcultures are claiming this convention as subcultural territory that requires the sacrifice, literally, of flesh and blood to occupy it. For most mainstream consumers this is more than they are willing to pay for the next fashionable body modification.

## It's Real to Me

In stark contrast, there is only minimal risk in a virtual world with a virtual body, which implores the mainstream and subcultures alike to explore its possibilities. As the world makes forays into the realms of technology and virtual worlds, the boundaries between mainstream and subculture blur, refocus, and blur again. Individuals with access to the Internet are using technology to escape their everyday lives and safely explore other identities, often subcultural in nature. Subculture members and mainstream individuals are exploring the body with virtual avatars in ways not easily accessible in the flesh-and-blood body and that do not have permanent and far-reaching consequences such as amputating a limb, adding cybernetic implants, acquiring animal fur, or removing/adding genitalia. In these virtual settings the subculture body style has no limits and is not bound by practical aspects of the human body.

## Anonymity

Anonymity in a virtual world, such as *World of Warcraft, Sims*, and *Second Life,* empowers individuals to break down barriers and try on new and different identities. The bank clerk who lives in mainstream culture has the ability log into a virtual world from the safety of her or his living room and try on the appearance and lifestyle of a gutter Punk, a seductive Goth, or a modified Modern Primitive. These virtual worlds also enable people to fully engage as subcultural members and make connections to other members.

Still, the same anonymity that empowers some can result in risks for others. When relationships that develop in virtual spaces continue away from the computer in reality, they stand the risk of being destroyed by unrealistic expectations. Individuals become addicted to participating and existing in virtual worlds, resulting, possibly,

in loss of a job or relationships due to excessive time being spent on the computer. Attractions to virtual worlds for those in the Urban Tribal movement include the ability to continually and endlessly modify the virtual body, which can be a tempting for body enthusiasts.

Thus, time, beyond that which is spent in a virtual world, becomes an important factor when occupying virtual space. In the introduction of *Body Modification*, Mike Featherstone (2000) posits:

> Technology, as yet, has no prospect of mastering time: if we can't escape time, we can't escape the body. We may seek to ignore time, but time as a major form of social synthesis is ultimately grounded in the human body. The finitude of the human life course and lived body time still impose limits on our capacity for technological mastery. (12)

Yet, this is exactly what individuals are attempting to do within virtual worlds. In these virtual worlds, it is possible to defy time by maintaining an ageless and flawless appearance, even while constructing new and experimental identities. Individuals are also able to change body modifications from day to day, staying ever current with fashions without real commitment.

Featherstone's quotation begs the question: Is the avatar's body less grounded in time than a flesh-and-blood body? The answer may be "yes," if there needs to be physical signs of aging or evidence of experiential activities, but it could be argued that these virtual characters or avatars are grounded in time for the user who lived through their virtual experiences. Furthermore, while human life is finite, as Featherstone argues, in a virtual world an avatar does not need to be mortal. An avatar could embody generations of experiences and live on from one version of the software to the next.

In virtual worlds, the subcultural body as an avatar may be defined and redefined continuously, and even abandoned if it no longer serves a purpose. What is the subcultural body in a virtual world? Does the subcultural body have different boundaries and limitations in a world where animals walk upright and talk? Is it even possible to carry over the meanings of the subcultural body seen on urban streets to those avatars with similar appearances in *Second Life*? Can the subcultural body exist as a timeless avatar or does it need to be grounded in time as flesh and blood? The future Urban Tribal subcultural body style positions itself beside and inside these technologies.

## Church of Body Modification

I return to discussions about understanding the body as more than a machine. It is possible to comprehend and appreciate why some subcultures are seeking the "ghost in the machine," or how the mind/soul and body interact at the conscious or even spiritual levels. Select subcultures such as the Modern Primitive and the Urban

Tribal resurrected ideas about the spiritual possibilities and dimensions of the body with their use of body modifications and related practices (but not all subcultural body modifications have spiritual significance). For some subculture members, their body modification design is chosen to communicate cultural protection and spiritual meaning. Still, others participate in body modification practices and rituals in an attempt to impact their lives in spiritual ways.

Steve Haworth, for example, approaches the creation of three-dimensional body modifications as a spiritual process, choosing a specific environment and setting for the insertion of the implant, whether it is a public performance or a private sitting, along with soothing music (Mercury 2000, 65). Before he begins, Haworth meditates about the anticipated procedure with scalpel in hand (Mercury 2000, 67). Haworth demonstrated his commitment to body modifications and the human right and spiritual need to have them by helping found the Church of Body Modifications. This church is a nondenominational congregation that teaches ownership over one's own body. The mission statement of the Church of Body Modifications is as follows:

> The Church's purpose is for our modified society to harmoniously return to its spiritual roots that have been forgotten. The modified community shall no longer be dismissed, and the Church of Body Modification is the spiritual hub in which modified individuals around the world will find strength and procure the respect from society as equal, intelligent, feeling, human beings. (Church of Body Modification 2002)

Moreover, the Church of Body Modification teaches and participates in both modern and ancient body practices, rites, and rituals, believed to be critical to the bond between the mind, body, and soul. When this bond is strengthened, a healthy space is created for spirituality and existence.

The very founding and existence of the Church of Body Modification suggests the depth and range of the body renaissance and the Urban Tribal movement. The formation of the Church of Body Modifications also indicates the Western search for spirit in the ever mechanized and "mediated" body.

## Mediated Body

The media plays an important role in subcultures, from the naming of specific subcultures to the portrayal of certain groups as "moral panics" or "freaks" (Thompson 1998). In the twentieth century, tattoos were common among a wide variety of subcultural groups, such as the Yakuza and motorcycle and street gangs (Hill 2006). As a result of media portrayals of these groups, these body modifications are often associated with males, criminals, deviants, and subcultural activities. The *mediated* body is one portrayed by media sources and may not accurately reflect the *lived* body. In the twenty-first century, tattoos are found on men and women, young and old, in all sizes, designs, and colors, and no longer associate the wearer with deviant activities.

As previously mentioned, the Internet allows not only others to mediate subculture but also members to mediate themselves. Body Modification Ezine (BME.com), for example, is a Web site where subculture members can post their body modifications and discuss their related experiences. With such Web sites, subcultures now have ways to mediate themselves not previously available through more traditional channels of media.

Subcultures are part of the visible mediated landscape, bleeding into the fringe of mainstream culture and ideals. This is most evident in the growing popularity of body modifications among the mainstream culture that were once only practiced and worn by subculture members. Moreover, the popular media introduces members of this subculture to mainstream society. For instance, there was a self-proclaimed Modern Primitive participant on the Western cable reality-television series *Mad Mad House* (Sci-Fi Channel 2004), and Urban Tribal subculture members have been featured in documentaries—such as *Body Art* (Bacher 2000) and *Human Canvas* (Perry 2000)— and shown on cable television's Discovery Channel and the Learning Channel.

Urban Tribal subcultures play a visible role in current society, one that they have the power to mediate far more than ever before with the prevalence of Internet access. What will subcultures do with this capacity to mediate their existence, identities, and roles? How will the subcultural body choose to portray itself? How will others portray subcultural body style? What will this mean for the boundaries between subcultures and mainstream culture? Who will mediate the subcultural body style? What role will the body renaissance play in future subcultural body style?

## Summary

Defining, characterizing, or classifying what *is* the subcultural body is difficult, if not impossible. In some respects it is easier to understand what the subcultural body *is not*—*not* normative, *not* mainstream, *not* fixed, and *not* universal. For this reason, generalizations made for the sake of this text do not reflect all subculture members within an individual subculture. Subculture members are less likely to identify themselves as such even when asked, and instead leave it to the observer to interpret and determine who they are and what group they belong to. Furthermore, time plays a crucial role in the identification and identity of the subcultural body. The subcultural body style of five years ago does not reflect the body of today; similarly, the subcultural body style of today has much bearing on the body of the future. This only further complicates the already ambiguous nature of the subcultural body style.

I sought to illuminate the subcultural body and encourage discussions about its past, present, and possible futures. I also dispelled myths about the inconsequential nature of subcultures, especially within the arenas of dress. The subcultural body, as presented, is a form of nonverbal communication. A single body modification on the subcultural body, for example, has multiple layers of visual or nonverbal

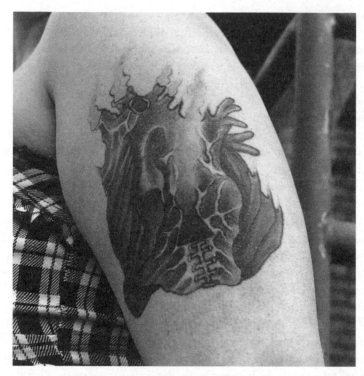

**Image 21** A subculture member's group identity and membership is literally inked, pierced, and burned into the flesh of the subcultural body, and these same body modifications nonverbally communicate personal and intimate information about the wearer. (Photo: T. Winge, unpublished research image, 2008)

communication, such as visual cues about membership, distinction from mainstream culture, or the narrative or significance related to a given body modification. Accordingly, it is important to recognize the significant role of dress, specifically body modifications and related body supplements, in establishing and continuing the identity of a subculture member and, collectively, the subculture. The types of body modifications chosen by subcultures directly reflect their ideology. In some subcultures, group identity and membership is literally inked, pierced, and burned into the flesh of the subcultural body.

Since World War II, subcultures have flourished in Western culture, distinguishing themselves from one another and creating subcultural postmodern identities with their appearances and styles. The identity and agency of the subcultural body is highly dependent on the visual and material culture of its styles and fashions. The Urban Tribal subcultural body style reflects bodily experiences, agency, and tribal identity.

The increased interest in body modifications over the past thirty years by the mainstream has been the result of Urban Tribal subculture members, such as the

Modern Primitives, displaying and even promoting their subcultural body style. This interest has led to a body renaissance and growing numbers of body modification practitioners and clientele. Subsequently, Urban Tribal subcultures are turning to more elaborate body practices and modifications less desired by mainstream consumers. The fear among some subculture members is that more extreme body practices may do a disservice to the subcultural body by creating a carnivalesque atmosphere around their body practices, rather than communicate a bodily awareness and knowledge that results from the acquisition of a body modification (T. Winge, unpublished research fieldnotes, 2003).

# Notes

## Chapter 1: Introduction to Subcultural Body Style

1. Edward Said (1978) first used the term "Other" to discuss how the colonial Europeans studied Asian cultures. "Other" commonly refers to a cultural generalization about a culture or people based on bias, and these generalizations do not always reflect the actual culture. Specifically, Said used this term to indicate people subjugated by and who have less power than those in authority. The term "Other" may refer to the connotations of a subculture by the dominant or mainstream culture, or it may refer to cultures or groups that the subculture members romanticize or idealize.
2. I present, in this context, my definition of "subculture" as a guide for my subcultural research. I was encouraged to develop a working definition for the term that reflected my subcultural experiences, both personally and professionally. This definition is the result of years of research with individuals who recognized their nonmainstream appearance, and ideology, but were less likely to identify with a specific subculture or label.
3. Eicher and Roach-Higgins (1992) define "dress" with the classifications of body modifications: (1) permanent or temporary, (2) odor and scent, (3) volume and proportion, (4) shape and structure, (5) surface design, (6) texture, (7) taste, (8) sound, and (9) color.
4. In 1882 the Barnum & Bailey Circus was created when P. T. Barnum joined his circus with James Anthony Bailey's circus (Davis 2002). Barnum and Bailey were each superb showmen, and their combined skills created a highly successful circus, which continues to feature amazing animal acts and human exhibitions.
5. In 1889 the Moulin Rouge nightclub opened and presented Paris, France, with a glimpse of the sexual and gaudy bohemian night life, with its risqué comedy acts and cancan dancers (Albright 2007).
6. When I was a child, my family worked on the carnival circuit for the Gooding's Million Dollar Midway and Tip Top Rides and Attractions. As a child I was introduced to my grandparents' friends who were "retired" vaudeville performers. They regaled me with stories about performances featuring the body, such as sword swallowing and fire-breathing acts.
7. Participants interviewed in my body modification study ranged in age from nineteen to forty-six, and included nine males and ten females. The demographics of

the participants interviewed were college-educated, employed, and modified (i.e., having body modifications). Their body modifications included: brands, implants, piercings, stretched piercings, and tattoos, as well as hairstyles (i.e., dreadlocks, Mohawks, scalplocks, and shaved heads). I conducted the sixty-minute interviews in Minneapolis, Minnesota; Milwaukee, Wisconsin; and New York, New York. The participants were from the following geographical locations (when a specific location was provided by the participants): Atlanta, Georgia; Chicago, Illinois; Miami, Florida; Milwaukee, Wisconsin; Minneapolis, Minnesota; New York, New York; Norway; Ontario, Canada; and Seattle, Washington. Through my participant observation, I collected fieldnotes about body modifiers from Austria, Australia, Canada, England, Germany, the Netherlands, and North America.

8. The *lived body* is understood as it is experienced firsthand from the person *living*, *knowing*, and *being* the body (van Manen 1998). In my research, the lived body is explored as a modified and subcultural body from the perspective of the individuals living, knowing, and being said body.

9. I developed the term "body renaissance" after hearing my research participants' accounts of reclaiming the body as an expression of self and agency, as well as noting the significant and growing ways that body modifications exist in mainstream culture and media venues. While the term's specific construction was inspired by Arnold Rubin's (1988) use of "tattoo renaissance," "body renaissance" is meant to encompass a new emphasis on the entire body and ways it is being expressed and modified.

## Chapter 2: Subcultural Body Style History

1. "Primitive" is an ethnocentric term used to refer to cultures that are non-Western. Subcultures use "primitive" to indicate "first" or "primacy," referring to ancient (typically non-Western) cultures (Vale and Juno 1989, 1–3).

2. In the 1980s The Dead Kennedys were a North American hardcore Punk band with distinct influences from British Punk bands.

3. The Gits were a North American Punk band from the mid-1980s, and were part of the West Coast music scene until 1993 when Mia Zapata, lead singer, was murdered (Rule 2004).

4. I greatly appreciate The Lizardman's clarifications about his body modifications and setting the record straight about The Enigma's horn implants (The Lizardman, personal communication with the author, 2011). I also appreciate The Enigma's additional details about his current silicone horn implants (The Enigma, personal communication with the author, 2011).

## Chapter 3: Subcultural Body Style and Identity

1. The Enigma informed me that he no longer has Teflon implants. Instead, he has silicone horn implants (the size was not specified), and the sclera of his eyes

were tattooed black by Howard Rollins from LunaCobra in 2011 (The Enigma, personal communication with the author, 2011). Both silicone implants and eye tattoos are highly controversial because the health risks are currently unknown.

2. There are numerous examples of heavily modified subcultural bodies displayed for public consumption (and entertainment), such as Mr. Lifto and Katzen.

3. Stelarc's Web site can be accessed at: http://www.stelarc.va.com.au/.

4. "Blackie" was a pseudonym chosen by a male research participant. All research participants are identified in this text by a pseudonym. Nearly all of the participants in my research chose their own pseudonyms, with the exception of subcultural celebrities and body practitioners, who have public personas and are referred to by their professional identity.

5. "Straightedge" is a term is used to describe a person who does not use drugs or alcohol. Some ultra straightedgers do not consume drugs of any kind, including caffeine and aspirin.

6. The "collective unconscious" is a collection of knowledge and information about the world that is inherent to every human being (possibly every living thing), regardless of past experiences (Jung 1972, 1977). This knowledge is stored in the human psyche and is not always accessible by the conscious mind (Jung 1972, 1977).

## Chapter 4: Subcultural Body Style

1. Claude Lévi-Strauss first employed the term "bricolage," but it is Hebdige's use of this term that is associated with subcultures. Specifically, Hebdige (1979) demonstrated how subcultures gather and combine diverse elements in order to create their unique appearances.

2. Tattoos are the result of the skin being subdermally injected with pigment in designated designs, which permanently or semipermanently transforms the skin. The word "tattoo" originated from the Tahitian *tatau*, which means "to mark something," and may have also resulted from the sound the tatau sticks make during a tattooing session (Gilbert 2001). Tattooing is a process of puncturing and depositing pigments into the skin with a variety of methods into a desired design.

   The electric tattooing gun is the common method for tattoos in many cultures around the globe. The tattoo artist guides the electric tattoo gun with its dye-loaded needles across the skin to create the desired pattern or design (Winge 2004f). Less common, but still used, are ancient tattooing techniques that use sharpened sticks or bones to puncture the skin and deposit ink.

3. Cuttings are incisions in the surface of the skin, which may be allowed to heal and naturally scar. Placing inert materials, such as clay or soot, into the fresh cuts produces pronounced scars or keloids (Winge 2004e). Branding modifies the surface of the skin by a branding tool that is either extremely hot or cold; destroying layers of skin tissue encourages a raised or sunken scar according to a

predesignated design (Winge 2004b). The two primary types of brands are strike and cautery. Strike branding is most common and uses branding irons, while cautery brands use electrical devices, such as lasers (Winge 2004b). The branding tool is pressed against the skin to create third-degree burns, leaving permanent scars as the designated design.

## Chapter 5: Future of Subcultural Body Style

1. During this research, I was denied admittance to a body modification convention because I did not have a significant amount of modifications. I have two piercings and one tattoo.

# Further Readings

The individual has always had to struggle to keep from being overwhelmed by the tribe. If you try it, you will be lonely often, and sometimes frightened. But no price is too high to pay for the privilege of owning yourself.

—Friedrich Nietzsche, *Thus Spoke Zarathustra*, 1892/2007

I brought together a diverse and large amount of research in order to discuss a variety of subcultural bodies. The following compilation is a list for further reading that corresponds to themes and subcultures presented.

Camphausen, Rufus C. 1997. *Return of the Tribal: A Celebration of Body Adornment*. Rochester, VT: Park Street Press.

Demello, Margo. 2000. *Bodies of Inscription: A Cultural History of the Modern Tattoo Community*. Durham, NC: Duke University Press.

Featherstone, Mike, ed. 2000. *Body Modification*. Oxford: Sage Publications.

Fraiser, Mariam, and Monica Greco, eds. 2005. *The Body: A Reader*. Oxon, UK: Routledge.

Gelder, Ken, and Sarah Thornton, eds. 1997. *The Subcultures Reader.* London: Routledge.

Gilbert, Steve. 2001. *The Tattoo History Source Book*. Brooklyn: Powerhouse Books.

Haiken, Elizabeth. 1999. *Venus Envy: A History of Cosmetic Surgery*. Baltimore: Johns Hopkins University Press.

Hebdidge, Dick. 1979. *Subculture: The Meaning of Style*. London: Routledge.

Hodkinson, Paul. 2002. *Goth: Identity, Style and Subculture*. Oxford: Berg.

McNab, Nan. 1999. *Body Bizarre Body Beautiful*. New York: Fireside Publications.

Mercury, Maureen. 2000. *Pagan Fleshworks: The Alchemy of Body Modification*. Rochester, VT: Park Street Press.

Muggleton, David. 2000. *Inside Subculture: The Postmodern Meaning of Style*. Oxford: Berg.

Muggleton, David, and Rupert Weinzierl, eds. 2003. *The Post-Subcultures Reader*. Oxford: Berg.

Pitts, Victoria. 2003. *In the Flesh: The Cultural Politics of Body Modifications*. New York: Palgrave Macmillan.

Polhemus, Ted. 1989. *Body Styles*. New York: Seven Hills Books.

Redhead, Steve C., Derek Wynne, and Justin O'Connor, eds. 1998. *The Clubcultures Reader: Readings in Popular Culture Studies*. Malden, MA: Wiley Blackwell.

Rubin, Arnold, ed. 1988. *Marks of Civilization: Artistic Transformation of the Human Body*. Los Angeles: Museum of Cultural History, University of California, Los Angeles.

Vale, V., and Andrea Juno, eds. 1989. *Modern Primitives: An Investigation of Contemporary Adornment and Ritual.*. San Francisco: Re/Search Publications.

Wojcik, Daniel. 1995. *Punk and Neo-Tribal Body Art*. Jackson: University Press of Mississippi.

# References

Albright, Ann Cooper. 2007. *Traces of Light: Absences and Presence in the Work of Loïe Fuller*. Middleton, CT: Wesleyan University Press.

Angel, Elayne. 2009. *The Piercing Bible: The Definitive Guide to Safe Body Piercing*. Berkeley, CA: Crossing Press.

Appignanesi, Lisa, and Geoffrey Bennington. 1989. *Postmodernism*. London: Free Association Books.

Bacher, Kevin. 2000. *Body Art*. New York: Pangolin Pictures.

Barcan, Ruth. 2004. *Nudity: A Cultural Anatomy*. Oxford: Berg.

Barthes, Roland. 1967/1990. *The Fashion System*, trans. Matthew Ward and Richard Howard. Berkeley: University of California Press.

Baudrillard, Jean. 1995. *Simulacra and Simulation (The Body, in Theory: Histories of Cultural Materialism)*, trans. Sheila Faria Glaser. Ann Arbor: University of Michigan Press.

Baudrillard, Jean. 1998. *The Consumer Society: Myths and Structures*. London: Sage.

Beaubien, Greg. 1995. "Burning Question: Branding Makes its Mark as the Latest Fad in Body Modification, but is it Art or Self-Mutilation?" *Chicago Tribune* (February 17).

Beauvoir, Simone de. 1949/1972. *The Second Sex*, trans. H. M. Parshley. New York: Penguin.

Beck, Peggy, Nia Francisco, and Anna Lee Walters, eds. 1995. *The Sacred: Ways of Knowledge, Sources of Life*. Tsaile, AZ: Navajo Community College Press.

Becker, Howard. 1963/1973. *Outsiders: Studies in the Sociology of Deviance*. New York: Free Press.

Bell, Quentin. 1976. *On Human Finery*. London: Hogarth Press.

Bending, Lucy. 2000. *The Representation of Bodily Pain in Late Nineteenth-Century English Culture*. Oxford: Clarendon Press.

Benson, Susan. 2000. "Inscriptions of the Self: Reflections on Tattooing and Piercing Contemporary Euro-America." In *Written on the Body: The Tattoo in European and American History*, ed. Jane Caplan. Princeton, NJ: Princeton University Press.

Berns, Marla C. 1988. "Ga'anda Scarification: A Model for Art and Identity." In *Marks of Civilization*, ed. Arnold Rubin. Los Angeles: University of California, Los Angeles.

Berns, Marla C., and Barbara R. Hudson. 1986. *The Essential Gourd: Its Art and History in Northeastern Nigeria.* Los Angeles: University of California, Los Angeles.

Body Modifications Extreme. 1997. Available at http://www.bmezine.com. Accessed April 30, 2002.

Bohannon, P. J. 1956. "Beauty and Scarification amongst the Tiv." *Man* 56(129): 117–30.

Bourdieu, Pierre. 1984. *Distinction: A Social Critique of the Judgment of Taste.* Cambridge, MA: Harvard University Press.

Bourdieu, Pierre. 1986. "The Forms of Capital." In *Handbook of Theory and Research for the Sociology of Education*, ed. John G. Richardson. New York: Greenwood Press.

Bourdieu, Pierre. 1990. *The Logic of Practice*, trans. Richard Nice. Stanford, CA: Stanford University Press.

Breward, Christopher. 2001. *The Culture of Fashion: A New History of Fashionable Dress.* Manchester, UK: Manchester University Press.

Brian, Robert. 1979. *The Decorated Body.* New York: Harper & Row.

Brooke, Michael. 1999. *The Concrete Wave: The History of Skateboarding.* Toronto, Ontario, Canada: Warwick Publishing.

Bryson, Norman. 2003. "Westernizing Bodies: Women, Art, and Power in Meiji Yoga." In *Gender and Power in the Japanese Visual Field*, eds. Joshua S. Mostow, Norman Bryson, and Maribeth Graybill. Honolulu: University of Hawai'i Press.

Calefato, Patrizia. 2004. *The Clothed Body.* Oxford: Berg.

Califa, Pat. 1994. "Modern Primitives, Latex Shamans, and Ritual S/M." In *Public Sex: The Culture of Radical Sex*. Pittsburgh: Cleis Press.

Camphausen, Rufus C. 1997. *Return of the Tribal: A Celebration of Body Adornment.* Rochester, VT: Park Street Press.

Carlyle, Thomas. 1869. *Sartor Resartus (Tailor Retailored).* London: Chapman & Hall.

Catlin, George. 1867. *O-Kee-Pa: A Religious Ceremony; and Other Customs of the Mandans.* London: Trubner.

Church of Body Modification. 2002. Available at http://uscobm.com. Accessed December 2002.

Clark, David. 1999. "'Total Pain,' Disciplinary Power and the Body in the Work of Cicely Saunders, 1958–67." *Social Science and Medicine* 49(6): 727–36.

Cohen, Albert. 1955. *Delinquent Boys: The Culture of the Gang.* New York: Free Press.

Curry, David. 1993. "Decorating the Body Politic." *New Formations* 19: 69–82.

*Dances Sacred and Profane.* 1985. Waverly, PA: Thunder Basin Films and Valley Filmworks.

Davis, Fred. 1994. *Fashion, Culture and Identity*. Chicago: University of Chicago Press.

Davis, Janet. 2002. *The Circus Age: Culture and Society Under the American Big Top*. Chapel Hill: University of North Carolina Press.

Descartes, René. 1911/1967. "Meditations." In *The Philosophical Works of Descartes*, ed. and trans. Elizabeth Haldane and G. R. T. Ross. Reprint, London: Cambridge University Press.

Dilger, Bradley. 2003. *Hacking Subculture*. Unpublished manuscript.

Douglas, Mary. 1973. *Natural Symbols*. New Orleans: Pelican Press.

Douglas, Mary. 1984. *Implicit Meanings: Essays in Anthropology*. London: Routledge.

Drewal, Henry John. 1988. "Beauty and Being: Aesthetics and Ontology in Yoruba Body Art." In *Marks of Civilization*, ed. Arnold Rubin. Los Angeles: University of California, Los Angeles.

DuBois, Page. 1991. *Torture & Truth*. New York: Routledge.

Edgar, Andrew, and Peter Sedgwick, eds. 1999. *Key Concepts in Cultural Theory*. London: Routledge.

Eicher, Joanne B. 2000. "Dress." In *Routledge International Encyclopaedia of Women: Global Women's Issues and Knowledge*, eds. Chris Kramarae and Dale Spender. London: Routledge.

Eicher, Joanne B., Sandra Lee Evenson, and Hazel A. Lutz. 2008. *The Visible Self: A Global Perspective on Dress*. New York: Fairchild Publications.

Eicher, Joanne B., and Mary Ellen Roach-Higgins. 1992. "Definition and Classification of Dress: Implications for Analyses of Gender Roles." In *Dress and Gender: Making and Meaning in Cultural Contexts*, eds. Ruth Barnes and Joanne B. Eicher. New York: St. Martin's Press.

Engler, Alan. 2000. *Body Sculpture: Plastic Surgery for the Body of Men and Women*. 2nd ed. New York: Hudson Publishing.

Entwistle, Joanne. 2000. *The Fashioned Body: Fashion, Dress and Modern Social Theory*. Cambridge: Polity Press.

Entwistle, Joanne. 2001. "The Dressed Body." In *Body Dressing*, eds. Joanne Entwistle and Elizabeth Wilson. Oxford: Berg.

Entwistle, Joanne, and Elizabeth Wilson, eds. 2001. *Body Dressing*. Oxford: Berg.

*Extreme Body Modifications-Implants*. 1999. Available at ambient.ca/bodmod/implants.html. Accessed June 2003.

Farnell, Ross. 1999. "In Dialogue with 'Posthuman' Bodies: Interview with Stelarc." In *Body Modification*, ed. Mike Featherstone. London: Sage Publications.

Favazza, Armando R., ed. 1996. *Bodies Under Siege: Self-Mutilation and Body Modification in Culture and Psychiatry*. Baltimore: Johns Hopkins University Press.

Featherstone, Mike, ed. 2000. *Body Modification*. London: Sage Publications.

Fetto, John. 2003. "Twenty-one, and Counting." *American Demographics* (September): 48.

Fields, Howard L. 1987. *Pain.* New York: McGraw-Hill.

Fine, Gary Alan, ed. 1995. *A Second Chicago School?: The Development of a Post-war American Sociology.* Chicago: University of Chicago Press.

Flügel, J. C. 1930. *The Psychology of Clothes.* London: Hogarth Press & Institute of Psycho-analysis.

Foucault, Michel. 1979. *Discipline and Punish: The Birth of the Prison*, trans. Alan Sheridan. New York: Vintage Books.

Francis, Lee. 1996. *Native Time: A Historical Time Line of Native America.* New York: St. Martin's Press.

Gans, Eric. 2000. "The Body Sacrificial." In *The Body Aesthetic: From Fine Art to Body Modification*, ed. Tobin Siebers. Ann Arbor: University of Michigan Press.

Gatewood, Charles. 2002. *Primitives: Tribal Body Art and the Left-Hand Path.* San Francisco: Last Gasp Books.

Gilbert, Steven. 2001. *The Tattoo History Source Book.* Brooklyn, NY: PowerHouse Books.

Gits, The. 1988/1996. "Cut My Skin," from *Kings and Queens.* Broken Rekids, compact disc.

Goffman, Erving. 1959. *The Presentation of Self in Everyday Life.* New York: Anchor Doubleday.

Goffman, Erving. 1963. "Embodied Information in Face-to-Face Interaction." In *The Body: A Reader*, eds. Mariam Fraser and Monica Greco. Oxon, UK: Routledge.

Goffman, Erving. 1967. *Interaction Ritual.* Chicago: Aldine & Doubleday.

Goffman, Erving. 1981. *Forms of Talk.* Oxford: Blackwell.

Gogol Bordello. 2005. "Illumination," from *Gypsy Punks: Underdog World Strike.* Side One Dummy, compact disc.

Good, Byron J. 1992. "A Body in Pain: The Making of a World of Chronic Pain." In *Pain as Human Experience: An Anthropological Perspective*, eds. Mary-Jo DelVecchio, Paul E. Brodwin, Byron J. Good, and Arthur Kleinman. Berkeley: University of California Press.

Goodrum, Alison L. 2005. *The National Fabric: Fashion, Britishness, Globalization.* Oxford: Berg.

Gordon, Milton M. 1947/1997. "The Concept of the Sub-Culture and its Application." In *The Subcultures Reader*, eds. Ken Gelder and Susan Thornton. London: Routledge.

Gottschalk, Simon. 1993. "Uncomfortably Numb: Countercultural Impulses in the Postmodern Era." *Symbolic Interaction* 16(4): 351–78.

Gritton, Joy. 1988. "Labrets and Tattooing in Native Alaska." In *Marks of Civilization*, ed. Arnold Rubin. Los Angeles: University of California, Los Angeles.

Hadingham, Evan. 1994. "The Mummies of Xinjiang." *Discover* 15(4): 68–77.

Harris Interactive. 2003. *Harris Poll #58*. Available at http://www.harrisinteractive. com/news/allnewsbydate.asp?NewsID=691. Accessed December 10, 2003.

Hebdige, Dick. 1979. *Subculture: The Meaning of Style*. London: Routledge.

Hetherington, Kevin. 1998. *Expressions of Identity: Space, Performance, Politics*. London: Sage Publications.

Hilfiger, Tommy. 1997. *All American*. New York: Universe Publishing.

Hill, Dee J., and Phil Hollenbeck. 2004. *Freaks and Fire: The Underground Reinvention of Circus*. New York: Soft Skull Press.

Hill, Peter B. E. 2006. *The Japanese Mafia: Yakuza, Law, and the State*. Oxford: Oxford University Press.

Hodkinson, Paul. 2002. *Goth: Identity, Style, and Subculture*. Oxford: Berg.

Holland, Samantha. 2004. *Alternative Femininities: Body, Age and Identity*. Oxford: Berg.

Hollander, Anne. 1980. *Seeing Through Clothing*. New York: Avon Books.

Hollander, Anne. 1994. *Sex and Suits*. New York: Kodansha International.

Hughes, John. 1985. *The Breakfast Club*. Universal City, CA: Universal Studios.

"Humbug." 1995. *The X-Files* (Season 2, Episode 20). Original airdate March 31.

Institute for Cultural Research. 2000. *Modern Primitives: The Recurrent Ritual of Adornment*. London: Institute for Cultural Research.

Irwin, John. 1970. "Notes on the Status of the Concept Subculture." In *Subcultures*, ed. David O. Arnold. New York: Glendessary Press.

Jonaitis, Aldona. 1988. "Women, Marriage, Mouths and Feasting: The Symbolism of Tlingit Labrets." In *Marks of Civilization*, ed. Arnold Rubin. Los Angeles: University of California, Los Angeles.

Jones, Meredith. 2008. *Skintight: An Anatomy of Cosmetic Surgery*. Oxford: Berg.

Jung, Carl G. 1972. *Psychology and Alchemy: Collected Works of C.G. Jung*. Vol. 12, 2nd ed. Princeton, NJ: Princeton University Press.

Jung, Carl G. 1977. *Mysterium Coniuctionis: Collected Works of C.G. Jung*. 2nd ed. Princeton, NJ: Princeton University Press.

Kaiser, Susan B. 1990. *The Social Psychology of Clothing: Symbolic Appearances in Context*. New York: Macmillan Publishing.

Kaldera, Raven, and Tannin Schwarzstein. 2002. *The Urban Primitive: Paganism in the Concrete Jungle*. St. Paul, MN: Llewellyn Publications.

Keenan, William J. F., ed. 2001. *Dressed to Impress: Looking the Part*. Oxford: Berg.

Kleese, Christian. 2000. "'Modern Primitivism': Non-Mainstream Body Modification and Racialized Representation." In *Body Modification*, ed. Mike Featherstone. London: Sage Publications.

Lacan, Jacques, and Wladimir Granoff. 1956. "Fetishism: The Symbolic, the Imaginary and the Real." In *Perversions: Psychodynamics and Therapy*, ed. Sándor Lorrant. New York: Random House.

Lagnado, Lucette. 1998. "Women Find Breast Surgery Attractive Again." *Wall Street Journal* (July 14): B1.

Larratt, Shannon. 2002. *ModCon: The Secret World of Extreme Body Modification.* Canada: BMEbooks.

Laver, James. 1969. *Modesty in Dress.* Boston: Houghton Mifflin.

Leblanc, Lauraine. 1999. *Pretty in Punk: Girls' Gender Resistance in a Boys' Subculture.* New Brunswick, NJ: Rutgers University Press.

Lévi-Strauss, Claude. 1958/1968. *The Savage Mind.* Chicago: University of Chicago Press.

Lind, Charlene, and Mary Ellen Roach-Higgins. 1985. "Collective Adoption, Fashion, and the Social-Political Symbolism of Dress." In *The Psychology of Fashion*, ed. Michael R. Solomon. Lexington, MA: Lexington Books.

Linton, Ralph. 1936. *The Study of Man: An Introduction.* New York: Appleton-Century-Crofts.

Lorber, Judith. 1994. *Paradoxes of Gender.* Binghamton, NY: Vail-Ballou Press.

Lyotard, Jean-Francois. 1984. *The Postmodern Condition: A Report on Knowledge,* trans. Geoff Bennington and Brian Massumi. Vol. 10, *Theory and History of Literature.* Minneapolis: University of Minnesota Press.

MacKendrick, Karmen. 1998. "Technoflesh, or 'Didn't That Hurt?'" *Fashion Theory* 2(1): 3–24.

Madison, Gary Brent. 1988. *The Hermeneutics of Postmodernity: Figures and Themes.* Bloomington: Indiana University Press.

Mails, Thomas E. 1995. *The Mystic Warriors of the Plains Indians.* New York: Marlowe & Company.

Marx, Karl. 1867/1999. "Fetishism of Commodities." In *Social Theory: The Multicultural and Classical Readings*, ed. Charles Lemert. New York: W. W. Norton.

Mascia-Lees, Francis, and Patricia Sharpe, eds. 1992. *Tattoo, Torture, Mutilation and Adornment: The Denaturalization of the Body in Culture and Text.* Albany: State University of New York Press.

McLaren, Malcolm. 1990. "Punk and History." In *Discourses: Conversation in Postmodern Art and Culture*, eds. Russell Ferguson, William Olander, Marcia Tucker, and Karen Fiss. Cambridge, MA: MIT Press.

McNab, Nan. 1999. *Body Bizarre Body Beautiful.* New York: Fireside.

McNeil, Legs, and Gillian McCain. 1997. *Please Kill Me: The Uncensored Oral History of Punk.* New York: Penguin Books.

Mead, Margaret. 1953. *The Study of a Culture at a Distance.* Chicago: University of Chicago Press.

Mercury, Maureen. 2000. *Pagan Fleshworks: The Alchemy of Body Modification.* Rochester, VT: Park Street Press.

Merleau-Ponty, Maurice. 1962. *Phenomenology of Perception.* London: Routledge & Kegan Paul.

Merleau-Ponty, Maurice. 1969. *The Visible and the Invisible.* Evanston, IL: Northwestern University Press.

Miller, Daniel. 2005. "Introduction." In *Clothing as Material Culture*, eds. Susanne Kucheler and Daniel Miller. Oxford: Berg.

Mirzoeff, Nicholas, ed. 1999. *The Visual Culture Reader.* London: Routledge.

Mizrach, Steve. 2002. "'Modern Primitives': The Accelerating Collision of Past and Future in the Postmodern Era." Available at http://www.fiu.edu/~mizrachs/ Modern_Primitives.html. Accessed Fall 2002.

Moore, Ryan. 2004. "Postmodernism and Punk Subculture: Cultures of Authenticity and Deconstruction." *The Communication Review* 7(3): 305–27.

Morris, David B. 1991. *The Culture of Pain.* Berkeley: University of California Press.

Muggleton, David. 2000. *Inside Subculture: The Postmodern Meaning of Style.* Oxford: Berg.

Muggleton, David, and Rupert Weinzierl, eds. 2003. *The Post-Subcultures Reader.* Oxford: Berg.

Musafar, Fakir. 1996. "Body Play: State of Grace or Sickness?" In *Bodies Under Siege: Self-Mutilation and Body Modification in Culture and Psychiatry*, ed. Armando R. Favazza. Baltimore: John Hopkins University Press.

Musafar, Fakir, and Mark Thompson. 2002. *Fakir Musafar: Spirit + Flesh*. Santa Fe, NM: Arena Editions.

Myers, James. 1992. "Nonmainstream Body Modification: Genital Piercing, Branding, Burning and Cutting." *Journal of Contemporary Ethnography* 21(3): 267–306.

Neihardt, John G. 1988. *Black Elk Speaks.* Lincoln: University of Nebraska Press.

Niesson, Sandra. 2003. *Re-Orienting Fashion: The Globalization of Asian Dress.* Oxford: Berg.

Nietzsche, Friedich Wilhelm. 1892/2007. *Thus Spoke Zarathustra.* New York: Barnes & Noble Books.

"One Out of Ten Americans Is Tattooed." 1936. *Life Magazine* 1(5): 30–31.

Orbach, Susie. 2009. *Bodies.* New York: Picador.

Perry, Hart. 2000. *Human Canvas.* Los Angeles: The Learning Channel.

Pitts, Victoria. 2000. "Body Modification, Self-Mutilation and Agency in Media Accounts of a Subculture." In *Body Modification*, ed. Mike Featherstone. London: Sage Publications.

Pitts, Victoria. 2003. *In the Flesh: The Cultural Politics of Body Modifications.* New York: Palgrave Macmillan.

Polhemus, Ted. 1989. *Body Styles.* London: Leonard Publishing.

Polhemus, Ted. 1994. *Streetstyle: From Sidewalk to Catwalk.* London: Thames & Hudson.

Polhemus, Ted. 2000. *The Customized Body.* London: Serpent's Tail.

Polhemus, Ted. 2004. *Hot Bodies, Cool Styles: New Techniques in Self-Adornment.* London: Thames & Hudson.

Polhemus, Ted, and Lynn Proctor. 1978. *Fashion and Anti-Fashion*. London: Thames & Hudson.

Polosmak, Natalya. 1994. "A Mummy Unearthed from the Pastures of Heaven." *National Geographic Magazine* 186(4): 80–103.

Randall, Housk. 1993. *Revelations: Chronicles and Visions from the Sexual Underworld*. London: Butler & Tanner.

Rey, Roselyne. 1995. *The History of Pain*. Cambridge, MA: Harvard University Press.

Roach-Higgins, Mary Ellen, Joanne B. Eicher, and Kim K. P. Johnson, eds. 1995. *Dress and Identity*. New York: Fairchild Publications.

Roome, Loretta. 1998. *Mehndi: The Timeless Art of Henna Painting*. New York: St. Martin's Griffin.

Rosenblatt, Daniel. 1997. "The Anti-Social Skin: Structure, Resistance, and 'Modern Primitive' Adornment in the United States." *Cultural Anthropology* 12(3): 287–334.

Rubin, Arnold, ed. 1988. *Marks of Civilization: Artistic Transformations of the Human Body*. Los Angeles: University of California, Los Angeles.

Rule, Ann. 2004. *Kiss Me Kill Me: Ann Rule's Crime Files*. New York: Simon & Schuster.

Said, Edward. 1978. *Orientalism*. New York: Random House Publishers.

Sanders, Clinton R. 1989. *Customizing the Body: The Art and Culture of Tattooing*. Philadelphia: Temple University Press.

Sanders, Lisa. 1997. "Zapping Your Way to a Younger-Looking Face." *BusinessWeek* (October 16): 162–E2.

Sartre, Jean-Paul. 1956. *Being and Nothingness: A Phenomenological Essay on Ontology*, trans. Hazel Barnes. New York: The Philosophical Library.

Scarry, Elaine. 1985. *The Body in Pain: The Making and Unmaking of a World*. New York: Oxford University Press.

Seeger, Jan. 1996. "Sculpting in Flesh." *Body Art Magazine* 23: 24–29.

Siebers, Tobin, ed. 2000. *The Body Aesthetic: From Fine Art to Body Modification*. Ann Arbor: University of Michigan Press.

Siggers, Julian, and Raven Rowanchilde. 1998. "How the Iceman was Tattooed." *In the Flesh* 1(2): 9–11.

Singleton, Jesse. 1997. "Piercing and the Modern Primitive." Available at http://www.bmezine.com/pierce/articles/p&mp. Accessed September 2002.

Sprague, Erik. 2008. "The Lizardman." Available at http://thelizardman.com. Accessed Fall 2008.

Steele, Valerie. 1996. *Fetish: Fashion, Sex and Power*. New York: Oxford University Press.

Steele, Valerie. 1998. *The Corset: A Cultural History*. New Haven, CT: Yale University Press.

Steele, Valerie, and Jennifer Park. 2008. *Gothic: Dark Glamour*. New York: Yale University & Fashion Institute of Technology.

Steele, Valerie, and Irving Solero. 2000. *Fifty Years of Fashion: New Look to Now*. New Haven, CT: Yale University Press.

Stevenson, Robert Louis. 1879/2004. "Truth of Intercourse." In *Viginibus Puerisque and Other Papers, Memories and Portraits*. Whitefish, MT: Kessinger Publishing.

Stone, Gregory. 1962. "Appearance and the Self." In *Human Behaviour and Social Processes: An Interactionist Approach*, ed. Arnold M. Rose. New York: Houghton Mifflin.

Storm, Penny. 1987. *Functions of Dress: Tool of Culture and the Individual*. Englewood Cliffs, NJ: Prentice Hall College Division.

Stovall, Edward (Pan). 1999. "Pan's Sun Dance." *Body Play and Modern Primitives Quarterly* 5(2): 14–21.

Strauss, David Levi. 1989. "Modern Primitive." In *Modern Primitives: An Investigation of Contemporary Adornment and Ritual*, eds. V. Vale and Andrea Juno. Hong Kong: Re/Search Publishers.

"Supergirl 'Actionista' Launch Party." 2007. *Los Angeles Confidential*, 249.

Sweetman, Paul. 2000. "Anchoring the (Postmodern) Self? Body Modification, Fashion and Identity." In *Body Modification*, ed. Mike Featherstone. London: Sage Publications.

Szasz, Thomas. 1975. *Pain and Pleasure: A Study of Bodily Feelings*. 2nd ed. Syracuse, NY: Syracuse University Press.

Szostak-Pierce, Suzanne. 1999. "Even Further: The Power of Subcultural Style in Techno Culture." In *Appearance and Power: Dress, Body, Culture*, eds. Kim K. P. Johnson and Sharron J. Lennon. New York: Berg.

Tanaka, Shelley. 1996. *Discovering the Iceman*. Toronto: Madison Press Books.

Taylor, Lou. 2002. *The Study of Dress History*. Manchester, UK: Manchester University Press.

Taylor, Lou. 2004. *Establishing Dress History*. Manchester, UK: Manchester University Press.

Thevoz, Michel. 1984. *The Painted Body: The Illusions of Reality*. New York: Rizzoli International Publications.

Thomas, Sander. 2002. "Body Piercing: Reclamation, Enhancement, and Self-Expression." Available at http://www.bmezine.com/pierce/reclaim.html. Accessed October 2002.

Thompson, Dave. 1995. *Perry Farrell: The Saga of a Hypster*. New York: St. Martin Griffins.

Thompson, Kenneth. 1998. *Moral Panics*. London: Routledge.

Thornton, Sarah. 1997. "General Introduction." In *The Subcultures Reader*, eds. Ken Gelder and Susan Thornton. London: Routledge.

Toaph. 2002. "The Urban Primitive Movement." Available at http://www.actwin. com/toaph/life/primitive/primitive.html. Accessed Fall 2002.

Torgovnick, Marianna. 1990. *Gone Primitive: Savage Intellects, Modern Lives*. Chicago: University of Chicago Press.

Torgovnick, Marianna. 1992. "Skin and Bolts." *Artforum International* (December 1992): 64–65.

Tseëlon, Efrat. 1995. *The Masque of Femininity: The Representation of Woman in Everyday Life*. London: Sage Publications.

Turner, Bryan. 1996. *The Body and Society: Explorations of Social Theory.* Oxford: Oxford University Press.

Turner, Bryan. 2000. "The Possibility of Primitiveness: Towards a Sociology of Body Marks in Cool Societies." *Body and Society* 5(2–3): 39–50.

Turner, Terence. 1969. "Tchikrin: A Central Brazilian Tribe and Symbolic Language of Bodily Adornment." *Natural History* 78(8): 50–59.

Turner, Victor. 1969. *The Ritual Process: Structure and Anti-Structure*. Chicago: Aldine Publishing.

Turner, Victor. 1982. *From Ritual to Theatre: The Human Seriousness of Play*. New York: PAJ Publications.

University of Pennsylvania Museum of Archaeology and Anthropology. 1998. "Body Modifications Ancient and Modern." Available at http://www.museum.upenn.edu/ new/exhibits/online_exhibits/body_modification/bodmodtattoo.shtml. Accessed Fall 1998.

Vale, V., and Andrea Juno, eds. 1983. *Industrial Culture Handbook.* San Francisco: Re/Search Publications.

Vale, V., and Andrea Juno, eds. 1989. *Modern Primitives: An Investigation of Contemporary Adornment and Ritual.* San Francisco: Re/Search Publications.

Vale, V., and John Sulak. 2002. *Modern Pagans: An Investigation of Contemporary Ritual*. San Francisco: Re/Search Publications.

van Gennep, Arnold. 1982. *The Rites of Passage.* Chicago: University of Chicago Press.

van Manen, Max. 1998. *Researching Lived Experience: Human Science for an Action Sensitive Pedagogy*. 2nd ed. Cobourg, Ontario, Canada: The Althouse Press.

Vaughan, Daniel, Taylor Asbury, and Paul Riordan-Eva. 1999. *General Ophthalmology*. Stamford, CT: Appleton & Lange.

Waters, John. 1988. *Hairspray*. Los Angeles, CA: New Line Cinema.

West, Candance, and Don Zimmerman. 1987. "Doing Gender." *Gender and Society* 1: 125–51.

Willis, Paul. 1978. *Profane Culture*. London: Routledge & Kegan Paul.

Wilson, Elizabeth. 1990. "These New Components of the Spectacle: Fashion and Postmodernism." In *Postmodernism and Society*, eds. Roy Boyne and Ali Rattansi. London: Macmillan.

Winge, Therèsa M. 2001. "An Exploration of the Parallels between the Modern Primitive Subculture and the Framework of Complex Adaptive Systems." Master's thesis, University of Minnesota.

Winge, Therèsa M. 2003. "Constructing 'Neo-Tribal' Identities Through Dress: Modern Primitives Body Modifications." In *The Post-Subcultures Reader*, eds. David Muggleton and Rupert Weinzierl. Oxford: Berg.

Winge, Therèsa M. 2004a. "Modern Primitives' Body Modification Experiences Explored Using Hermeneutic Phenomenology." Unpublished manuscript, University of Minnesota.

Winge, Therèsa M. 2004b. "Branding." In *Encyclopedia of Clothing and Fashion*. Vol. 1, ed. Valerie Steele, 186–187. New York: Charles Scribner's Sons.

Winge, Therèsa M. 2004c. "Implants." In *Encyclopedia of Clothing and Fashion*. Vol. 2, ed. Valerie Steele, 233–235. New York: Charles Scribner's Sons.

Winge, Therèsa M. 2004d. "Modern Primitive Subculture." In *Encyclopedia of Clothing and Fashion*. Vol. 2, ed. Valerie Steele, 420–421. New York: Charles Scribner's Sons.

Winge, Therèsa M. 2004e. "Scarification." In *Encyclopedia of Clothing and Fashion*. Vol. 3, ed. Valerie Steele, 144–145. New York: Charles Scribner's Sons.

Winge, Therèsa M. 2004f. "Tattoos." In *Encyclopedia of Clothing and Fashion*. Vol. 3, ed. Valerie Steele, 268–270. New York: Charles Scribner's Sons.

Winge, Therèsa M. 2010. "Body Art." In *The Berg Encyclopedia of World Dress and Fashion*. Vol. 3, *The United States and Canada*, ed. Phyllis G. Tortora, 183–189. Oxford: Berg.

Wohlrab, Silke, Jutta Stahl, Thomas Rammsayer, and Peter M. Kappeler. 2007. "Differences in Personality Characteristics Between Body-Modified and Non-Modified Individuals: Associations with Individual Personality Traits and Their Possible Evolutionary Implications." *European Journal of Personality* 21(7): 931–51.

Wojcik, Daniel. 1995. *Punk and Neo-Tribal Body Art*. Jackson: University Press of Mississippi.

Wolfgang, Marvin, and Franco Ferracutti. 1967. *Subculture of Violence*. London: Tavistock.

Wroblewski, Chris. 1991. *Skin Shows: The Art of Tattoo*. New York: Carol Publishing Group.

Wroblewski, Chris. 1992. *Tattooed Women*. New York: Carol Publishing Group.

Yinger, J. Milton. 1960. "Contraculture and Subculture." *American Sociological Review* 25(5): 625–35.

Young, Alana, and Christine Dallaire. 2008. "Beware *#! SK8 at Your Own Risk: The Discourses of Young Female Skateboarders." In *Tribal Play: Subcultural Journeys through Sport*. Bingley, UK: Emerald Group Publishing.

# Index